ODILON REDON

Richard Hobbs

STUDIO VISTA
LONDON

Acknowledgements

I should like to express my gratitude to Professor Jean Seznec, at whose suggestion I began to study Redon, for all his invaluable help and encouragement. Many other people also aided my work, notably Mlle Roseline Bacou of the Louvre, and my thanks go to all of them.

R.J.H.

The photographs were all supplied by the owners of the pictures, except in the following cases: 1,3,5,9,11,*12*,14,*17*,52,99 Bulloz, Paris; 43 M. T'Felt, Antwerp; *15,16* Fratelli Fabbri Editori, Milan; 24 John Freeman, London; *4* Gerhard Howald, Berne; *17*,74,98 Rijksmuseum, Amsterdam; *10* Elton Schnellbacher, Pittsburgh; *1,* 20,81,93,94 Service de Documentation Photographique de la Réunion des Musées Nationaux, Paris (Numbers in italics refer to colour illustrations.)

A Studio Vista book published by
Cassell & Collier Macmillan Publishers Ltd,
35 Red Lion Square, London WC1 4SG
and at Sydney, Auckland, Toronto, Johannesburg,
an affiliate of
Macmillan Publishing Co. Inc.
New York

Copyright © Richard Hobbs 1977
First published in 1977

ISBN 0 289 70615 7
Designed by Anthony Cohen
Set in Optima 10 on 12pt
by Spectrum Typesetting Ltd
Printed in the UK by Sackville Press Billericay Ltd., Billericay, Essex
Bound by R. J. Acfords Ltd., Chichester, Sussex

Contents

Preface

In 1894, Odilon Redon wrote in a letter to his friend and patron Edmond Picard: 'People are wrong in supposing that I have intentions. I only create art . . . The artist . . . will always be a special, isolated, solitary agent, with an innate sense for organizing matter.'[1] This claim to be an independent and isolated figure was made in response to the exaggeratedly speculative and literary commentaries that his work was then attracting. It is justified in the sense that he at no time followed any doctrinal programme of the kind that was being attributed to him, and was very much concerned with what he called the 'genius' of his medium: the intrinsic qualities of charcoal, lithography, pastels and oils. Yet today few would think of Redon as being an isolated artist. In the past, some critics have seen his work as a unique phenomenon that defies categorization; Jacques Morland, for example, declared in the catalogue to the large Redon retrospective held in Paris in 1926: 'His work will evade any classification. An isolated artist in his lifetime, he will remain unique.'[2] But half a century later, Morland's attitude hardly seems defensible. On the contrary, Redon is now widely considered to be one of the most typically·Symbolist painters of his time, an artist whose work was deeply involved in contemporary tendencies and events. Even his insistence to Picard that he was essentially solitary may be seen in retrospect not only as a statement of his independence from any Parisian group or faction, but also as a typically Symbolist expression of individualism. Experimenting freely with their means of expression in a spirit of idealism and subjectivism, Symbolists naturally tended to aspire towards isolation, and this amounted on the whole to a consciousness of their uniqueness as individuals rather than true solitariness. Redon's view of himself as an artist belongs to his times rather than separating him from them. His work both contributed to the contemporary artistic scene and also developed in response to it.

Nonetheless, the nature of Redon's involvement in his times was unusual. Few painters have waited so long for success or found themselves in so curious a position once they have begun to achieve it. Only in the early 1880s, after his fortieth year, did Redon start to make himself known in Paris, and even then the public at large remained indifferent towards his work or at best was mocking and hostile. It was a small minority whose approval Redon was not even seeking that greeted his art with enthusiasm: this was the literary avant-garde. From this situation there evolved the intricate and far-reaching relationship between Redon and his work on the one hand, and his Symbolist supporters and friends on the other hand, that forms one of the most intriguing and revealing episodes of the Symbolist era. Although he made some fruitful contact with fellow painters, such as the Nabis, Redon's direct and indirect links with Symbolist milieux concerned a far wider and more varied section of this world. A succession of prominent critics, writers, patrons and men from other walks of life, as well as painters, all contributed to his career as an artist in a variety of ways over the years. The

publication in 1960 by Arï Redon and Roseline Bacou of *Lettres de Gauguin, Gide, Huysmans, Jammes, Mallarmé, Verhaeren . . . à Odilon Redon,* the letters addressed to Redon preserved in his son's collection, made clear the rich and diversified orientation of Redon's life as an artist. The members of the Symbolist world who affected the course of his artistic career ranged from Huysmans to Sérusier, and from Mallarmé to the outstanding patrons of his later life, such as Bonger and Frizeau. Whilst retaining a vital degree of independence, Redon entered into a productive relationship with many of the leading figures and prominent 'cénacles' of his time that resulted in remarkable projects and commissions as well as an entry for himself and his work into the circles of the Symbolists.

It is the aim of this book to view the work of Redon in this context of his relations with the Symbolists. By reconstructing here around certain key works, such as his lithograph albums, the milieux in which Redon was involved, and by reproducing the perceptions and misunderstandings made about his art by critics, friends and patrons of the time, some light may be shed on both the nature of Redon's work and his position as an artist. His identity as a Symbolist, after all, concerns the role he played in Symbolism as well as the particular features of his style. This perspective emphasizes certain aspects of Redon's art at the expense of some others. No attempt is made here to be comprehensive in biographical completeness or iconographic analysis, and the intention is to add to rather than duplicate the approaches contained in those earlier studies of Redon that remain indispensable to any examination of the artist: the books of André Mellerio, Roseline Bacou and Sven Sandström. On the other hand, certain problems emerge more clearly from this kind of study than would otherwise be possible: for example the questions of how prevailing conditions and circumstances influenced Redon's very aims as an artist, and whether Redon in fact became a 'literary' artist as a consequence of the literary orientation of his career. And these as well as other questions surround a problematic central issue: what do we understand by the term Symbolist when it is applied to Redon's art?

A better understanding of this issue may be reached by retracing Redon's career, with regard both to the way his contemporaries reacted to his art and to the actual developments of his style.

Bristol, July 1975.

The Shadow of Romanticism

The Salon of 1868

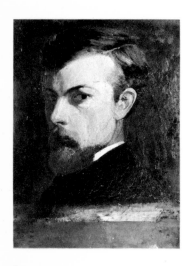

1
Self Portrait 1867, oil on wood,
35 x 25cm. 13¾ x 9⅞ in. Arï Redon
Collection, Paris

In the early summer of 1868, the Bordeaux newspaper *La Gironde* published a series of three articles reviewing the year's Salon exhibition that had just opened in Paris.[1] Appearing on the inside pages of a provincial daily, surrounded by shipping information, advertisements and *faits divers,* the review naturally went largely unnoticed. The name of the writer, Odilon Redon, was after all quite unknown. Although already twenty-eight years of age, Redon was then, as he was to remain for some years, an obscure figure. Only in retrospect and in the light of his later career as an artist have the articles attracted attention. For they form not so much an account or analysis of the pictures on display as a declaration of principles, almost a manifesto, written by a man whose work was later to be called 'the Pandemonium of Symbolism'.[2]

The Salon of 1868 offered its visitors the habitual quota of mediocre or now forgotten artists. When Emile Zola came to review the exhibition, he began, before he had even set foot there, by gloomily prophesying a low standard of achievement.[3] Yet his pessimism was not altogether justified. Although the honours were awarded to the likes of Gustave Brion, the presence of Daubigny on the selecting jury had helped to allow not only Manet to exhibit, but also some of the future Impressionists, including Monet, Pissarro and Renoir. Zola was able to praise the portrait of himself by Manet, Monet's *Ships Leaving the Jetties of Le Havre,* or the landscapes of Jongkind. Redon also noticed these painters, but his attitude towards them was totally different from Zola's. Whereas the champion of Manet compared them favourably with certain artists whose preoccupation with the ideal had led them to neglect nature, Redon accused Manet and others of limiting the scope of painting by excluding fantasy and the imagination. His personal enthusiasm was reserved for other figures: Corot, Fromentin, and an artist whose work was not even present, Rodolphe Bresdin.

Redon's three articles correspond to three stages in a coherent argument concerning the present state of painting and the future of art. The first one regrets, in terms similar to Zola's, the slump in general quality at the Salon, but contrasts this downward trend with the achievements of Corot and his pupil Chintreuil as landscape painters. Redon praises their landscapes as being among the highest achievements in contemporary art, because these works demonstrate what is to him an essential truth: that the painter must be a poet figure, studying nature closely, but using this study as a basis for expressing fantasy and the imagination. He sums up his belief succinctly: 'The outstanding artist is a painter before nature, a poet or thinker in the studio.'[4] Without denying the value of literal imitation, he insists categorically on the necessity of invention. In his diary of the time, Redon noted down the advice given him personally by Corot: 'Go every year to paint in the same place; copy the same tree,' and also, 'Beside the ill defined, place the well-defined.'[5] Redon's own landscape drawings of the time reflect such attitudes. His observation that the older painter 'bases his dreams

8

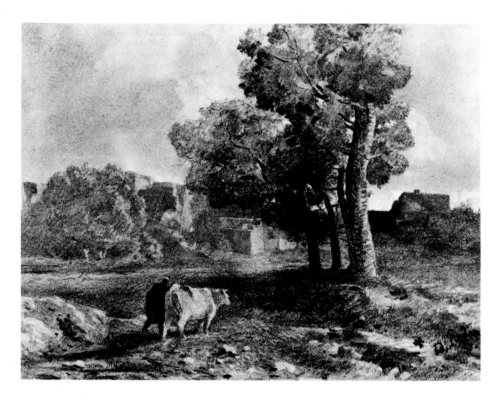

2
Landscape at Peyrelebade 1867,
charcoal, 32 x 43cm. 12⅝ x 16⅞in.
Collection M. Imberti, Bordeaux

upon an observed reality',[6] for instance, is applicable to his own *Landscape at Peyrelebade* of 1867 (Plate 2).

The second article turns from the success of Corot and Chintreuil to what Redon considers to be the failure of Courbet, Manet, Pissarro, Jongkind and Monet to fulfil this dual task of the artist, both to imitate nature and to invent the imaginary. They have rendered 'la réalité *vue'*, or observed reality, admirably, but excluded 'la réalité *sentie'*, that of the inner sensations. Courbet is a great colourist, but narrow in his art. Manet's strength is as a painter of still lifes and even his portrait of Zola falls into this category. Redon's quarrel with them does not concern their skills, but their attitudes. In his view, they have erred on an essential question, and it is this matter of principle to which he turns in his third article, which is ostensibly concerned with 'genre' painting, but in fact is a conclusion to his review of the Salon.

One painting exhibited at the 1868 exhibition is selected by Redon as the pivot of this final stage of his argument: *Centaurs and Centauresses Practising Archery* by Eugène Fromentin (Plate 3). Although his reputation was founded on his North African pictures and books, Fromentin had turned part of his attention that year to Hellenism. The mythological beasts are shown calmly practising their skills in a gentle landscape. Critical reaction to this return to ancient Greece was mixed. Edmond About, in *La Revue des Deux Mondes*, praised the boldness of the conception strongly and considered the result to be far superior to Corot, but he had reservations about the acceptability of centaurs as images in the modern world.[7] Lafenestre, in *La Revue Contemporaine*, would not even go that far, judging the technical qualities of the canvas quite inadequate for the subject matter.[8]

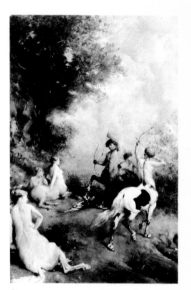

3
Eugène Fromentin *Centaurs and Centauresses Practising Archery*
1868, oil, 203 x 130cm. 79⅞ x 51⅛in.
Musée du Petit Palais Paris

Redon admired the picture enormously and used it to spell out the central point of his ideas: the subject of the picture was not limited to the imitative, but made free use of the imaginary. Like the masters of the past, Fromentin had given rein to his powers of invention, transcending the literal to express the ideal. Artists, Redon declares with some rhetoric, must follow this example in order to reclaim for painting its rightful qualities.

The views Redon expresses in these articles not only lay down the principles for his own development, but they also anticipate the attitudes of many of his friends and allies of the 1880s. Although of the same generation as Monet and Renoir, Redon had embarked on a different course from theirs. He later referred to the Impressionists as 'real parasites of the object',[9] preferring works of art that, besides pleasing the eye, provoked in the spectator a state of indefinite but suggestive thoughtfulness. Yet, for all their interest, these articles are not as prophetic as they might at first appear. They are forward-looking, to be sure, in their tone and intentions, but they are also backward-looking in their content and assumptions. They end, for instance, with a eulogy to Rodolphe Bresdin, absent from the Salon, but present in Redon's life over the preceding four years as an invaluable example of an artist who had based a visionary style on meticulous observation of the objective world. Looking back at these earlier years, Redon later referred to the 'black fumes of Romanticism which still clouded my mind'.[10] Redon's articles represent not only a personal manifesto concerning the future, but also a reflection of the provincial Romanticism of his past.

Redon's beginnings

The finest account of Redon's childhood remains the one he wrote himself late in life in 'Confidences d'artiste', which later became part of his book of personal reflections, *A soi-même*. Here he compensates for the almost total lack of significant incident by providing a sensitive evocation of the influences that affected his sensibility. His father had left France during the turbulent Napoleonic wars, and sailed for New Orleans in search of a more stable environment in which to pursue his ambition for material wealth. He was highly successful. Although impoverished on his arrival in America, he was able to return to France in 1840 with a substantial fortune. Odilon, the second son of his marriage in America, was born in Bordeaux very shortly after this return. But the consequences of this comfortable, bourgeois background were not as beneficial as might be expected. The solitude and melancholy of Redon's childhood resulted partly from the use to which his father put the money he had accumulated in the plantations of Louisiana. In 'Confidences d'artiste', he describes the bleak loneliness of the Médoc, where his father had bought the estate of Peyrelebade, at that time a far more remote and undeveloped region than today. He developed the habit of inactive, solitary introspection. 'I lived only within myself,' he confessed, 'with a loathing for any physical effort.'[11] Because of ill health, he did not go to school until he was eleven, and then was wretchedly miserable. Happily, there was also a positive side to the intensity of his solitary experiences. The natural beauty of the country with its vast skies and vineyards, the silence of inactivity imposed by illness, adolescent religious experiences, these and other sensations added joys to the spleen of those years. And Redon's later memories of this period of his life were of great importance to him. He regarded his early life at Peyrelebade as

a vital source of the sombre yet highly suggestive charcoal drawings that are an essential part of his work. He returned constantly to Peyrelebade as the natural place for him to work in, the cradle of those sensations and memories that fed his creative imagination. The eventual sale of the estate in 1897 was to him an event of great significance, the material break with a form of experience he had cherished, for all its darker sides, as long as he could remember.

In 'Confidences d'artiste', Redon also records his earliest experiences of paintings. At the age of seven he spent a year in Paris, where he visited museums. Memories of violently dramatic paintings, undoubtedly those of Delacroix and the Romantics, remained with him from these visits. At fifteen, he began to have lessons from an artist who had withdrawn from Paris to the calm of provincial Bordeaux: Stanislas Gorin, a minor figure but a stimulating teacher. Gorin's principles were those of the Romantic generation. His insistence that art should be the expression of one's individuality, transmitted to others by suggestive effects, established in his pupil's mind values that he would never seriously question. Gorin passionately admired Delacroix, Corot and the early paintings of Gustave Moreau, praising examples of their work in conversation with Redon. The works Redon produced at this time are described in 'Confidences d'artiste' as imaginative but undisciplined, enthusiastically created but brimming with Romantic despair.

In the late 1850s, then, when in Paris Courbet and others were pursuing anything but a Romantic course, Redon was responding to the turbulence of Romanticism with an intensity more readily associated with the 1830s. But he was not out of touch with the latest developments in the arts. Another of his early mentors, the remarkable Armand Clavaud, was one friend who constantly drew his attention to innovations. Clavaud was a man of broad and brilliant gifts. Professionally a scientist, his contributions to botany were in the forefront of research. His work on the animal characteristics of certain plants may well have contributed to Redon's imagery as an artist. But he was also highly sensitive to changes in the field of the arts, particularly of literature. Through him, Redon knew Les Fleurs du mal, Madame Bovary and translations of Edgar Allan Poe at the time of their publication.[12] Clavaud was also acutely interested in ancient Indian literature, then becoming available in French translation. The guidance of his knowledge, perception and idealism was precious to Redon both at this time and in subsequent years.

Redon's position in his late teens was therefore not without its contradictions. The Romanticism of his background and of the lessons of Gorin was already complicated by a consciousness of the changes prevalent in Paris. And although during the next few years his belief in idealist principles did not falter, he hesitated considerably over the course of action that he might pursue. Only a good deal later would his ambitions become finally orientated. In the meantime he considered a variety of futures. At the age of seventeen, he began to train as an architect. He failed the examinations, but he later considered his brief study of architectural solids, and of drawing, to have been valuable. His younger brother Gaston was to succeed where Odilon failed, becoming a notable teacher of architecture, although his actual architectural designs were perhaps less impressive than the visionary drawings he later made. After a little experience of sculpture, Redon's attempts to train in the respectable institutions in accord

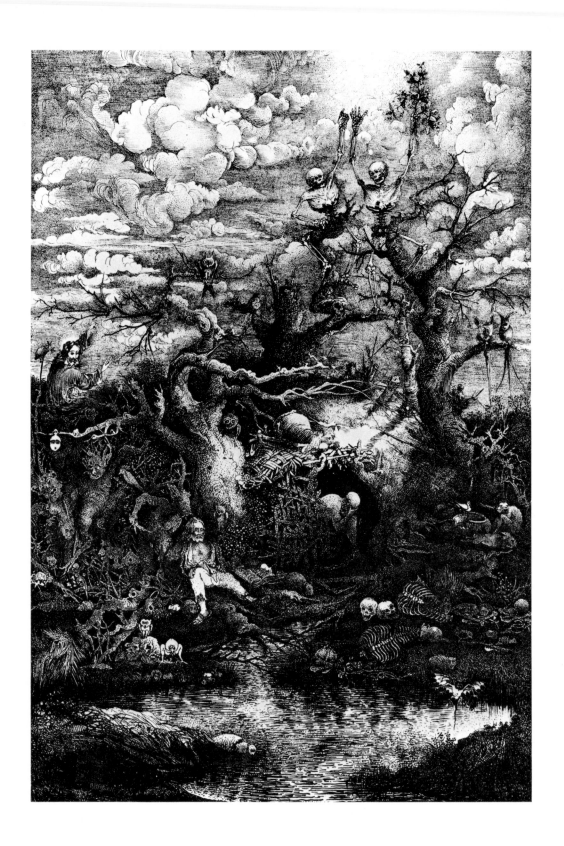

with his family's wishes reached a climax with his entry in 1864 to the Parisian studio of the painter Jean-Léon Gérôme, then a well-established figure. The project was doomed to failure. The painstaking attention to detail and the strong colours of Gérôme's paintings are diametrically opposed to the vague evocations with which Redon was concerned, and this conflict of aims led inevitably to the pupil's feeling victimized by the teacher and leaving his studio.[13]

It was at this most discouraging point, having achieved nothing but failures at the age of twenty-four, that Redon made the acquaintance in Bordeaux of Bresdin. Rodolphe Bresdin's reputation has been bound up with a bizarre legend of bohemian existence ever since Champfleury used him as a model for his story 'Chien-Caillou'. Although this tale, which depicts with some extravagance the poverty of an artist's garret, is anything but a biographical study of Bresdin, it does have some basis in the very real material distress of Bresdin's life, from which he sought to escape by adopting the life-style of a simple peasant or by toying with dreams of new and favourable conditions beyond the Atlantic on the frontiers of the New World. The visionary drawings and etchings of his production as an artist do nothing to contradict this legend. These small works, some of them positively tiny, are the expression of a highly original and powerful imagination. Features of the natural world, and in particular trees, are drawn with immense care, but are also transformed into elements of a visionary world, by virtue of their almost animate dynamism and also through their being blended with fantastic imagery: skulls, morbid creatures and sublime, sometimes Biblical motifs (Plates 4 and 5).

4 *Opposite*
Rodolphe Bresdin *The Comedy of Death* 1854, lithograph, 21.8 x 15cm. 8⅝ x 5⅞ in. British Museum, London

5
Rodolphe Bresdin *The Holy Family Beside a Rushing Stream* (detail) c. 1853, lithograph, 22.5 x 17.3cm. 8⅞ x 6⅞ in. Courtesy of The Art Institute of Chicago

Bresdin was important to Redon with regard to his way of life as well as his procedures as an artist. Following the fiasco of his passage through Gérôme's studio, Redon was able to recognize in Bresdin's bohemian existence an attitude towards success as an artist that provided some comfort in his own failure. Several years later, in 1873, Redon wrote a letter to Bresdin on this very subject: 'For a long time I have seen myself drawn between the stiff collar and the smock, without having the courage to break with the former . . . True, I shall have to make the break, otherwise no progress will be possible for me.'[14] Redon is distinguishing here between two ways of life, two notions of success: that of the 'faux-col', the bourgeois respectability of his background, and that of the 'blouse', or bohemian individualism. Although the first of these had brought no advance in his career, the second remained open as an alternative course to pursue. Bresdin provided an example of this alternative course, with its absence of any acclaim by a bourgeois public, but with its opportunities for very real achievements. In 1873, Redon evidently regarded this whole question as a distressing dilemma and could find no easy solution to his predicament. And indeed this would remain the case for years to come. Nonetheless, in the mid-1860s Redon was able to turn his attention away from the Parisian fame of Gérôme towards the poverty and obscurity of Bresdin, and so envisage with more confidence his own future as an artist. For the rest of Bresdin's life, beset as it was with poverty, illness and lack of recognition, Redon looked towards the older man as a kind of *maître*.

One of Redon's best-known works of the 1860s, an etching entitled *The Ford,* is signed by Redon 'élève de Bresdin' (Plate 6). Elsewhere, too, we find evidence of a master-pupil relationship existing between Bresdin and Redon. But we cannot infer from this that Bresdin was a seminal influence on Redon's formation, the figure who more than any other might have affected the development of his mature style. A close look at the situation, such as that undertaken by Dirk van Gelder,[15] quickly reveals the limitations of this interpretation. The two men were not in close or constant enough contact for such a relationship to develop. Their initial meeting was memorable for Redon, to whom Bresdin remained an exemplary figure, but it was not exactly a turning point; their association was to produce an alliance of interests rather than a dramatic change of direction for either of them. Both men, in exploring the visionary potential of black and white media, were studying the achievements of Rembrandt and of Dürer. Both men, also, were much concerned with the relationship between imitation and invention, between the copying of the observed world and the creation of the fantastic and the imaginary. Bresdin undoubtedly provided a powerful stimulus to Redon's development, and this is evident in works such as *The Ford.* Redon's later use of the tree motif or of flowers may also be related to Bresdin. But the older artist was reinforcing Redon's attachment to certain aims rather than revealing new ones to him. Clavaud, Gorin and other early influences had already instilled in Redon the conviction that art must be idealist whilst retaining its basis of observation, poetically suggestive as well as technically accomplished.

In January 1869, Redon published a fourth article in *La Gironde.* Entitled 'Rodolphe Bresdin', it gave an enthusiastic account of some of his works, and repeated some of the principles already set out in 'Salon de 1868', for example: 'To all the resources of the subtle and consummate practitioner he brings in

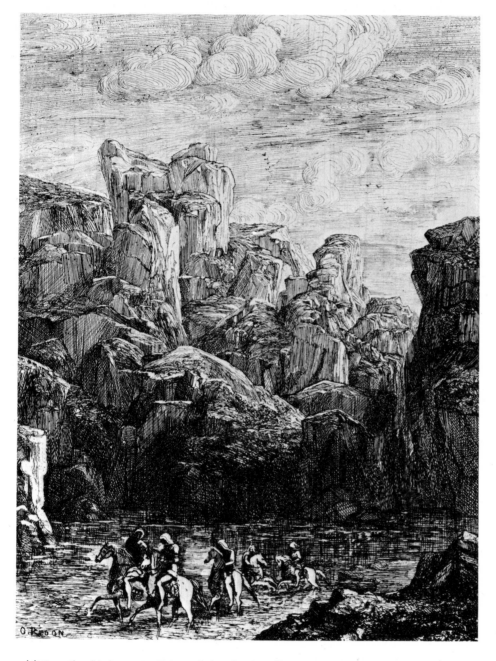

6
The Ford 1865, etching,
18 x 13.5cm. 7⅛ x 5⅜ in. Collection
Haags Gemeentemuseum, The
Hague

addition the highest qualities of the thinker.'[16] But as the decade drew to a close Redon still did not produce works himself that carried out these principles in a mature style. His drawings and the few etchings he had produced show some skill and power of suggestion but little of the originality and assurance of his later work. Only in the following decade, after the age of thirty, did his lengthy, hesitant formative period give way to a more productive phase. Indeed, when Redon came to look back over his life and career, he regarded the year 1870 as

15

something of a watershed and even a starting point: 'My originality . . . appeared later, after the age of thirty, that is to say after the war of 1870.'[17] The year 1870, that for France as a whole was so momentous, marked a vital beginning for Redon.

The early 'noirs'

It is rare to find in Redon's writings allusions to historical or political events. Those of 1870-71 would seem at first glance to be an exception to this rule. Far-reaching as the general effects of the Franco-Prussian War and the Commune were, however, Redon's comments, even in this case, concern the benefit they contributed to his development as an artist rather than the changes they brought to France. Redon's active involvement in the war of 1870 was slight. He did serve briefly in the French army, but he did not take part in a major battle or in the defence of Paris. Yet the simple fact of active service stimulated him to adopt a more positive and deliberate attitude to his own gifts. In retrospect he was to call this moment 'ma date véritable du vouloir',[18] the time when he took stock of his past experiments as a draughtsman and of his speculation about the future of art in order to assert his individuality as an artist. After this experience of military life that paradoxically represented for him a time of rest from the uncertainties of his hesitant career, he began at last to produce works in a mature style.

The charcoal drawing *The Fallen Angel* (Plate 7) for example, which dates from 1871, shows a clear and decisive advance compared to *The Ford, Landscape at Peyrelebade,* or other early works such as *Fear* (Plate 8). The subject matter is taken from the realm of religion and mythology, enabling Redon to evoke a visionary world from which time and realistic space are absent. But the subject does not belong to a familiar religious or mythological frame of reference. The angel is fallen or lost, stripped of any attributes of divine joy and beauty, but for no definable reason. We are simply shown wings that are like stone, and a head suggesting sadness and suffering. We are at the opposite pole from allegorical or Biblical art, for here there is a deliberate cult of the inexplicable and the ambiguous. The captivity and the melancholy of the angel are not reducible to an objective interpretation, although they do disturb the subjective responses of the spectator. The effect is indefinitely suggestive, with a degree of ambiguity that Redon himself compared to music.[19] The angel is used to express personal suffering and pessimism. And here Redon's medium is also of vital importance. The rich sombre tonal values he achieves with charcoal result in textures that are themselves amazingly suggestive and resonant.

The Fallen Angel is better known in the lithograph version (bearing the caption, 'The lost angel then opened black wings') that Redon made some fifteen years later for his album of lithographs, *Night.* The only important difference between the two is the omission in the second of the angel's imprisoning belt and chain. The 1871 work is entirely in place in this later context. Even the suppression of the idea of captivity does not represent any really permanent modification on Redon's part, for this theme is present in other works of the 1880s, for example *Captive Pegasus* (Plate 9). Nor is it altogether unusual to find drawings from the 1870s contributing to Redon's ideas and projects of years to come. There is a real continuity between such works and Redon's drawings and lithographs of the 1880s or 1890s. All these works go together to make up what Redon himself

7
The Fallen Angel 1871, charcoal,
28 x 22.5cm. 11 x 8⅞ in. Rijksmuseum
Kröller-Müller, Otterlo

called his 'noirs', the hundreds of suggestive fantasies in black and white that
dominated his output until he began to use colour just as forcibly in the 1890s.
This is not to say that a drawing such as *The Fallen Angel* marks the beginning of
Redon's true public career as an artist. Only after about 1880, when conditions
and circumstances permitted him to make his works known to the public at large,
would this be the case. The 1870s, in fact, perpetuate some of the failures and
obscurity of earlier years, but with the difference that Redon was now
consolidating and expanding his style in a number of remarkable drawings, of
which *The Fallen Angel* is one example among many.

 In the development of his subject matter during the 1870s, Redon looked not

8
Fear 1865, etching, 11.2 x 20cm.
$4\frac{3}{8}$ x $7\frac{7}{8}$ in. British Museum, London

9 *Opposite*
Captive Pegasus 1889, lithograph
34 x 29.3cm. $13\frac{3}{8}$ x $11\frac{5}{8}$ in. British
Museum, London

only to the religious domain of *The Fallen Angel,* but he also continued to study landscapes, especially trees. In 1875 we find him following in the footsteps of the series of landscape artists who worked at Barbizon. He found there not only a peace that was a welcome relief from Parisian life, but also the opportunity to study the forest of Fontainebleau. During these years, Redon also constantly returned to rural, provincial Peyrelebade to find similar working conditions. The charcoal drawing *The Enchanted Forest* (Plate 11) was made in the mid-1870s, and may have its source at Barbizon or at Peyrelebade. These possible sources, however, are of little relevance to the finished work, for the objective model was important only as a starting point. The addition of a mysterious robed figure to the natural scene removes it from the nineteenth century to bring it closer to *The Fallen Angel* in its evocation of an imaginary world of visionary strangeness. Even the natural phenomena, the tree, water and grass, are made mysterious by a skilful marriage between a deliberate vagueness of detail and a lively exploration of tonal values. The slightly earlier *Angel and Demon* (Plate 10) makes use of the same techniques. Observation of the natural world is an indispensable aspect of such works, but their quality lies rather in Redon's ability to transform these sources into potent works of the imagination.

The animal kingdom attracted Redon for similar purposes. He studied the bone structures of various creatures at natural history museums. From this basis of observation he proceeded to distort natural forms and to create imaginary beings. The first plate of the lithograph album *Origins* (Plate 25), for example, shows a primeval creature of a kind that never lived. Yet it is not a totally

18

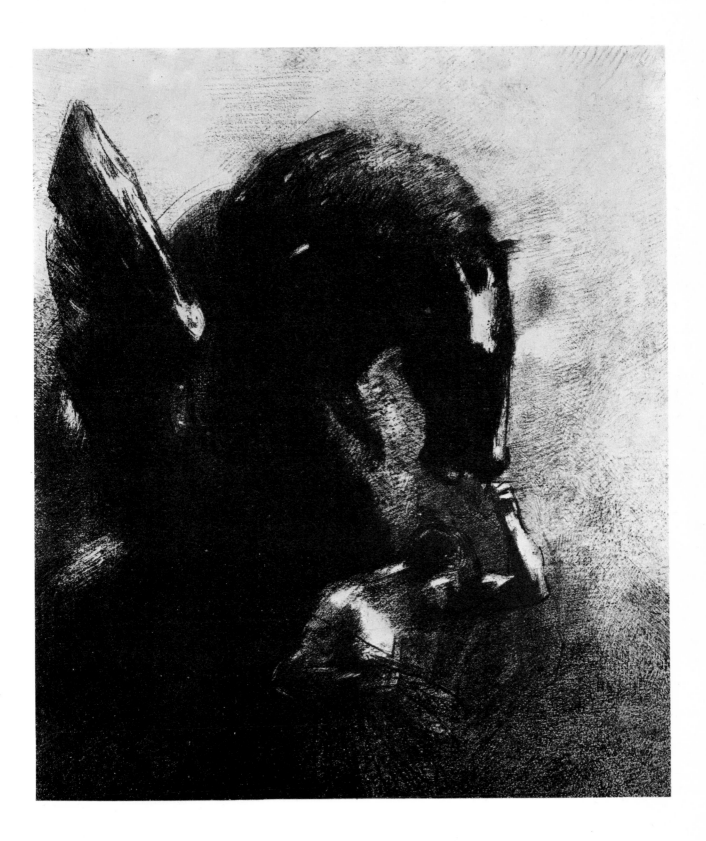

10
Angel and Demon c. 1875, charcoal,
45.5 x 36.5cm. 17$\frac{7}{8}$ x 14$\frac{3}{8}$ in. Musée
des Beaux-Arts, Bordeaux

11
The Enchanted Forest c. 1875,
charcoal, 60 x 50cm. 23$\frac{5}{8}$ x 19$\frac{5}{8}$in.
Musée des Beaux-Arts, Bordeaux

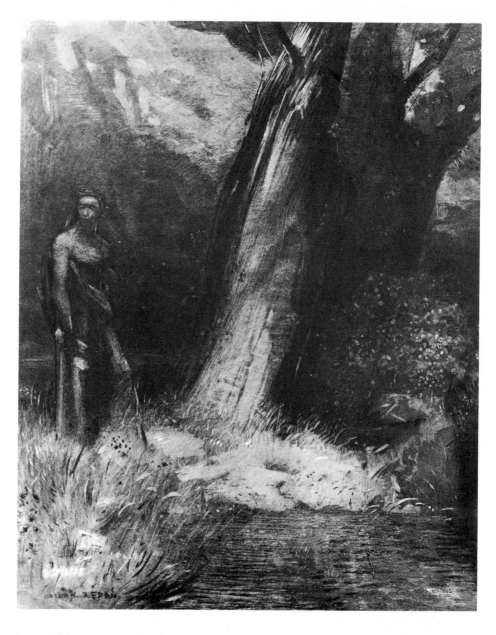

impossible organism. Redon's aim was to retain a viable link with the visible world whilst exploring the imaginary and visionary. He himself wrote in 'Confidences d'artiste': 'All my originality consists **then** of making improbable beings come to life humanly according to the laws of the probable, putting, as far as possible, the logic of the visible at the service of the invisible.'[20] And it is the human qualities of such creatures, on which Redon remarks, that make them disturbing. Rather than becoming monsters, they become the expressions of states of mind. The well-known *The Smiling Spider* of 1881 (Plate 12) is another of the many works where the observed world appears in strange, troubling guises.

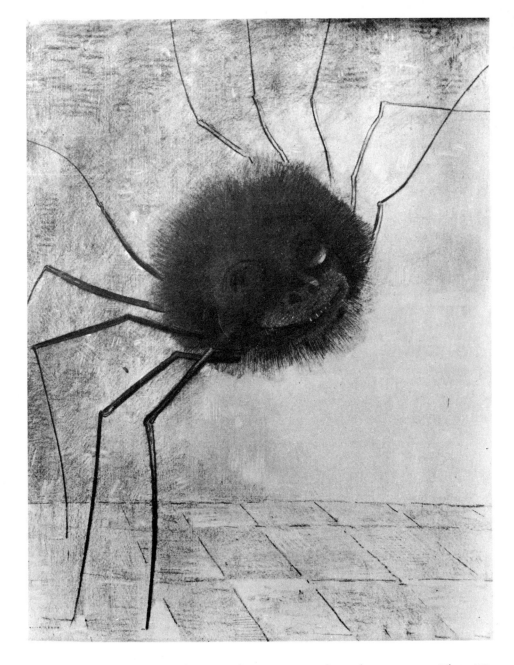

12
The Smiling Spider 1881, charcoal,
49.5 x 39cm. 19½ x 15⅜ in. Musée
National du Louvre, Paris

 Even more effective, perhaps, is *The Cactus Man* from the same year (Plate 13),
in which two familiar objects, a cactus and a man's head, are brought into
expressive fusion. Here the introduction of plant life into the human and animal
world points to another possible field of sources used by Redon: that of
caricature. His possible debt to Grandville has been pointed out by Sandström
and others. Several caricaturists use imagery that comes close to the creations of
Redon. Alfred Le Petit's *Fleurs, fruits et légumes du jour,* a series of lithographs in

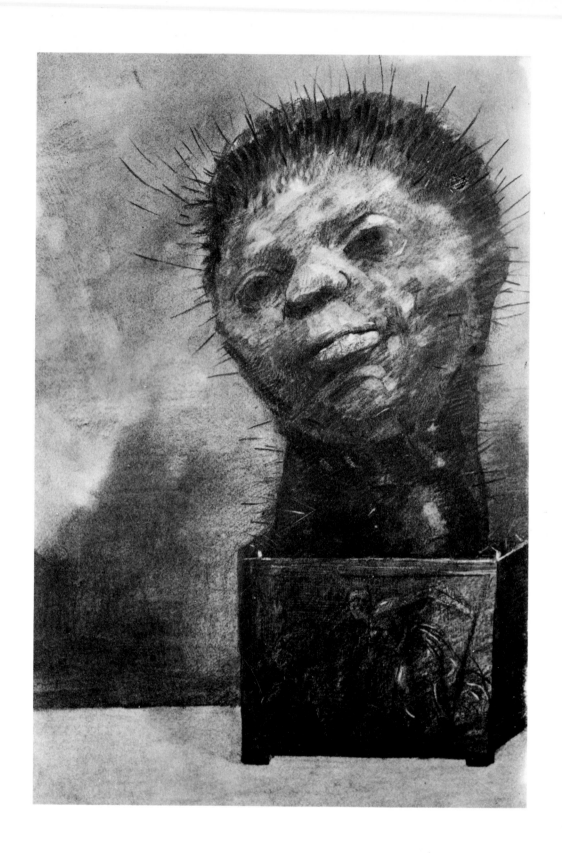

22

which the heroes and villains of 1870-71 are caricatured as members of the plant world, is just one instance of this kind of work. But Redon does not acknowledge any debts in that direction, preferring to emphasize his attention to models taken from the natural world.

During these years, Redon's use of religious and mythological subject matter also progressed. Occasionally we find a work that, unlike *The Fallen Angel,* appears to have a specific subject. His *Head of Orpheus Floating on the Waters* of 1881 (Plate 14), for example, seems to refer to a particular episode from the Orpheus myth. But it is not simply this myth that interests Redon here. Earlier, in 1877, he had made a drawing called *Head of a Martyr on a Platter* (Plate 15). The

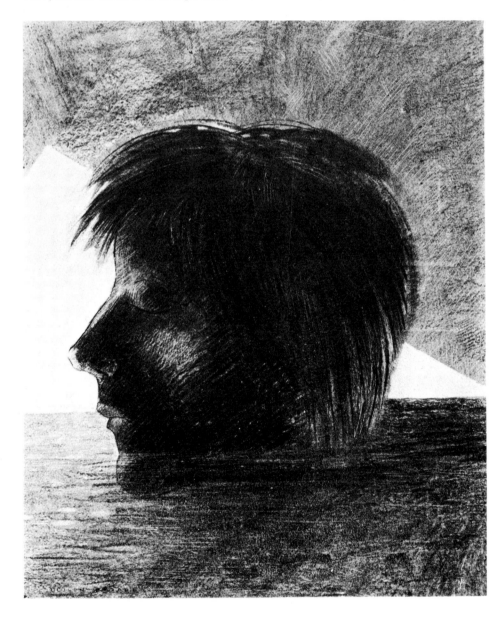

14
Head of Orpheus Floating on the Waters 1881, charcoal, 41 x 31cm. 16⅛ x 12⅛ in. Rijksmuseum Kröller-Müller, Otterlo

13 *Opposite*
The Cactus Man 1881, charcoal, 46.5 x 31.5cm. 18¼ x 12¾ in. Ian Woodner Family Collection, New York

23

15
Head of a Martyr on a Platter 1877,
charcoal, 37 x 36cm. 14⅝ x 14⅛in.
Rijksmuseum Kröller-Müller, Otterlo

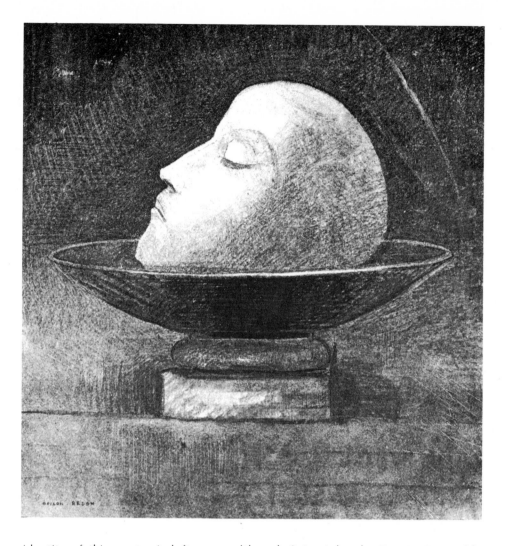

16 *Opposite*
The Apparition 1883, charcoal,
58 x 44cm. 22⅞ x 17¾ in. Musée des
Beaux-Arts, Bordeaux

identity of this martyr is left open, although Saint John the Baptist inevitably
comes to mind. Redon knew the Salome theme well; his *The Apparition* of 1883
(Plate 16) shows a clear debt to Gustave Moreau's treatment of the subject. The
feature common to Orpheus and John the Baptist is that of the severed head, a
theme not uncommon in the art and literature of the time. But Redon's use of the
image is even less particularized than this. The severed head of *The Apparition* is
also a head floating through space, and this floating head is a motif much
favoured by Redon. The drawing *Winged Head above the Waters* of 1875 (Plate
17) is an example. The head is not only a powerful visionary image, but it also
enables Redon to make effective use of one of his most frequent compositional
features, the sphere, which recurs in various forms throughout the 'noirs'.
Head of Orpheus Floating on the Waters is not, therefore, the depiction of
Orpheus simply for the sake of exploring that particular theme. It is the indefinite
association of a myth with motifs and geometric forms that are of personal
importance to Redon.

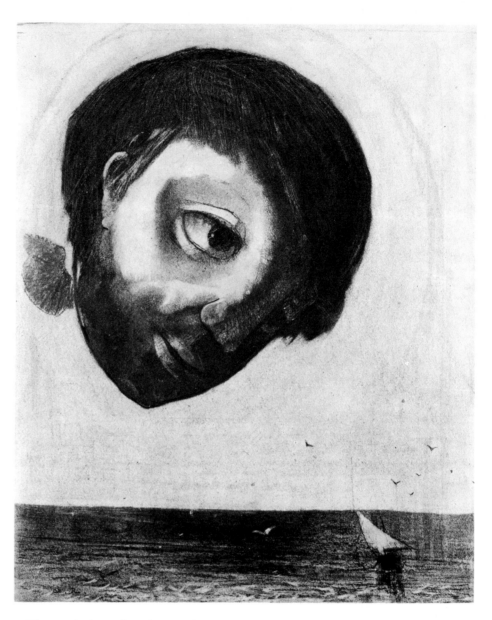

 The evolution of Redon's subject matter was accompanied by the develop-
ment of his understanding of black and white media. With the creation of the
imaginary world of the 'noirs' grew the conviction that charcoal was the medium
best suited to expressing it. Black and white served well the melancholy and
pessimism that was predominant in his work, but the importance of this medium
to Redon was broader than this. In 1913 he remarked: 'Black must be respected.
Nothing adulterates it. It does not give pleasure to the eyes and awakens no
sensuality. It is an agent of the mind far more than the fine colour of the palette
or prism.'[21] By confining himself almost exclusively to charcoal drawings, he was
able to concentrate his style on states of mind, directing the spectator's attention

away from the sensuous evocation of the objective world. Chiaroscuro effects and suggestive exploitation of the very textures of charcoal became fundamental to his style. In this, the example of Rembrandt remained precious to him. In 1878 he made his first journey to Holland, and so was able to add to the number of Rembrandts he already knew from the Louvre. At Antwerp he saw Rubens' *Raising of the Cross* and could feel no sympathy with such painting, for all its qualities. *The Night Watch,* however, and to an even greater extent *The Syndics,* enchanted Redon by what he called their magic.[22] Perhaps he had already read Fromentin's recently published *Les Maîtres d'autrefois* in which the painter of *Centaurs and Centauresses Practising Archery* had described Rembrandt's achievement as 'a daring and elaborate spiritualization of the material elements of his craft'.[23] Redon's own aims were not dissimilar.

During the 1870s therefore, Redon's 'noirs', the essential part of his production as an artist until the 1890s, came into existence. The contributory elements in the long formation of this authentic visionary style were many and complex; other visual and intellectual stimuli could be added to those already mentioned. The hesitant experiments of the 1860s had given way to an impressive, mature style. Yet a major problem remained: the means to public recognition. Much as his charcoal drawings fulfilled his intentions, they failed to procure him success. He tried to exhibit at the Salon; in 1878, he did in fact have a drawing, *Faun Leading an Angel,* accepted by the jury, but this was entirely inconsequential. He remained an obscure and provincial figure, distant from progressive circles during the winters he spent in Paris, and eager to retreat to Peyrelebade during the summers. The problem of exhibiting and making himself known was becoming increasingly urgent.

From Mme de Rayssac to the avant-garde

One Parisian circle into which Redon did become integrated during the 1870s was the salon of Mme de Rayssac, the widow of a minor and now forgotten poet, Saint-Cyr de Rayssac. From 1874 onwards, it was amongst her friends, rather than with more progressive or even fashionable elements of the art world, that Redon found real companionship.

The values of Romantic art were predominant in Mme de Rayssac's salon. Not only her husband's poetry (much influenced by a Romantic poet of the previous generation, Alfred de Musset), but also her own background, assured their somewhat anachronistic survival. Her father had been page to Charles X and a prominent politician under Louis-Philippe. Through him she had had contact as a child with leading intellectuals of the time, learning at first or second hand of Victor Hugo, Musset, Stendhal and others. As the ward of the Catholic Lyons painter Louis Janmot (1814-1892), she had continued this education. She became devoutly Catholic and royalist, as well as being steeped in an idealist view of the arts. And she remained profoundly attached to this rather backward-looking and reactionary ethos. One admirer wrote of her: 'She sometimes makes me think of a young Récamier.'[24] The reference is to a lady whose star had shone brilliantly in artistic and literary society some fifty years earlier, and the comment seems appropriate in that the world of Mme de Rayssac was scarcely that of the Third Republic. The senior members of her salon of the 1870s were men who had been personally involved in the heyday of Romanticism forty years previously, and

who willingly recounted their memories of it to the young, one of whom was Redon. Outstanding amongst them was the painter Chenavard, who had been the companion of Delacroix, Rossini, Baudelaire and many others, and whose anecdotes Redon recalls in his writings.[25] Information about Delacroix, whom he admired so much, was especially precious to Redon. Because of this environment, Redon's debt to Romanticism, which had been such a feature of his early life, received a fresh boost at the very time when Monet, Renoir and their companions were confronting Paris with the first Impressionist exhibition.

Fortunately, there was also a young generation present at Mme de Rayssac's salon, from whose friendship Redon benefited.[26] Indeed, one of their number was Camille Falte, whom Redon would marry in 1880. Another was Ernest Chausson, Mme de Rayssac's godson and subsequently a considerable composer. His presence stimulated the musical activities of the salon. Mme de Rayssac was a keen musician and painter, as well as being the widow of a poet, and this preoccupation with different art forms echoed Redon's own interests. It reinforced his sympathy with the salon's attitudes. Chausson and Redon became friends, playing music together and taking an interest in each other's works. But there was another figure at the salon who was still more important to Redon's career: Fantin-Latour. He it was who gave Redon decisive advice about the problem of achieving success. In view of Redon's almost total failure to have his charcoal drawings exhibited at the official salon, Fantin-Latour suggested that he should try a new method of making his work known to the public: lithography. Instead of depending on exhibiting his drawings, he should reproduce them in editions of lithographs, and distribute them to the buying public. 'I therefore made my first lithographs *in order to multiply my drawings*,' he later recalled.[27] For the next twenty years, lithography would be one of his most successful and valued means of expression.

Redon's first album of lithographs, based for the most part on earlier drawings, appeared in 1879 under the appropriate title *In Dream*. It contained ten lithographs and a frontispiece, and was published in an edition of twenty-five copies. Familiar motifs are present: trees for the frontispiece and for one plate, but more especially spheres, seven of the lithographs depicting severed or floating heads, and an eighth a floating eye. Very brief captions reinforce the effect of the plates, some having overtones of the natural world, such as 'Blossoming' or 'Germination', others emphasizing the title of the whole album, such as 'Limbo' or 'Vision'. The all-pervading melancholy of the work, often of nightmarish strength, is also reflected in these captions, for example in 'Sad Ascent'. The album is a successful summary of Redon's progress as a draughtsman during the 1870s. 'Blossoming' (Plate 18) recalls Redon's attachment to natural observation, whilst suggesting a world of indefinite time and space dimensions. 'Sad Ascent' (Plate 19) is perhaps reminiscent of the way in which the balloon had become a familiar image at the time of the Siege of Paris, but here the motif is made at the same time imaginary and human. Both lithographs also demonstrate clearly Redon's skill in transferring the textural qualities he had discovered in charcoal to the lithographic stone.

Lithography was not the only alternative route to success that Redon now turned to. In 1881 and 1882 he held his very first one-man exhibitions. And these took place not through the auspices of an official organization such as the Salon,

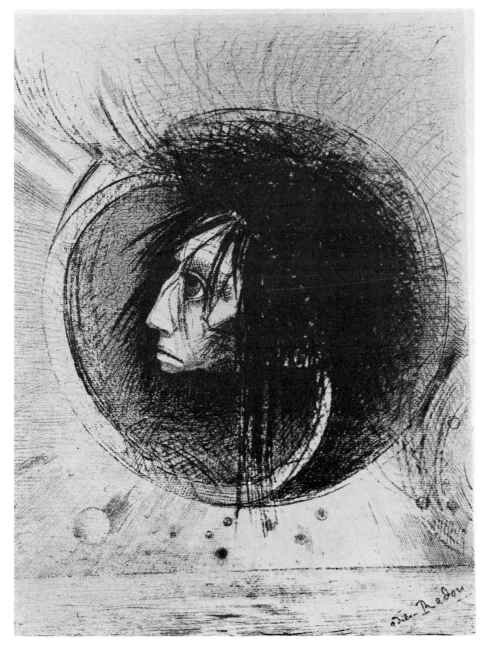

18
'Blossoming', *In Dream* 1879,
lithograph, 32.8 x 25.7cm.
$12\frac{7}{8}$ x $10\frac{1}{8}$ in. British Museum, London

but in the offices of newspapers. In 1881 he held a show with *La Vie Moderne,* Charpentier's weekly illustrated review, whose contributors included Huysmans and whose previous one-man shows included one dedicated to Renoir. In 1882 he held a second exhibition, this time with the long-standing national daily *Le Gaulois.* By changing his approach to the question of exhibiting and success, Redon had at last, at the age of about forty, embarked on his public career. Finally abandoning his initial ambitions with regard to the Salon, he now hoped

19
'Sad Ascent', *In Dream* 1879,
lithograph, 26.7 x 20cm. 10½ x 7⅛ in.
British Museum, London

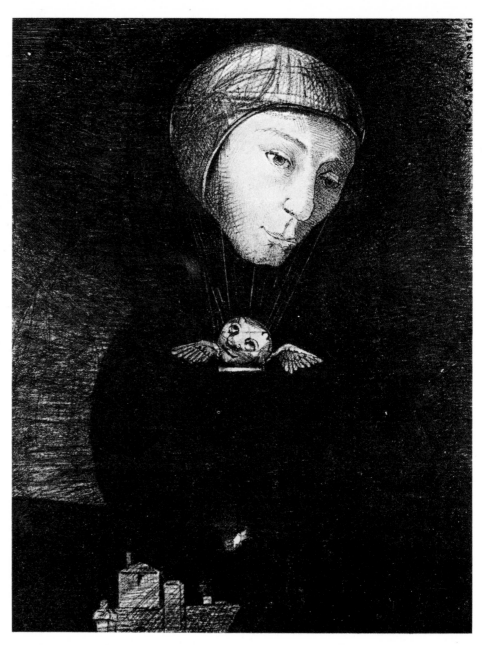

that recognition from the public would be his, and, in a sense, he did achieve it. The form this recognition took, however, was unexpected.

Redon considered the first exhibition to be a disquieting failure. A friend since childhood, Jules Boissé, loyally published an article explaining his aims,[28] and J.-K. Huysmans added an approving footnote about him to his article 'Le Salon officiel de 1881',[29] but such responses were few and far between in a generally cold and indifferent reception. The second exhibition served only to accentuate this situation. At the time, *Le Gaulois* was advertising with some success *Pot-*

bouille, the latest novel by Zola, whose work was then becoming increasingly accepted by the reading public. Redon's very different art was greeted with general derision. Huysmans' admiration, however, redoubled. He wrote a longer account of Redon's art praising its bizarre visionary qualities,[30] contacted Redon and became his friend. Nor was he alone in this growing enthusiasm, for, by this time, Emile Hennequin, a young literary critic, was also acclaiming Redon. In his review of the 1882 exhibition, he praised Redon as the outstanding figure in a new movement in the arts that was resolutely hostile to the precepts of Zola: that of the Decadents.[31] Without having such an aim in mind, and almost in spite of himself, Redon had suddenly become the hero of elements of the literary avant-garde. He was scarcely closer to public fame, but he had achieved some success in a milieu of far greater consequence than the salon of Mme de Rayssac.

Odilon Redon embarked on the truly substantial part of his life as an artist at an age when many would already have given of their best. By far the greatest part of the works and achievements for which he is remembered today belong to the thirty-five years or so of activity following 1880. Not that he had been altogether inactive until that time. On the contrary, it was during the long formative period of his early 'noirs' that his attitudes towards art, his personal style and his ambitions evolved, laying the foundations for later developments.

Yet he never ceased, over these years, to be an alienated figure, often associating his hopes for the future with the past examples of Romanticism. He did not find any group of artists or even individual figures whom he could truly identify with his own aims, or with whom he could collaborate. Even Fromentin, praised so highly in 'Salon de 1868', was a profound disappointment to Redon when he visited the older artist later that year. The distant, obscure figure of Bresdin was an even more alienated individual than Redon himself. And this situation was due to the circumstances of the time as well as to the slow personal development of Redon. His visionary art, consisting mainly of relatively small charcoal drawings, was very distant from the tendencies of the official Salon, and it was distant too from the progressive and controversial Impressionist exhibitions. In Paris in the 1870s it was difficult for him to find circles in which his attachment to visionary and suggestive art was echoed by others, and he succeeded in finding a reflection of his beliefs only in a milieu such as the salon of Mme de Rayssac. Although he was seeking to create a new idealist art, he was paradoxically obliged to seek support from somewhat reactionary sympathizers. Redon's provincialism also contributed to this pattern. Although he spent much time in Paris and tried to exhibit there, he did not become integrated into Parisian life. On the contrary, he remained indifferent to the fashionable trappings of the existence in the capital, and was happy to escape from it in travel or in occasional returns to Peyrelebade.

'Salon de 1868' had looked both backwards and forwards in providing a manifesto of Redon's aims. And in the 1870s, the same tendency persisted. As he developed the mature style of his charcoal drawings and lithographs, the 'black fumes of Romanticism' of his beginnings gave way to tendencies that anticipate the Symbolism of the 1880s and 1890s. But they had not entirely dissipated when the figure who had been inconspicuous even at Mme de Rayssac's salon suddenly achieved the unexpected success of being acclaimed a leading Decadent.

The Subtle Lithographer of Suffering

Fin de siècle Decadence is generally associated with a voluptuous cult of the artificial, or with a way of life in which useful or constructive actions are abandoned in favour of the superior rewards of the imagination or the senses. Its basis, however, is less titillating, since it lies in pessimism. Disenchantment with science or materialism as panaceas offering paths to progress and happiness, scepticism about moral or religious codes, the belief that society is degenerate or decaying, these and other forms of disillusionment are the archetypal starting-points of the Decadent sensibility in the nineteenth century. It is in this pessimism that a self-indulgent *culte du moi,* attractive though it may seem, has its roots. This sensibility is not confined to the eighties and nineties, since it is already apparent amongst the Romantic generation. Renunciation of material progress, individualism, a sometimes morbid passion for the artificial and an interest in the decadence of past civilisations, especially that of Rome, are all to be found several decades before the appearance of Huysmans' hero Des Esseintes. It is a widespread tendency that became so diverse through the century that it is difficult, if not impossible, to view it as a coherent or specific artistic current. Théophile Gautier wrote the most eloquent description of this sensibility in his preface to *Les Fleurs du mal,* where he describes a luxurious, byzantine style that, unlike classicism, has room for superstition, the monstrous and the unknown. Yet for all Gautier's perception, his definition can hardly be applied to a work such as Couture's painting *The Romans of the Decadence,* 1847, with its debt to Veronese.

In the 1880s, the prestige of Baudelaire gave Gautier's words a new and startlingly accurate relevance. But the identification of a coherent or specific Decadent movement is still problematic, for the term has been applied in retrospect far more than it was used at the time. Anatole Baju's review *Le Décadent* began to appear in 1886, but by then Huysmans' *A rebours* had already taken Decadence to a point that would scarcely be surpassed, and the term Symbolism was fast becoming the centre of attention. Nonetheless, even as late as the 1890s Joséphin Péladan's Rose+Croix, the artistic society whose exhibitions became a focal point of mystic painting from 1892 to 1897, owed something to his preoccupation with the decadence of the Latin races; so that the notion continued to receive publicity until Symbolism itself was becoming something of a spent force. The idea of Decadence in fact accompanied the whole course of Symbolism, but it also preceded it, and this is where much of its importance lies. Even where the term itself is absent, attitudes of intense pessimism and the extravagant cultivation of decadent sensibilities in the early 1880s contributed to a change in the arts that paved the way for the advent of Symbolism itself in about 1886. Eccentric organizations such as the Hirsutes and the Zutistes, small reviews such as *Lutèce,* publications such as Verlaine's *Les Poètes maudits,* minor poets such as Maurice Rollinat, whose *Les Névroses* of 1883 established a fashion for macabre and demented pessimism, all these and other phenomena contained

elements of what has come to be regarded as Decadent. Pursuing the strange and the unknown by making free use of the individual imagination, they advocated idealism and subjectivism rather than the dubious certainties of scientific rationalism. Although no simple Decadent movement came into being, the notion was very much in the air. Less assertive and more perverse, perhaps, than the Symbolists of the latter part of the decade, the Decadents are their immediate precursors, and there is a real continuity between the two. When, therefore, Odilon Redon was acclaimed the outstanding example of a Decadent artist by Hennequin in 1882, this amorphous but highly topical identity launched him into a complex and predominantly literary avant-garde that would lead him directly to involvement in the mainstream of French Symbolism.

Hennequin, Huysmans and the Decadents

Ironically, Redon's earlier failure to achieve public recognition contributed significantly to the sudden interest of the avant-garde in his work. Such distance from established taste, in addition to his evident opposition to figures whose fortunes were growing, such as the Impressionists or Zola, gave his work that stamp of profound originality that was to the Decadents a supreme quality in itself. Hennequin was categorical about this in reviewing the 1882 exhibition: 'Alone amongst our artists, painters, men of letters and musicians, he seems to us to have attained that absolute originality that today, in our world that has grown so old, is also the absolute merit.'[1] Such originality was particularly precious because it implied an antagonistic disenchantment with the contemporary world. Huysmans makes a similar point about originality in his account of the same exhibition. After describing Redon's nightmarish subject matter and praising *In Dream* as well as other lithographs and drawings that were on show, he notes some affinity between Redon and Gustave Moreau or Goya, but concludes that he is really utterly distant from earlier or contemporary painters, having real precursors only in Baudelaire and Poe.[2] The uninhibited licence of such judgements is an early indication of the disadvantages for Redon of the praise of writers. Such praise was eloquent and voluble, but also distorting and misleading.

Hennequin and Huysmans were on common ground in praising Redon for originality, but otherwise their enthusiasm stems from different points of view. When they adopted Redon's work as being allied to their own, each of them interpreted it in the light of his own beliefs. Those of Hennequin are the less known, partly because his early death nipped his promising career in the bud, and partly because the remarkable critical works for which he is still remembered today were produced after 1885, when he came to reject Decadent attitudes and adopt more optimistic and even scientific views.[3] It was the less mature man who saw in Redon's works an expression of pessimistic ideas and the Decadent spirit. In his article of 1882 which discusses Redon, he acknowledges a debt to another young writer, Paul Bourget, and there is a very real similarity between the positions of these two men. Bourget published in 1882 *Les Aveux*, poems expressing nihilism and misery in an idiom close to Baudelaire. Hennequin too was engaged in writing highly personal poems, in his case prose poems, very few of which have survived but of which this passage is typical:

In our maddened brains, words are visions, ecstatic visions, fanciful visions; words are visions without models and without objects, ideals rather than

images, desires rather than reminders: and how distant these ideals, how painful these desires.[4]

Not only is everyday life unsatisfactory, but the ideal visions created by language are too insubstantial to do more than create impossible desires. This intense personal pessimism led him to sympathize with the potent melancholy of Redon's 'noirs'. But Hennequin's interpretation of the 'noirs' is not simply subjective. He also identifies their significance with the attitudes and ideas of his contemporaries and his fellow Decadents, claiming that 'Redon alone has managed to express by certain symbols, by subtle syntheses, our most profound modern ideas about corruption, depravity, guile, and on the other hand, about the grandiose and the beautiful.'[5] And this is where he comes closest to Bourget, whose *Essais de psychologie contemporaine* were then being published as articles prior to their appearance in book form in 1883. In these essays, Bourget attempted to account for his personal pessimism by relating it to the cultural and especially the literary influences that he and his whole generation had experienced. Pessimism, in Bourget's view, was the hallmark of those whose formative years had taken place in the shadow of the French defeat of 1870. It was with this broader perspective in mind, rather than simply a personal appreciation of his style, that Hennequin communicated his enthusiasm for Redon to his contemporaries. Although he wrote some fine and perceptive commentaries on the 'noirs' and quickly became a close friend of Redon, his interpretation of Redon's works associated them with ideas that were close to the influential writings of Paul Bourget.

Huysmans' interpretation of Redon was even more markedly literary in its emphasis. Already in 1882 he had described the 'noirs' as 'une véritable transposition d'art' (a transposition, that is to say, from one art to another) when comparing his work to the writers who were becoming increasingly the two literary heroes of the avant-garde, Baudelaire and Poe.[6] This bias is developed even further in *A rebours,* where a description of Des Esseintes's collection of Redon's drawings is included, identifiable from their descriptions, although they are not named. They include *The Smiling Spider* and the slightly earlier *The Ball* of 1878 (Plate 20), which had been exhibited at *Le Gaulois* in 1882. Huysmans' description of this last drawing is evocative: it features, he writes, 'a bearded man, at the same time part bonze and part speaker at a public meeting, touching with his finger a colossal cannon ball.'[7] But it is also a part of the very fabric of his novel, and is therefore related directly to the psychology of its bizarre hero, Des Esseintes, and to the various features of his decadent existence. The central theme of *A rebours* is Des Esseintes's cult of the artificial, which stems from his pessimistic rejection of the natural world. Various chapters are dedicated to the different manifestations of this cult: monstrous flowers, literature of the Roman Decadence, perversely elaborate tastes, the hero's growing nervous disorders, and so on. The chapter on painting concerns chiefly Gustave Moreau, but includes also passages on Redon and Bresdin. These figures, and others, are used to suggest themes that go beyond what is intrinsic in their works, evoking a world of neuropathic delights and agonies that are those of the fictional Des Esseintes. Whereas Hennequin had simply indicated the significance that Redon's art might have for his generation of writers, Huysmans had gone much further. In *A rebours* he transformed Redon's 'noirs' into a literary motif in their own right.

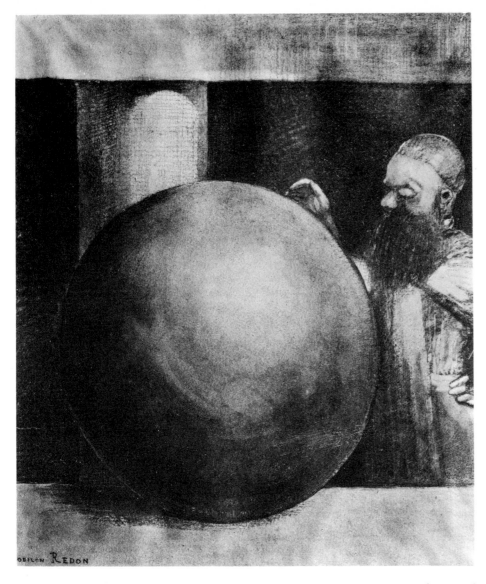

20
The Ball 1878, charcoal,
41.8 x 36cm. 16½ x 14⅛ in. Musée
National du Louvre, Paris

The publication of *A rebours* in 1884 was a major literary event. The novel caused a sensation and was quickly established as the archetype of the aims and tastes of the Decadents. Redon received publicity as a literary phenomenon that he had never enjoyed by exhibiting his works, achieving the dubious feat of having a reputation amongst some intellectuals who had never even seen his drawings and lithographs. At the same time, Hennequin was also giving a wide stimulus to Redon's growing reputation, although in a different manner. A professional journalist, he continued to praise Redon in enthusiastic articles, reviewing new lithograph albums as they appeared. He also used his personal influence to spread Redon's name among his friends and contacts in the world of journalism and literary reviews. One of these friends, the minor poet and outstanding critic Gabriel Sarrazin, later wrote a vivid account of this infectious

enthusiasm.[8] He recalled how he, like others, had been struck by Hennequin's 1882 article, and was intrigued by a Redon drawing that Hennequin owned. Hennequin took him to Redon's studio, where he was delighted to discover a kind of art that echoed his own preoccupations, at that time decidedly Decadent. In later years, Sarrazin was to show no interest in Redon or in the visual arts at all. Nonetheless, in the early 1880s, he followed Hennequin's example in praising Redon's art. The extent of this private advocacy by Hennequin of Redon's 'noirs' is impossible to gauge, but his journalistic contacts include several of Redon's later supporters and patrons: Charles Morice, Téodor de Wyzewa, Adrien Remacle and others.

Hennequin and Huysmans, therefore, contributed far more to Redon's career than their initial favourable responses at the exhibitions at *La Vie Moderne* and *Le Gaulois*. Through them, Redon became increasingly known in association with the tastes, ideas and aims of literary Decadents. If any confirmation of this were needed, it is to be found in a literary work that, like *A rebours,* provided one of the few popular and comprehensive focal points of the Decadence of the early 1880s: *Les Déliquescences, poèmes décadents d'Adoré Floupette,* the brilliant parody of Decadent poetry composed by Gabriel Vicaire and Henri Beauclair. When it first appeared in May 1885, this book quickly sold out. To a second edition, published the following month, there was added an account of the imaginary author's life, and here we find Redon included. Floupette's friend Marius Tapora tells how, after a bewildering evening in Le Panier Fleuri, the literary café the poet frequents, he accompanies the drunken Adoré to his fifth-storey room, where he notices a drawing by the great artist Pancrace Buret of a 'gigantic spider that carried, at the end of each of its tentacles, a bouquet of eucalyptus flowers and whose body consisted of an enormous, desperately pensive eye, the sight alone of which made you shudder.'[9] Readers of this would have had no difficulty in recognizing it as a parody of Des Esseintes's collection of Redons, transported into the world of the literary café. For better or for worse, Redon's work had become an integral part of the literary Decadence.

La Société des Artistes Indépendants

Redon was not, however, obliged to seek success purely in this literary world with which he was becoming increasingly involved, despite his growing reliance on writers to serve as his supporters and public. The year 1884 was momentous not only for the publication of *A rebours,* but also for the events that gave Redon his first opportunity to collaborate and exhibit with progressive Parisian painters. Already anxious to avoid the label 'literary', he was now able to seek a public in the company of painters, outside the sphere of literature. The opportunity he needed came with the foundation of the Société des Artistes Indépendants in response to the outcry surrounding the 1884 Salon.

Dissatisfaction with the official Salon was a familiar enough complaint amongst nineteenth-century artists, the monopolistic position of the Salon jury leading to upsurges of both individual and collective revolt, of which the Salon des Refusés of 1863 is the most celebrated example. Towards the end of the century, however, the authority of the Salon really began to fragment and dissolve. Alternative means of exhibiting became increasingly common, and 1884 was an important moment in this development. When the Salon opened in April

of that year in the Palais de l'Industrie, the jury came in for wide attack from artists who had been excluded, despite the high number of works admitted. Protest meetings were organized by the artists themselves, and it was decided to hold an independent exhibition, free of any jury, rather like the Salon des Refusés. An organizing committee was set up which persuaded the Parisian municipal authorities to lend them the necessary facilities, and on 15 May the exhibition opened in the presence of various official dignitaries. Among the many exhibitors was Redon, undeniably among 'les refusés'.

The exhibition was not, however, a success. There was no coherent tendency in evidence, artists of every kind being present: conservative and progressive, professional and amateur, talented and mediocre. Nor was the hanging of this heterogeneous assortment at all well organized. Redon's works were badly placed, as was the painting that has since become the best known of those shown: Seurat's *Bathers at Asnières*. Critical response to the show was generally one of confusion and disappointment. But the protest meetings of independent artists were not so anti-climactic. Further discussions were held at the time of the exhibition with the aim of making Les Indépendants not a single event, but a society that would continue to exist as an alternative organization to the Société des Artistes Français. And Redon now began to participate as an organizer as well as an exhibitor. When a splinter group protested against the slowness of the exhibition committee to act, Redon was their president and figurehead. During the lively exchanges that took place between these two factions, he remained in the limelight, no longer as a leader, but as a member of the alternative committee established on 29 July. By autumn, he was a vice-president.

One of the first actions of this new society, when the dust began to settle around its eventful instigation, was to organize another exhibition. This took place at a highly unusual time of year for such shows, opening on 10 December 1884. There were fewer works than in May, and the character of the exhibition was different. As Pierre Angrand has pointed out,[10] in May there was a diversified expression of discontent, whereas in December there was a clear affirmation of the idea of an independent group, free from control by jury or patronage, and giving rein to the artist's right to control his own affairs. Redon exhibited again, but once again neither he nor any other painter achieved any real success. Few critics mentioned Redon, not even his future friend and warm supporter Roger Marx; those who did describe his works did so with ambivalence or hostility.

The whole episode of Les Indépendants was in fact ultimately a disappointment to Redon. This organization that seemed to be attacking the very obstacles that had obstructed him for years held no future for him. He played no further substantial part in the society after these first turbulent months. Yet in spite of the failure, this episode, and the general growth of such organizations of artists or alternative means of exhibiting, were symptomatic of the kind of opportunities that were becoming open to Redon. All the exhibitions of the rest of his life took place in such a context. In May and June 1886, he exhibited at the last Impressionist exhibition, although, in the absence of Monet, Renoir and Sisley and the presence of Seurat and Signac, the show had little in common with the original Impressionist group. At about the same time, he was invited to take part in the exhibition in Brussels of Les XX, a progressive group of artists who had formed there in 1883. His most important show of the 1890s took place at a

dealer's gallery, that of Durand-Ruel in 1894. Vollard also gave him facilities in the late 1890s. After the turn of the century he would exhibit again with dealers, and also at the Salon d'Automne. The liberalization of art institutions at the end of the century provided Redon with new conditions for making his work known.

The public with which Redon had contact tended, however, to be a limited one. Over the years, he was constantly to bemoan the absence from his life of critical acclaim and public renown. In the 1880s, certainly, the successes he did achieve were with a small number of enthusiasts rather than a wide public. And writers too remained an essential feature of these conditions. Despite Les Indépendants and a growing number of allies amongst painters who included Gauguin and Schuffenecker, Redon was becoming largely dependent on writers for support, patronage and even companionship.

Developments in the early lithograph albums

The literary orientation of Redon's career affected not only his reputation but also his style. He responded to Decadent fashion and to the changes in his environment by incorporating features into his works that show a clear understanding of where his most sympathetic public lay. This is particularly true of his lithograph albums, a medium he had adopted in order to attract a wider audience. Huysmans called him 'the subtle lithographer of Suffering',[11] and it was chiefly in this identity that he was achieving some notoriety. Following *In Dream*, further albums appeared in 1882, 1883, 1885 and 1886, and continued until the late 1890s. Each one, particularly of the earliest examples, demonstrates Redon's ambivalent but unmistakable awareness of his debt to literary supporters. Already in 1882, Redon's initial appeal to the Decadants was strongly favoured by the appearance of his album *To Edgar Poe* at the very time of Hennequin's and Huysmans' enthusiastic praise of the *Le Gaulois* exhibition. This use of Poe naturally led Decadents to believe that Redon was influenced by him in the same way as they were. Yet this is not the case. The captions that the lithographs bear were composed, contrary to what was inferred by some, not by Poe but by Redon, and his reasons for choosing such a literary title were somewhat devious.

He was already working on this second album at the time of *In Dream*. This was the time when he was investigating the nature of lithography, and it was in this context, rather than for literary motives, that he adopted the devices of a literary title and captions. Reflecting on the question later, he pointed out that the great lithographers of past years had used captions that appealed to contemporary taste, having in mind, no doubt, Delacroix, who had used Shakespeare and Goethe as subject matter for collections of lithographs.[12] In *To Edgar Poe* he was following Delacroix's example: he was seeking to win over a public by exploiting contemporary literary fashion. Much later he wrote of the captions that 'They were at the most an *equivocal* way . . . of helping the understanding and penetration of an art that, when it appeared, seemed incoherent and mad.'[13] They were designed to make his work more acceptable to the public. He recalled also that Poe was not his personal preference, but a subject suggested to him by his friends.[14] They were no doubt influenced by the real points of comparison existing between Poe's reputation in about 1880 and Redon's aims. Poe was admired above all for the mathematical logic by means of which he made his fantasy seem human and credible, while Redon, similarly, was concerned with

representing the imaginary according to the logic of the visible world.

Far from being a Decadent admirer of Edgar Allen Poe, therefore, Redon was simply recognizing the aptness and potential of associating the writer's popularity with his own bid for success. The technique was expedient rather than necessary stylistically. A plate such as 'A mask tolls the funeral knell' (Plate 21) is

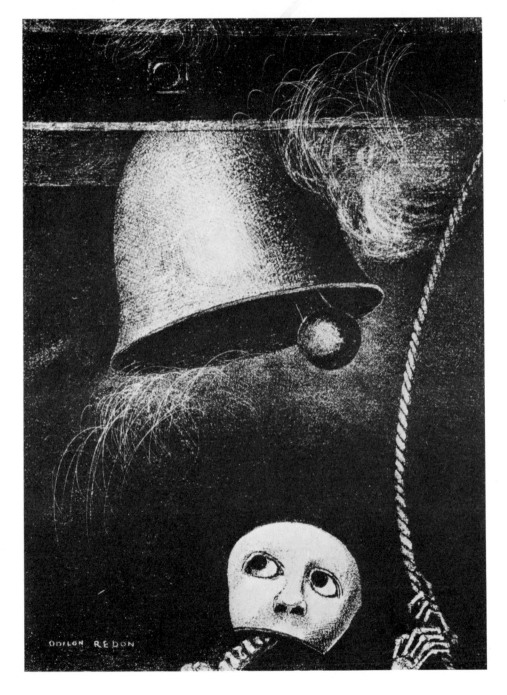

21
'A mask tolls the funeral knell', *To Edgar Poe* 1882, lithograph, 15.8 x 19.2cm. 6¼ x 7⅝ in. British Museum, London

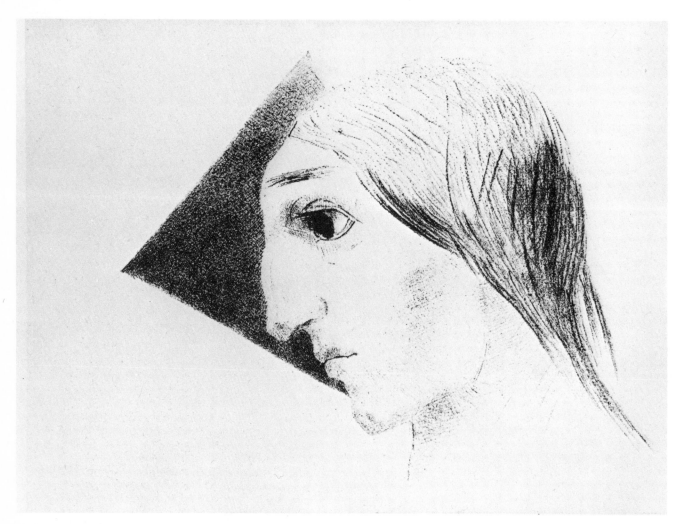

22
'Madness', *To Edgar Poe* 1882,
lithograph 14.5 x 20cm. 5¾ x 7⅞ in.
British Museum, London

23 *Opposite*
The Masque of the Red Death 1883,
charcoal, 42 x 36cm. 16½ x 14⅛ in.
Museum of Modern Art, New York,
John S. Newberry Collection

a perfectly successful macabre image without allusion to Poe, as is 'Madness' (Plate 22). The striking aspect of the album is not Redon's debt to Poe, but his virtual independence of him. He is placing himself far more in the lineage of Delacroix's lithographs than in that of Poe's fantastic works. Redon came to regret his expedient adoption of Poe, remarking of it, 'I had, alas, lost all my innocence.'[15] He was using effects that he believed in retrospect to be adulterations of the simple, suggestive qualities of *In Dream*. Apart from a very few examples from 1882 to 1883, he made no further use of Poe in his works. These may have been enough, however, to consolidate this aspect of his reputation. For example, in 1882, Hennequin's translation from Poe, *Contes grotesques,* was published with a cover illustration by Redon showing the raven perched at an open window (Plate 24). It is not a work of great quality, but it is a significant one. It is the first of the many commissions from writers and publishers that were to link Redon's name with literary productions for years to come. A charcoal drawing from 1883, *The Masque of the Red Death* (Plate 23), has equally strong literary connotations. Based on Poe's tale of the same title, long

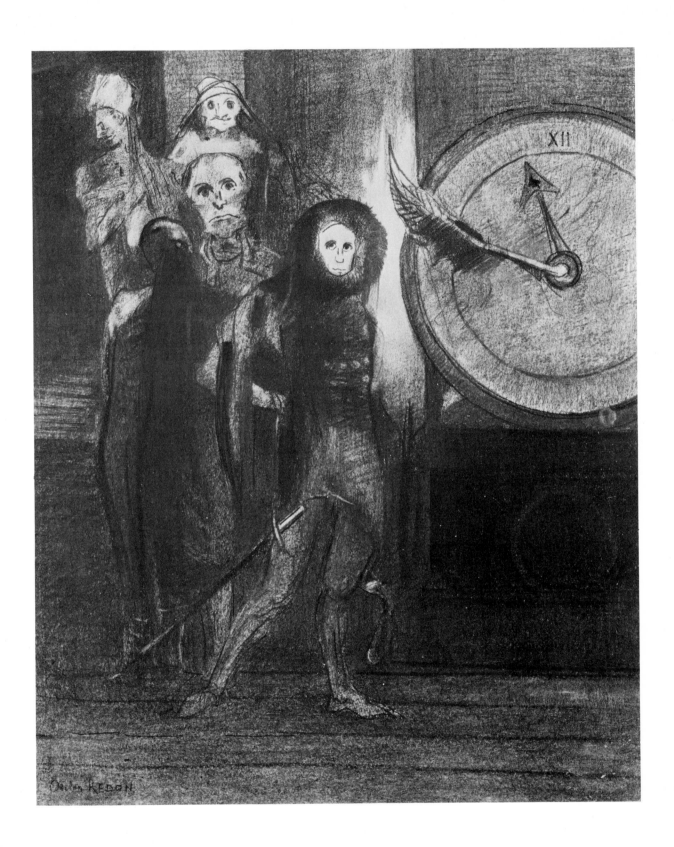

41

24
Cover illustration to *Contes
grotesques* (Hennequin's translation
of Poe's *Tales of the Grotesque*)
1882, lithograph, 16.2 x 10.6cm.
6⅜ x 4⅛ in. Author's collection

25 *Opposite*
'When life was awakening in the
depths of obscure matter', *Origins*
1883, lithograph, 27.5 x 20.3cm.
10⅞ x 8 in. British Museum, London

familiar to the French through Baudelaire's translation, it makes fairly literal use
of the clock and the masked figure that play so important a role in Poe's tale of
disease and decay. Redon's attitude towards Poe may have been a cautious and
uneasy homage, but his public had every reason to believe it was a strong and
committed one.

The insistence by writers that his work presented a close parallel with Poe was
therefore not altogether welcome to Redon, and in his next album he sought to
discourage these literary attitudes. *Origins* was published in 1883 without the
captions that he had written for it. These lithographs develop the theme of the
monster in Redon's work, using both mythological sources and something of the
evolutionist ideas of which Armand Clavaud had made him aware. Primeval
creatures (Plate 25), the plant with a human eye, the cyclops, siren, satyr, centaur
(Plate 26), Pegasus (Plate 27) and finally Man are presented in a series that
Hennequin recognized as the procession of forms that in the imagination of poets
preceded the existence of mankind.[16] Deprived of their captions, the plates are
no doubt intended to recapture the 'lost innocence' of *In Dream*. But a precedent
had been set with *To Edgar Poe* that was not to be escaped. Des Esseintes owned
drawings by Redon of prehistoric subjects that suggested to him a world
inhabited by primitive man whose savage features are reminiscent of a long lost
age.[17] Huysmans had seized upon the hind of evolutionism in *Origins* to imply that
Redon was discovering a new realm of nightmare visions in the revelations of
modern science. Later in the 1880s he developed this view in an essay entitled 'Le
Monstre', which appeared in *Certains*. Redon had used the microscope, he
claimed, to renew the imagery of the monster in art, practically defunct since the
Renaissance.[18] Although there is an undeniable grain of truth in Huysmans'
assertion about Redon's sources, he is bringing *Origins* far closer to the ideas of
Darwinism than Redon ever intended. *Origins,* therefore, despite its
comparatively innocuous title, did not escape being associated with notions that
far surpassed Redon's aesthetic of suggestive ambiguity.

Redon's next album, *Homage to Goya,* was published in 1885, after the success
of *A rebours* and the disappointment of the Société des Indépendants. Redon's
new failure with the public at large and the boost given his reputation in literary
circles are reflected in the deliberately literary characteristics of this work. The
title *Homage to Goya* appears at first sight to be anything but literary; nonethe-
less, like *To Edgar Poe* it encouraged this aspect of Redon's reputation. Goya was
becoming a highly popular artist in the 1880s and was often associated with Dec-
adent literature. Writers saw him as the creator of a world of nightmare, terror and
visions similar to that which they themselves sought to suggest. His reputation
therefore had much in common with that of Redon; Des Esseintes is reminded of
Goya when he looks at Redon's drawings, although he considers Goya too
popular an artist to be admitted to his private esoteric world. Both Huysmans
and Redon may have been familiar with Baudelaire's description of Goya's style:
'The great merit of Goya consists in creating the monstrous credibly. His
monsters are born viable, harmonious.'[19] This formulation is so close to Redon's
own aims that it provides in itself a convincing reason for Redon's choice of title.
But, be that as it may, the album is not using Goya's engraved work as a specific
source. It is part of a more general fashion for the artist, just as *To Edgar Poe*
was a response to the vogue for Poe that had flourished since mid-century.

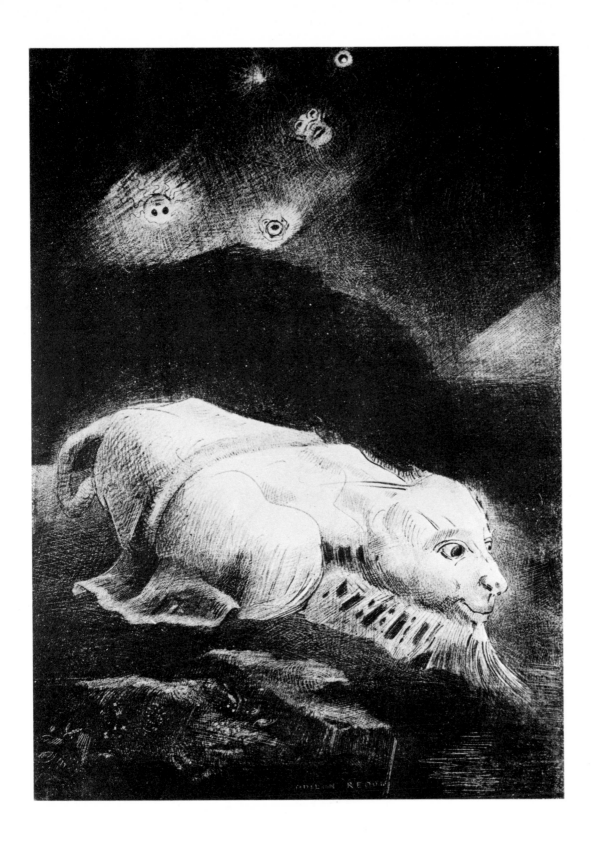

26
'There were struggles and vain
victories', *Origins* 1883, lithograph,
28.9 x 22.2cm. 11$\frac{3}{8}$ x 8$\frac{3}{4}$ in. British
Museum, London

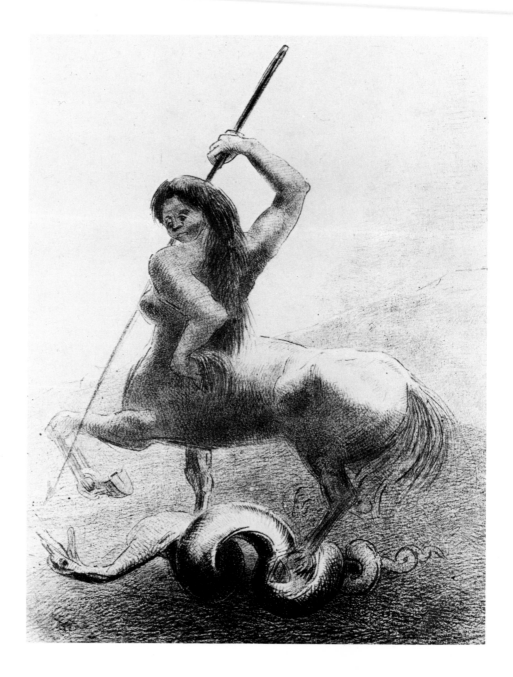

A more substantial literary feature of this album, however, is Redon's decision
to give his lithographs captions once more, and to increase their importance. In
To Edgar Poe the captions were simple supplementary additions to each plate,
taking up images and themes and rendering them mysterious and suggestive by
use of irrational, evocative language. Some, like 'Madness', are close to *In
Dream,* as indeed is much of the imagery. Others, such as 'A mask tolls the
funeral knell', go further by adding a commentary to the plate, albeit a

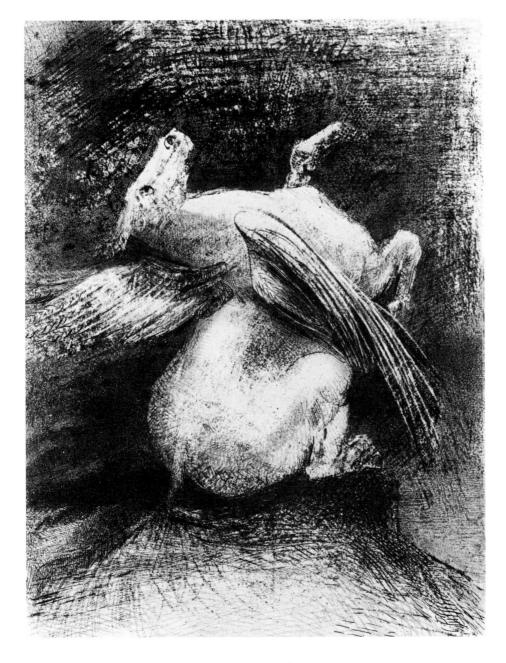

27
'The powerless wing did not raise the beast at all into those black spaces', *Origins* 1883, lithograph, 29.5 x 22cm. $11\frac{5}{8}$ x $8\frac{5}{8}$ in. British Museum, London

mystifying and inexplicable one. Both kinds are ultimately dispensable. In *Homage to Goya,* however, the captions are an integral part of the album, and the written word is incorporated into Redon's means of expression. Redon wrote them as a kind of prose poem:

In my dream, I saw in the Sky a FACE OF MYSTERY/the MARSH FLOWER, a human and sad head/ a MADMAN in a bleak landscape./ There were also EMBRYONIC BEINGS/ a

strange JUGGLER./ On waking, I saw the GODDESS of the INTELLIGIBLE with her severe and hard profile.

This poem is devoid of any definite meaning, but when the plates are viewed in relation to it, they take on a continuity and a vague overall significance: the description of a dream experience, ending in a return to the rational (Plates 28 to 31). It had been Redon's first intention to present *Origins* in the same way. The captions that he omitted in 1883 were later published, and again form a prose poem:

When life was awakening in the depths of obscure matter/there was perhaps a

28
'In my dream I saw in the sky a face of mystery', *Homage to Goya* 1885, lithograph, 29.1 x 23.8cm. 11½ x 9⅜ in. British Museum, London

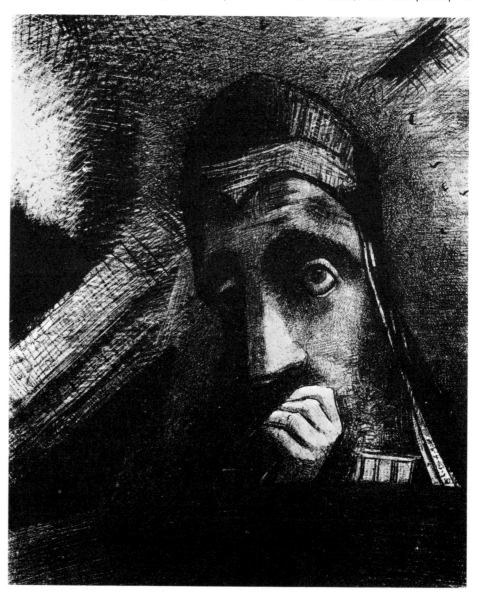

first vision attempted in the flower./ The deformed polyp floated on the shores, a sort of smiling and hideous Cyclops./ The Siren emerged from the waves, clothed in spikes,/ the Satyr with his cynical smile./ There were struggles and vain victories./ The powerless wing did not raise the beast at all into those black spaces./ And man appeared; questioning the ground from which he comes and which attracts him, he cleared the way towards sombre lights.

Redon's awareness of this coherent continuity of the captions is made clear by the fact that when he supressed them, he also changed the order of the litho- graphs;[20] he was using all the resources available to restore to his plates their full autonomy as purely visual works of art, their 'innocence'. Following the

29
'The marsh flower, a human and sad head', *Homage to Goya* 1885, lithograph, 27.5 x 20.5cm. $10\frac{7}{8}$ x $8\frac{1}{8}$in. British Museum, London

30
'A madman in a bleak landscape',
Homage to Goya 1885, lithograph,
22.6 x 19.3cm. $8\frac{7}{8}$ x $7\frac{5}{8}$ in. British
Museum, London

reverse swing of the pendulum towards the literary in *Homage to Goya,* Redon's
next album, *Night,* of 1886 (Plates 32 and 33) also has a prose poem included in it,
a vague meditation on death and the unknown:

> In OLD AGE,/ the man was solitary in a NIGHT LANDSCAPE./ The lost angel then
> opened BLACK WINGS./ The CHIMERA looked at everything with terror./ The
> priestesses were WAITING,/ and the seeker was engaged in INFINITE SEARCHING.

As in *Homage to Goya,* the mixing of capital and small letters creates two levels
of reading: the capitals simply indicate the subject in the manner of the titles in
In Dream, while the rest of the captions constitute a further dimension of

31
'On waking, I saw the Goddess of the Intelligible with her severe and hard profile', *Homage to Goya* 1885, lithograph, 27.6 x 21.7cm. $10\frac{7}{8}$ x $8\frac{1}{2}$ in. British Museum, London

expression — that of the prose poem commentary.*

Redon's use of the prose poem, like his allusions to Poe and Goya, has to do with literary fashion. The prose poem had been a substantial and independent literary form only since mid-century, and it was enjoying in the early 1880s its first real vogue. Huysmans had been using it for some time; Hennequin and many other young writers were now giving it wider popularity. It was Des Esseintes's favourite form; praising the prose poems of Aloysius Bertrand, Mallarmé and others, Huysmans' hero says of a single adjective in such poems that 'The reader could dream, for weeks at a time, about its meaning, at the same time precise and multiple.'[21] This was precisely the intended function of Redon's captions. Redon

*See Appendix for the original French captions of these three albums.

'The man was alone in a night landscape', *Night* 1886, lithograph, 29.3 x 22cm. 11½ x 8⅝ in. British Museum, London

was actively participating in avant-garde literary fashion and when *Homage to Goya* was published at the beginning of 1885, this tendency was further emphasized and developed by Huysmans. His review of the album, published in *La Revue Indépendante* for February of that year was itself a long prose poem transcription of the lithographs, a work that reached a larger audience under the title 'Cauchemar' in the second edition of his *Croquis parisiens* (1886). The

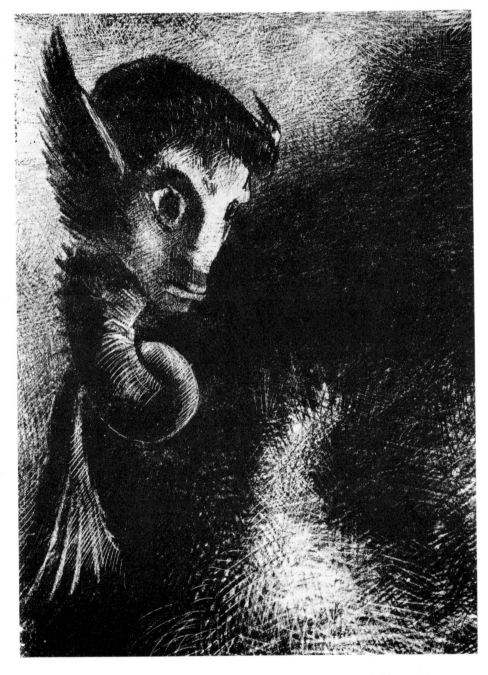

33
'The chimera looked at everything
with terror', *Night* 1886, lithograph,
25 x 18.5cm. 9¾ x 7¼ in. British
Museum, London

opportunity provided by its title and prose poem captions of allying *Homage to Goya* with contemporary literature had been readily seized by Huysmans.

This climax to Redon's hesitant incorporation of literary features into his art carried one stage further the chain reaction between writers' interpretations of his works on the one hand, and his own stylistic developments on the other. *A rebours* and *Homage to Goya* are examples not only of reaction or interaction

between art and literature, but of interpenetration. The basic style of Redon's 'noirs' was unchanged, as the presence of the lithograph version of *The Fallen Angel* in *Night* clearly shows. But Redon had responded to the praise of writers by achieving a delicate compromise in his style between the precepts of suggestive ambiguity that he refused to abandon and the growing literary orientation of his career.

Wagner

It is not uncommon to hear Redon derided as a 'literary artist'. He was himself sensitive on this point. But there is no reason why this term should be derogatory or insulting if the peculiarities of Redon's art are taken into account. To be wholly independent of literary considerations was hardly, after all, the rule to which all nineteenth-century artists adhered. Redon stated his own view on the subject in his diaries.[22] He advocates there not the exclusion of all literary elements but their subordination to the demands of visual form. He rarely failed to achieve this aim. Some 'noirs', and in particular some lithographs, have an undeniable literary dimension, but this does not devalue them as superbly invented and executed visual images, in which Redon's handling of his medium is the primary quality. This literary dimension developed fruitfully in the early 1880s, as it would continue to do for some years afterwards. The transformation of Redon from an obscure unknown to an admired Decadent had started a relationship between his work and literature that was a stimulus and benefit both to his career generally and to his 'noirs' in particular.

The growing number of misinterpretations of his work, however, soon brought home to Redon the disadvantages of his situation. The danger of a cult of suggestive ambiguity, after all, is that it does not preclude the possibility of doctrinal interpretations; in fact it enables inventive critics to propose unlimited quantities of them. Huysmans was far from being the only figure to take advantage of this. The first appearance of a work by Redon in a literary review provided a further stimulus for such wanton speculation. This was in August 1885, when his lithograph *Brünnhilde* (Plate 35) was published in *La Revue Wagnérienne*. This small but effective work is based on the final scene from Wagner's *Ring,* and appeared with a translation by Dujardin from the relevant passage in Wagner's libretto. Brünnhilde, having fallen from wisdom and divinity, has been led to betray Siegfried and bring about his death. She will herself perish on his funeral pyre. Redon represents Brünnhilde in the armour of a warrior, her gaze fixed and stern, but retaining something of her powers. Readers of *La Revue Wagnérienne* however, would have compared this lithograph not only with Wagner's musical drama, but also with Wagnerism, the theory of the arts being put forward by the review as the basis for future works and movements. Wagnerism advocated, broadly speaking, a new subjectivism in which a synthesis of various artistic currents would bring about a new kind of unity in the creative process. The suggestive and the descriptive, the visual and the literary and the musical, or the legendary and the personal would come together in the art of tomorrow. This was far from being the only form of Wagner's influence in France, being principally the rather eclectic theory of one of the review's editors, Téodor de Wyzewa. But its closeness to aspects of Decadence and Symbolism made it a highly influential and progressive one for a

35
Brünnhilde 1885, lithograph,
11.8 x 10cm. 4⅝ x 4in. British
Museum, London

34
Parsifal 1892, lithograph,
32.2 x 24.2cm. 12⅝ x 9½ in. British
Museum, London

short time. *Brünnhilde* was therefore an invitation to many to label Redon
Wagnerist, along with Fantin-Latour, the artist whom Wyzewa considered closest
to Wagnerism with regard to style and subject matter. The lithograph came to
distort Redon's reputation as well as stimulating it. But the project did hold
benefits for Redon, in that it marked the beginning of his own interest in
Wagnerian subject matter. In later years, particularly in the 1890s when
performances of Wagner were popularizing the operas in their own right, Redon
made skilful and successful use of Wagnerian motifs in, for example, his

36
Brünnhilde, Twilight of the Gods
1894, lithograph, 38 x 29.2cm.
15 x 11½ in. British Museum, London

37 *Opposite*
Profile of a Woman with Flowers
c. 1895, charcoal, 52 x 36.5cm.
20½ x 14⅜ in. British Museum, London

lithographs *Parsifal* (Plate 34) and *Brünnhilde, Twilight of the Gods* (Plate 36). In the latter, the warlike maiden is now shown with no Wagnerian attributes apart from her Germanic hair and the suggestion of a forest behind her. It is above all a lyrical bust portrait of a kind that interested Redon at the time (see for instance Plate 37). The topicality of Wagner, to which Wyzewa had contributed, had provided Redon with subject matter that he was able to adapt to his own needs. The spurious literary aura surrounding the 1885 *Brünnhilde* had culminated in a further fruitful exchange between Redon and intellectual fashion.

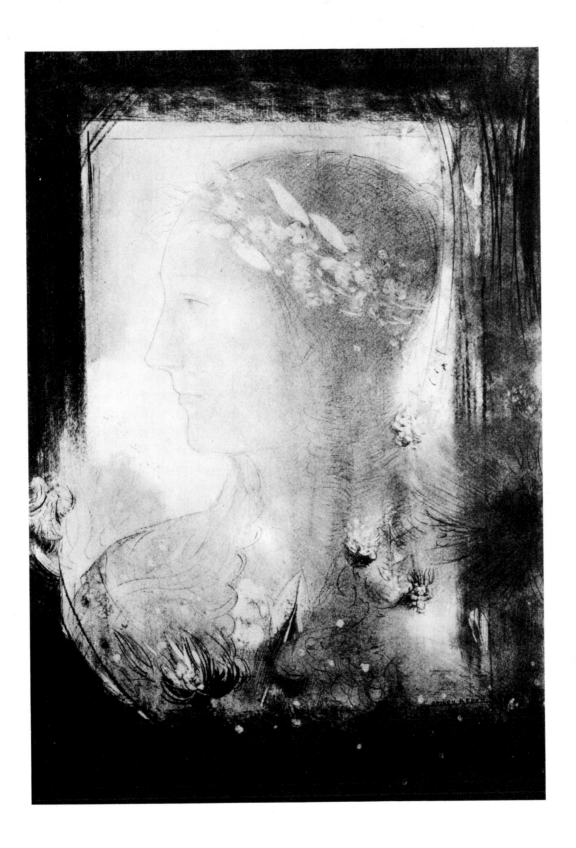

The Pandemonium of Symbolism

> All men of letters know the albums entitled *Night, Homage to Goya, To Edgar Poe,* etc., and the reputation of Mr Redon is no longer in the making. Writers like in him the harsh virginity of his concepts; artists give him credit for his powers of execution. A somewhat rare agreement.[1]

This observation was made by Gustave Kahn in April 1887, but his claim that Redon's reputation was now established was contradicted not long after, in 1891, by Henri Beraldi in his *Les Graveurs du XIXᵉ siècle.* 'French opinion,' wrote Beraldi, 'remains deaf and blind to this artist on the confines of all the arts. But in Belgium, apparently, he is receiving—more or less—the approbation he deserves.'[2] Both men were in fact right. On the one hand, the fame of Redon's lithograph albums was indeed being consolidated. For example, when *Le Petit Bottin des lettres et des arts* (an account of contemporary writers and artists) appeared in February 1886, it contained another poetic transcription of *Homage to Goya,* based on the first, second and sixth plates of the album and even borrowing from Redon's captions:

> In your indescribable work, clear-sighted allegorist,
> There is the wide open eye of a Chaldean magus;
> There is the doleful flower, a marsh being
> Rearing out of the grey water, embryonic and sad;
> At the edge of the dark world trodden by dreams,
> There is suddenly, in the light-riddled air,
> With her hard chin and her obstinate profile,
> The goddess of the Intelligible.[3]

This had been written by Jean Moréas, who had collaborated with Félix Fénéon, Oscar Méténier and Paul Adam over this artistic 'directory', and who was one of the most effective publicists of emerging Symbolism, notably in his celebrated manifesto of September 1886. Yet, on the other hand, the homage of Moréas, Kahn and others scarcely amounted to wide recognition, for all its enthusiasm. These supporters of Redon were themselves controversial artists and intellectuals, and outside these privileged circles, there was still much indifference to him. Nonetheless, as Beraldi commented, Redon was achieving some real success beyond the frontiers of France. It was in Belgium that he had made his strongest impact to date, and this had been at the 1886 exhibition of the remarkable group of artists, Les XX.

Belgian Symbolists

Earlier in the century, Belgian intellectual life had often seemed something of a standing joke to Parisians. Brussels represented a haven for French political exiles and a centre for clandestine publishing activities, but otherwise the Belgians came in for merciless satire and mockery, Baudelaire's *Pauvre Belgique* and

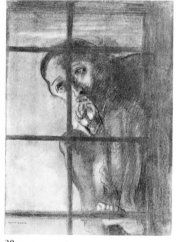

38
In the Corner of the Window or *The Accused* c. 1886, charcoal, 53.4 x 37.2cm. 21 x 14⅝ in. The Museum of Modern Art, New York, Lillie P. Bliss Bequest

Amoenitates Belgicae being perhaps the best known examples. Nor are these attitudes without some foundation. Belgian artists, such as Félicien Rops, were quickly attracted away from their native land towards Paris. By about 1880, however, an extraordinary renaissance was taking place. The 1880s saw the emergence of a new vitality in Belgian life, resulting not only in important social changes, but also in the establishment of Brussels as one of the most brilliant artistic and intellectual centres of Europe. The avant-garde circle of twenty artists known as Les XX was founded there late in 1883, under circumstances not dissimilar to the emergence of Les Indépendants, and this society remained an outstanding focus of both Belgian and French new painting for almost ten years.

Organized by their secretary Octave Maus, Les XX exhibited their works annually in Brussels, and also invited progressive foreign artists to participate. They did not follow any programme or set of rules, although the prominence of James Ensor in the society's early days gave it a provocative image in the eyes of most critics. The guest exhibitors for 1886 showed a fairly broad range of styles, including Monet, Renoir, and the Dutchman Breitner, as well as Odilon Redon. Press reaction was hostile to all these artists, as it was to Les XX as a whole, but the strongest invective was reserved for Redon, as Madeleine Maus recalled: 'He [Redon] received, of all the exhibitors, the most jeers. Literally, the titles of his lithographs made journalists furious.'[4] This critical fury was no doubt heightened by the sight at the exhibition of the notorious *Pornocrates* by Félicien Rops, now returned to Belgium. Popularly known as *Woman with a Pig,* this picture shows a blindfolded woman clad in nothing but stockings; gloves and hat being led by a pig on a lead. And a further reason for the touchiness of some critics may be found in the political events that took place at the very time of the exhibition. March 1886 saw the appallingly violent repression of striking miners in Belgian coal fields that was in fact to be a spur to Belgian socialism for years to come. Fear of anarchy and subversion was in the air, and works such as *Pornocrates* or Redon's lithographs were far from comforting to the bourgeois public.

But if Redon quickly became regarded in some quarters as scandalous, he became in others an object of adulation almost overnight. Not only were his drawings and lithographs on show, but his albums were on sale. These sold briskly during the run of the exhibition. His works were the centre of heated controversy, being attacked and defended with great energy and passion. The 'noirs' were described variously as masterpieces and the demented hallucinations of a madman. Even the reviewer in *L'Art Moderne,* the review most closely associated with Les XX, and probably Maus himself, conceded that Redon seemed something of a maniac, although he reserved his final judgement.[5] These extreme reactions had also been fed by the legend of Redon the Decadent that had reached Brussels from Paris. *A rebours* had caused a sensation in Belgium as well as in France, and had led some writers to a knowledge of Redon's 'noirs'. One of these men was the Belgian Jules Destrée, who became Huysmans' friend, and published an article on Redon in Brussels, that strongly echoed Huysmans' views, immediately before the exhibition.[6] Indeed, Redon the man became confused in the minds of many Belgians with the literary stereotype of the Decadent hero, so that for years to come they were astonished on meeting him to find not a flamboyant Des Esseintes but a quiet, unassuming, correct bourgeois. Les XX, a smaller and better organized group of artists than Les Indépendants in Paris, had

finally provided Redon with an exhibition that had given him a resounding *succès de scandale*.

It was inevitable that Redon's reception in Belgium, as in Paris, would come from writers as much as from artists or art critics. The whole orientation of his career, his style and his Parisian reputation all pointed to this. Destrée describes this literary reception in an account published five years later: 'The whole young generation of writers, so curiously smitten with pure art, became interested in Redon's extravagant personality and underwent his influence.'[7] By 'pure art' he meant Art for Art's sake, a doctrine popular amongst the supporters of the review *La Jeune Belgique*, something of a friendly rival to *L'Art Moderne*. These men, including Iwan Gilkin and Valère Gille, were to prove faithful supporters of Redon. But even their approval was less valuable in the short term than that of one individual who was only a minor figure in terms of creative writings, but who was nonetheless a most prestigious member of the Brussels avant-garde: Edmond Picard. A brilliant lawyer, an active Marxist politician who became a Senator, an incisive critic who with Maus was a founder of *L'Art Moderne*, a patron and benefactor to young artists and writers, Picard was for several years a focal point of the radically progressive arts in Belgium. His political convictions led him to advocate social art and attack the aestheticism of *La Jeune Belgique*. But he was also sensitive to the formal qualities of Decadent art and showed a remarkable breadth of understanding. Following the 1886 exhibition of Les XX, he demonstrated his appreciation of Redon's 'noirs' by giving him his most substantial commission to date. He ordered from Redon a series of works to be used at the following year's exhibition during his performance of a kind of theatrical monologue he had written entitled *Le Juré*.

Les XX were a centre for more than painters alone. Concerts and lectures were an integral part of their exhibitions, although the concerts became truly important only from 1888 onwards, after Maus's friendship with the composer d'Indy had become fruitful. The literary elements were highly progressive; lecturers in future years would include Villiers d l'Isle Adam, Stéphane Mallarmé and Paul Verlaine, and in 1887 Picard was already making a fascinating literary contribution with *Le Juré*. It is one of a series of works based on Picard's experience as a lawyer. Its theme is of a social nature: the responsibility borne by a juror in a court of law and its consequences. The juror of the title is dramatically cursed by a prisoner whom he is helping to condemn to death. As a result his doubts and conscience drive him to despair, and eventually to madness and suicide. It was a topical work, partly inspired by the controversial Peltzer trial of 1882 in which Picard had been defence counsel, and also a didactic one. But the form in which it is written is not doctrinaire or polemical. Picard calls it a 'monodrame', an original blend of monologue and drama, to be performed by one person without scenery or costume, and to be changed at will at each performance to preserve its topicality and enhance its effect. The impact made would be subjective, using 'le fantastique réel', a term Picard may well have taken from Baudelaire, and by which he means fantastic phenomena that have their roots firmly in the observed world, and not in fancy.[8] The fantastic and hallucinatory elements by which the juror's plight is presented would provoke in the audience an awareness of the horrors of guilt and despair that would otherwise lie beyond their experience.

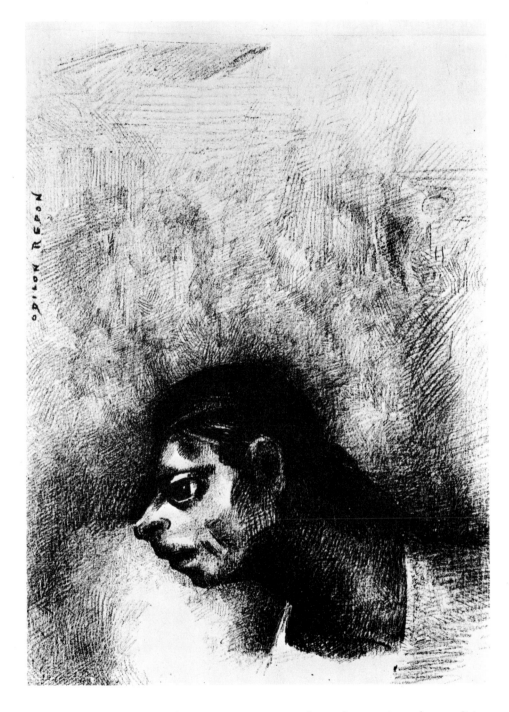

39
'A man of the people, a savage,
passed beneath the horses' heads',
The Juror 1887, lithograph,
18.3 x 13.6cm. 7¼ x 5⅜ in. British
Museum, London

Macabre fantasy and hallucinatory states of mind were just the qualities
that emerged from Redon's drawings and lithographs exhibited at Les XX. Picard
therefore commissioned from Redon a series of drawings that could be shown at
a performance of his 'monodrame', and then reproduced as lithographs for a

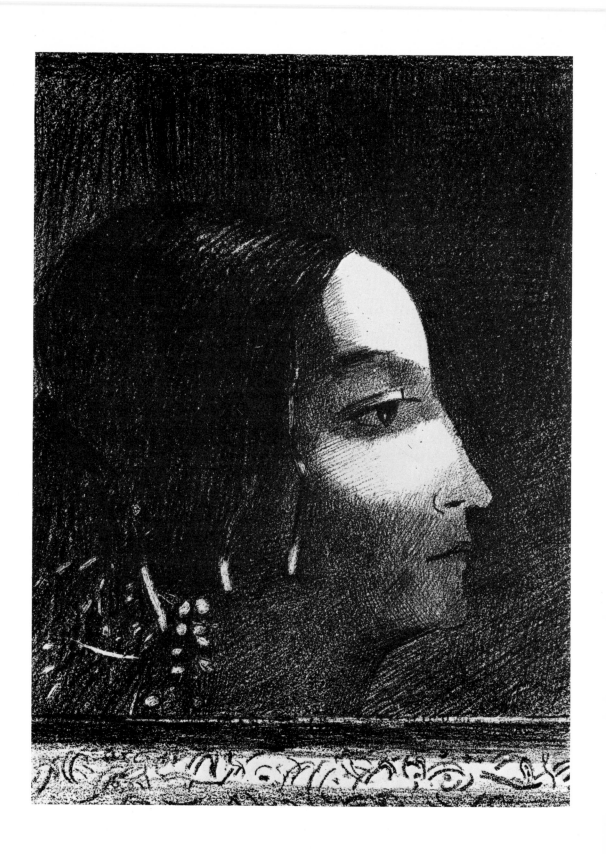

luxury edition of *Le Juré*. This performance duly took place on 19 February 1887 at the new exhibition of Les XX in the presence of Redon himself. It is in this way that Picard, a champion of social art, came to collaborate with Redon, who had little or no sympathy for such a doctrine. In 1913, indeed, Redon wrote in his diary: 'I catch sight in a shop window of a book with this title: *Social Art*. It is repulsive.'[9] Despite fundamental differences concerning the nature and aims of the arts, the two men had apparently found some common ground; Picard was certainly more than satisfied with the project,[10] and the 1887 edition of *Le Juré* is a handsome book. Yet this success had been achieved at the expense of distorting a basic precept of Redon's style. Whereas Redon used suggestiveness virtually as an end in itself, producing irreducible ambiguities, Picard had harnessed Redon's drawings to the single, explicit theme of *Le Juré*. It is not surprising, therefore, that when Redon came to publish the *Le Juré* lithographs in Paris in 1887 as an album—*The Juror*—without Picard's text except for very brief captions, he made changes that recall his 'anti-literary' alterations to *Origins*. The plates themselves remained the same, but by changing their chronology and liberating the captions from their thematic context, the lithographs came simply to resemble Redon's earlier albums. The very images can now be seen to be wholly consistent with his earlier works, and not a literary distortion. For example, 'A man of the people, a savage' (Plate 39) now seems close to 'Madness' (Plate 22) from *To Edgar Poe*, and 'She shows herself to him, dramatic and grandiose with her hair like a druid priestess's' (Plate 40) resembles 'On waking, I saw the Goddess of the Intelligible with her severe and hard profile' (Plate 31) from *Homage to Goya*. Clearly, not only had Picard adopted Redon's art for his purposes, but Redon in turn had adapted Picard's commission to suit his own preoccupations.

Picard was to remain Redon's friend after *Le Juré*, but their collaboration was short-lived. Redon did provide a frontispiece for an absorbing travel diary that Picard published in 1889, based on a journey he made to Morocco in the winter of 1887-88 with his painter friend Théo van Rysselberghe. But this work, *El Moghreb al Aksa*, was of no consequence, being printed in a tiny limited edition simply for circulation amongst friends. It is the *Le Juré* commission that represents a real achievement. For the first time, Redon had executed a series of lithographs based on a specific literary text rather than any other source. The precedent was of lasting effect, for of the albums he continued to produce over the following twelve years, only one, *Dreams*, was not related to a literary text.

Another commission that came about as a result of the 1886 exhibition also set a precedent for fruitful exchanges between Redon and the growing number of writers who were becoming his chief supporters and patrons. The prominent young poet Emile Verhaeren ordered from Redon a frontispiece for a volume of poetry he was soon to publish entitled *Les Soirs (Evenings)*, the first of several commissions of this kind he would receive. These poems are strongly pessimistic and disillusioned, evening landscapes transformed into expressions of suffering that are full of hallucination. Verhaeren sent Redon four poems from which to choose a text; Redon chose 'L'Idole' ('The Idol') and in particular the quatrain:

Wavy with pines, bushy with ivy,
Whilst the horizon of ebony and sunshine
Still looks on, a mountain is seen to rear up, like
Some enormous and nocturnal stone idol.[11]

40 *Opposite*
'She shows herself to him, dramatic and grandiose with her hair like a druid priestess's', *The Juror* 1887, lithograph, 19.2 x 14.3cm. 7½ x 5⅝ in. British Museum, London

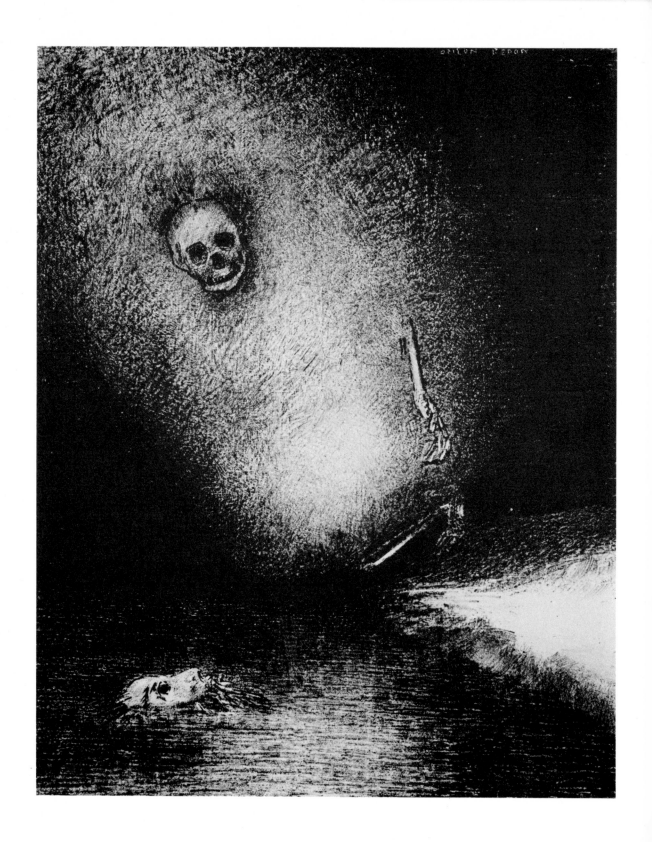

The rock that appears to be an idol, and to take on human features, fits Redon's style well (Plate 42). The idea of a landscape transformed by the imagination is one that matches Redon's own creative processes. Indeed, Redon continued to use this motif for his own purposes. Sandström reproduces a charcoal drawing, *Human Rock*, that uses the same visual ambiguity as 'The Idol'.[12] In the Salon Verhaeren of the Plantin-Moretus Museum at Antwerp, there is another drawing that uses this visual idea for a different purpose. Entitled *The Poet* (Plate 43), it embodies the suggestion of sorrow and suffering in a melancholic poet figure. And another example of this theme is a lithograph that was published in the Parisian review *La Revue Indépendante* in April 1887, *Black Summit,* in which the human element is now the suggestion of a woman's head. The literary source had provided a rich stimulus to Redon's visual inventiveness.

Such a successful commission was also important to Redon because Les XX unfortunately did not continue to offer him the opening to wider recognition that he was still seeking. In 1887, Redon was present at their annual exhibition only on account of *Le Juré,* and Picard's performance was a far less significant event than the dramatic arrival in Belgium that year of Neo-Impressionism, heralded by Seurat's *La Grande Jatte.* Octave Maus, always in touch with Parisian intellectuals, had made contact with Félix Fénéon, and the exhibition of Seurat's masterpiece in Brussels made an even greater impact, as far as Belgian painters were concerned, than Redon's work had done. Neo-Impressionism was to occupy a more and more important place in Belgian art over the next few years. Some, including Madeleine Maus, even came to see Symbolist art as a secondary, literary tendency.[13] This is not to say that Symbolism was dying out in Belgium. Figures such as Fernand Khnopff, the sculptor Georges Minne and the Dutchman Jan Toorop (who also popularized Redon's work in Holland) developed the style into the 1890s. The Belgians' fondness for the Pre-Raphaelites is also evidence that their tastes did not become dominated by Seurat. But several artists of Les XX benefited from Seurat's example in a way they had not from Redon's. Jean Sutter recounts the anecdote of Fénéon asking Seurat for a list of 'vingtistes' whom he considered his disciples.[14] The list named no fewer than nine artists. Rather as in the case of Les Indépendants, therefore, Redon became distant from his fellow artists, and was obliged once more to rely increasingly on literary support and patronage. After 1887, he exhibited with Les XX only in 1890, when his interpretations of *Les Fleurs du mal* and some other drawings were on show.

Of the remaining projects that emerge from Redon's links with Belgium, some, like 'The Idol', were frontispieces to literary works. Verhaeren's *Les Soirs* was in fact the first part of a trilogy that was completed by *Les Débâcles* and *Flambeaux noirs.* Both volumes appeared with lithograph frontispieces by Redon. Neither, however, repeats the success of *Les Soirs.* Verhaeren's style was undergoing a change, as the crisis that afflicted him in the mid-eighties had eased, preparing the way for his later urban, socialist poetry. The harmony of styles between the artist and the poet was short-lived, although Verhaeren continued to associate the production of his books with artists such as Khnopff and Minne. A happier collaboration was with another poet, Iwan Gilkin, a founder of *La Jeune Belgique* and one of its most lively animators. Despite close contacts with Picard, Gilkin immersed himself in Decadence and aestheticism, venerating Baudelaire, and producing poems of despairing satanism and perverse sensuality. Like Verhaeren,

42
'The Idol', frontispiece to
Verhaeren's *Les Soirs* 1887,
lithograph, 16.2 x 9.4cm. 6⅜ x 3¾ in.
British Museum, London

41 *Opposite*
'The sinister command of the
spectre is fulfilled. The dream has
ended in death', *The Juror* 1887,
lithograph, 23.8 x 18.7cm. 9⅜ x 7⅜ in.
British Museum, London

he planned to publish a trilogy, of which the first two volumes, *La Damnation de l'artiste (Damnation of the Artist,* 1890) and *Ténèbres (Darkness,* 1892) appeared with Redon frontispieces (Plates 44 and 45). The third volume, to be entitled *Satan,* never appeared, the poems that were to be included in it being published only in 1897 when all the poems of the trilogy were brought together under the

title *La Nuit*. Redon's collaboration with Gilkin is significant not only for the quality of the frontispieces, but also because the Belgian is a clear example of a poet who was directly influenced by Redon. Roseline Bacou has already singled out 'Fleurs humaines' by Gilkin as a poem from *La Nuit* that owes much to Redon's motif of the marsh flower.[15] And other examples abound in Gilkin's work where lines do not necessarily correspond to a single picture by Redon but nonetheless have much in common with his imagery; in 'Le Preneur des rats', for instance:

> Through disturbing landscapes,
> Under great trees,
> Tender and thoughtful faces
> Awaken dangerous love.[16]

That Redon is also adept at using Gilkin's imagery is demonstrated by the frontispieces. Neither has been credited with a specific source, but the lines that correspond most closely to the frontispiece to *La Damnation de l'artiste* are from a sonnet entitled 'Psychologie':

> A poet, I have noted down in my scrupulous verses
> What my sharp eyes have seen in this darkness.[17]

In Redon's illustration (Plate 44), the winged and bearded head that Mellerio identifies as 'the head of a bard'[18] confronts a lyre, an artist contemplating his means of expression, as strange visions emerge from the darkness above. Yet, for all this harmony between text and image, the rest of the poem is different, indulging

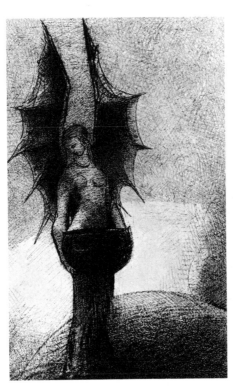

44 *Left*
Frontispiece to Gilkin's *La Damnation de l'artiste* 1890, lithograph, 19 x 12.5cm. 7½ x 4⅞ in. British Museum, London

45 *Right*
Frontispiece to Gilkin's *Ténèbres* 1892, lithograph, 19.8 x 12.3cm. 7¾ x 4¾ in. British Museum, London

in extremes of violent and putrescent subject matter that are quite unlike Redon's style. Similarly, the frontispiece for *Ténèbres* certainly relates to these lines from 'La Pensée':

> The black angel has handed me the cup of black onyx
> In which the cerebral drink boils sinisterly.[19]

But the continuation of this poem evokes an excess of morbidity that is foreign to the gentle melancholy of Redon's lithograph. The collaboration between Gilkin and Redon brought the Frenchman more closely into the arena of Belgian Symbolism, but the stylistic resemblances between the two have strict limitations, showing chiefly how Redon's work had become part of the very sensibility of a prominent poet.

The commissions of Picard, Verhaeren and Gilkin are in a sense the tip of the iceberg as regards Redon's popularity among Belgian Symbolists. These three differing examples of how his work was adopted by Belgians are simply the most obvious evidence of his success in these circles. Another focal point is provided by the most remarkable publisher of the Brussels avant-garde, Edmond Deman. Although not himself a creative writer, Deman was an important member of the young generation of intellectuals who came into prominence in the 1880s. He was a student at Louvain University with Verhaeren and others, participated in their early projects and subsequently helped them as their publisher whilst remaining their close companion. Nor were his activities limited to Brussels, for he made friends in Paris who included Mallarmé. He contributed to the success in and beyond Belgium of several outstanding contemporaries, and amongst them was Redon. Deman published several works containing Redon frontispieces, including those of Verhaeren and Gilkin; he acted as Redon's dealer, stocking lithographs such as *Captive Pegasus, Closed Eyes* and *Saint and Thistle;* and he was responsible for the production of Redon's first album of lithographs based on Flaubert as well as for his only interpretations of Baudelaire. These two commissions, in particular, show the mutual benefit that emerged from Redon's collaboration with Deman.

Flaubert's *La Tentation de Saint Antoine (The Temptation of Saint Anthony)* influenced Redon continually after 1882, when he first read the book. The climax of this theme in his work was to be reached only after his involvement in Belgian Symbolism had ended, but it was Deman who in 1888 commissioned and published in Brussels the first of the three Flaubert albums, as Redon recalled in 1898 in a letter to Mellerio: 'I would have you note,' he said, 'that the first series of lithographs I made based on this book was requested from me by the publisher Deman.'[20] There is a note almost of reproach in Redon's insistence that the initiative had come from Deman, for he was seeking as always to elude the epithet 'literary'. Verhaeren too had encouraged the project, as had the general topicality of the Saint Anthony theme in Belgium at the time. For example, the picture then considered by many to be the masterpiece of Félicien Rops had the same title as Flaubert's work. Painted in the late 1870s, it had been bought by Edmond Picard and occupied pride of place in his home, where it was seen by the endless stream of artists, writers and men from all walks of life who visited him. Other interpretations had followed, for example that of Fernand Khnopff whose oil painting *The Temptation of Saint Anthony* of 1883 is based on Flaubert's

episode of Saint Anthony being visited by the Queen of Sheba. And the growing popularity of the theme can be judged from the choice of Flaubert's work as the subject of one of the two lectures given at the 1885 exhibition of Les XX. The publication of Redon's album of ten lithographs, entitled *The Temptation of Saint Anthony* and using captions from Flaubert, came therefore at a time of general interest in the theme in Belgium. From the point of view of Deman, Redon was adding his version of the legend to that of Rops and other contemporaries. But, for Redon's part, the album was another significant starting point. After this album of 1888 (Plates 46 to 49), he published a similar but shorter one the following year in Paris called *To Gustave Flaubert* and finally the third series of 1896 that ranks with his finest achievements.

46
'It is the devil, carrying beneath his two wings the seven deadly sins', *The Temptation of Saint Anthony* 1888, lithograph, 25.4 x 20cm. 10 x 7⅞ in. British Museum, London

47
'Next there appears a curious being, having a man's head on a fish's body', *The Temptation of Saint Anthony* 1888, lithograph, 27.5 x 17.5cm. 10⅞ x 6¾ in. British Museum, London

48 *Opposite*
'It is a skull, with a wreath of roses. It dominates a woman's torso of pearly whiteness', *The Temptation of Saint Anthony* 1888, lithograph, 29.6 x 21.3cm. 11⅝ x 8⅜ in. British Museum, London

49
'The green-eyed chimera turns, barks', *The Temptation of Saint Anthony* 1888, lithograph, 27.5 x 16cm. $10\frac{7}{8}$ x $6\frac{1}{4}$ in. British Museum, London

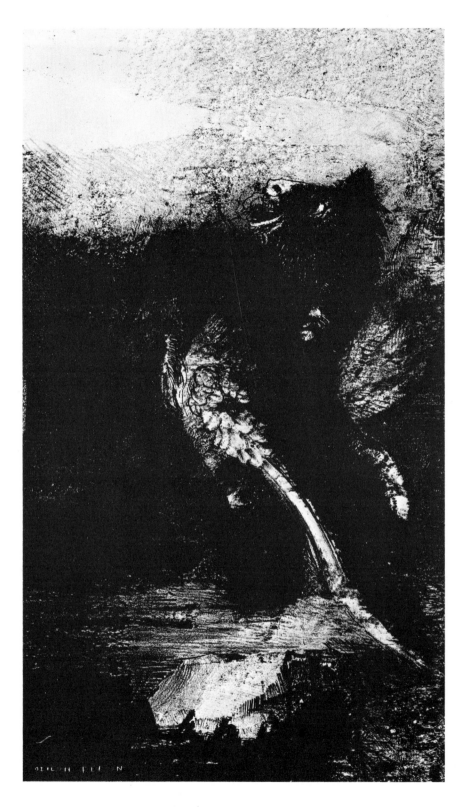

Deman's publication of Redon's *Les Fleurs du mal* in 1890 was a far less propitious project. These works were in fact not lithographs, but simply drawings that were reproduced without the artist's supervision. In this and other respects they cannot be regarded as a coherent series in the manner of other albums. The works themselves are of inferior quality. Perhaps the most successful drawing is 'Ceaselessly the demon stirs at my side' (Plate 50), in which two human figures are quite dominated by an expanse of water, a bare rock and the partial sphere of what could be either sun or moon. These features are typical of Redon's imagery, and yet this cannot be seen as a convincing interpretation of Baudelaire since they are not in evidence in the poem 'La Destruction'. Redon has taken advantage of the vagueness of the lines from the poem to introduce his own imagery. The other drawings of *Les Fleurs du mal* show a similar lack of harmony with their subject matter, tending to be banal when they are fairly literal, and

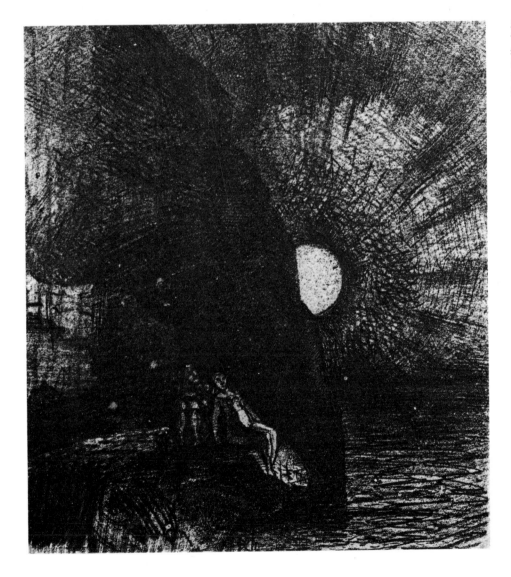

50
'Ceaselessly the demon stirs at my side', from the drawings for *Les Fleurs du mal* 1890, print, reproduced by the Evely Process, 21.4 x 18cm. 8⅜ x 7⅛ in. British Museum, London

successful when they are extremely free. There is little or none of the remarkable harmony between text and image that is typical of Redon's Flaubert albums. Nor did Redon ever turn again to Baudelaire for subject matter, as he would repeatedly to Flaubert. The comparative sterility of this project may well have surprised contemporaries who had become accustomed, ever since Hennequin and Huysmans had acclaimed him a Decadent, to associate Redon with Baudelaire and his legacy. But Redon himself rarely showed interest in the poet, and, although he readily accepted his stature and skill, he did not find in him the richness that attracted him in the prose of La Tentation de Saint Antoine.[21]

But if Les Fleurs du mal was a failure in comparison with La Tentation de Saint Antoine, Deman did make another successful contribution to Redon's career by publishing in 1891 the very first catalogue and full account of his lithographs: L'Œuvre lithographique de Odilon Redon by Jules Destrée. Only in 1913 would Redon be accorded this form of recognition in France when André Mellerio published his fine catalogue. Until then this Belgian catalogue, published in a limited edition and now extremely rare, was the only work of its kind about Redon, a fitting tribute to the artist's success in Belgium. And yet Destrée's catalogue marks the beginning of the end of Redon's popularity in Belgium rather than a climax to his recognition there. On a personal level, Destrée had become far less enthusiastic about Redon since his eulogistic article of February 1886. At that time he had been a Decadent writer, a disciple of Huysmans whom he knew well, and an advocate of Art for Art's sake. By the end of the decade he had changed his ideological stance, becoming a radical lawyer. Shortly after the publication of the Redon catalogue he embarked upon a full political career. By now a member of the Parti Ouvrier Belge, he entered the Belgian parliament at the next election. His involvement in the arts was far from over, but from now on it would be an aspect of his socialism and Walloon nationalism. This evolution from aesthete to politician is reflected in the Redon catalogue. His account of the early albums echoes the views of Huysmans, to whom the book is dedicated. But when Destrée comes to discuss more recent albums, his attitude changes. He reproaches not only the drawings of Les Fleurs du mal for their involvement in literature, finding them poor, but is equally harsh about the fine lithographs for La Tentation de Saint Antoine, remarking of them: 'How manifest the deficiency and poverty of plastic art is here! How indisputably obvious is the superiority of the written word.'[22] Only Gustave Moreau's art, he declares, is worthy of Flaubert's prose. Destrée evidently shifted his ground between 1886 and 1891.

On a more general level too, Redon's involvement with the Belgians was coming slowly to an end in the early 1890s. There was not a sudden break, but rather a gradual slackening of ties. The conditions of 1886 had gone. Picard and Destrée were active in new spheres; commissions from writers disappeared as Verhaeren, Gilkin and others developed forms of poetry that were distant from the 'noirs'; and even Les XX were dissolved. After their 1893 exhibition, the society's members decided that it was in danger of becoming obsolete and ended it. The organization that replaced it was significantly not a group of artists but one of patrons and lovers of the arts: La Libre Esthétique. Many of the battles of Picard and his friends had been won, and they enjoyed a taste of public approval at the impressively large first salon of La Libre Esthétique in 1894. Redon in fact exhibited with the group in 1894, 1895 and 1897, but his works caused no stir.

And in 1909, a final appearance of his work at its salon was surprising to the Belgians only in the discovery that his visions of hallucination and nightmare had given way to joyful flower pictures and sensitive portraits.

Redon's success in Belgium, then, came to an end after less than a decade, but it had brought him recognition and commissions such as he had not enjoyed in France at that time.

French theorists of Symbolism

Despite this success beyond the frontiers of France, it was a Frenchman writing of Redon's reputation in Paris who called his works the 'Pandemonium of Symbolism'. The phrase was coined by Henri de Régnier, who was describing the presence of the 'noirs' at a major focal point of French Symbolist activity. This was the 'mardis' of Stéphane Mallarmé, the regular Tuesday gatherings at which the poet presided over intense discussions. The reverence with which Redon's works were regarded in Mallarmé's circle is corroborated by another disciple of the master, René Ghil, who recalled portentously the following scene:

> One after another, after long periods of silence that seemed slightly suffocating summed up in a few words by the Master defining with an absolute Word all the suggestion that had come forth — Stéphane Mallarmé would turn pages of Odilon Redon: as if he were fearfully raising more and more sacred folds through which there showed forms of Mystery.[23]

Redon, a friend of the poet's, would be a quiet and retiring spectator when young intellectuals such as Ghil were initiated into the 'noirs' on these occasions. Through Mallarmé's circle, Redon's works received a kind of consecration from the outstanding Symbolist poet, and were accepted by many young followers on the authority of the master. Mallarmé's admiration for the 'noirs' is also demonstrated in his correspondence. A figure such as that of 'In my dream I saw in the sky a face of mystery' (Plate 28) appealed deeply to the writer of *Igitur* and *Un Coup de dés*.[24]

Henri de Régnier, however, may also have had another aspect of Redon's Parisian reputation in mind when describing the 'noirs' as the Pandemonium of Symbolism. A prominent feature of French Symbolism was its deep involvement with theorizing and speculating about the arts. Various figures, some of them rather secondary and inferior in retrospect, sought to give coherence and direction to innovations in the arts by advocating certain theoretical positions. The Wagnerism of Téodor de Wyzewa, with which Redon became involved through his *Brünnhilde* (Plate 35), is an example. Wyzewa's importance as a catalyst in the arts was very real, and so were the activities of others, such as Charles Morice and Albert Aurier. These theorists, often publishing their writings as journalists, ascribed theoretical positions to Redon's works, usually mistakenly, and thereby associated them with the mainstream of Symbolist ideas. From his connections with Wyzewa until the end of the century, Redon received constant publicity, being acclaimed in various guises in a manner that often bewildered and alarmed the artist himself. And it was partly this repeated identification with avant-garde Symbolist theory, brought about entirely without Redon's approval or co-operation, that made his 'noirs' a part of the very substance of Symbolism.

The theorists and journalists who acclaimed Redon's work in this way hark back ultimately to Hennequin, and constitute a more or less continuous line of development. Just as Hennequin had helped to create the notion of Redon the Decadent and Wyzewa that of Redon the Wagnerist, so did these men connect his name with successive phases of Symbolism. Charles Morice is a case in point. The earliest published writings by Morice about Redon had been in an article of 1885, written partly under the influence of Hennequin.[25] When an account by Morice of Redon's work appeared in 1890, however, in the review *Les Hommes d'aujourd'hui,* its frame of reference belonged to that of Morice's recent and influential book *La Littérature de tout à l'heure.* This work, reviewing the situation of the arts and defining the literature of tomorrow, established Morice briefly as the most prestigious young Symbolist of the day. Not that his views showed any great originality; on the contrary, they were eclectic and owed much of their influence to the way they brought together various growing tendencies under an increasingly familiar banner: that of synthesis. 'Suggest the whole of man through the whole of art' was the battle cry he sounded in his book and this aim was to be achieved, he explained none too clearly, through a triple synthesis: a synthesis of thought would free self-expression from the limits of particular philosophies; that of the idea would create a new fiction, following the example of Wagner; and that of forms of expression would use techniques of suggestion to open the way to achievements of unprecedented complexity.[26] If these formulations were evidently far more doctrinaire than Redon's art, Morice was nonetheless persuaded that common ground existed. While denying in his 1890 article that individual works by Redon illustrate literature, or indeed owe any debt to writers, he insisted that the general significance of Redon's style corresponded closely to that of literary Symbolism as he understood it. Developing Wagnerist ideas about the unity of the arts, he declared that Redon represented an outstanding example of this tendency. Elsewhere Wagner's attempt to realize the ideal of a synthesis of the arts is criticized by Morice, who finds his straightforward narration of legend to be a barrier to success:

> It would have been most worthy of Wagner to conclude . . . with the suppression of time and space, with the blossoming forth of Dream in its own kingdom which is without hours and places, not the forgotten but the unknown, not the too distant realm of the definite ground that bears our footsteps, but that beautiful land that can be seen on no continent.[27]

This formulation does correspond to Redon's creation of a visionary world in which the unknown is suggested and the impossible made plausible in the absence of time and realistic space. In 1890, therefore, Redon's art and Morice's influential theory of Symbolism seemed to many intellectuals quite compatible. And as the brief glory of Morice coincided with the appearance of his article on Redon, the artist's reputation was naturally stimulated by the theorist's prestige.

In the early 1890s Morice's position as one of the most acclaimed young writers and theorists of the arts in Paris was rivalled by the rising star of Albert Aurier. After some years of obscurity as a poet and novelist, Aurier had by this time achieved maturity as a forceful advocate of idealism and a promising satirical writer. His interest in painting had been strong from the beginning, and his poetry shows the probable influence of, amongst others, Redon. Lines such as

these echo strongly the colourless world of ambiguous forms and of anguish to be found in Redon's 'noirs':

> Apparition risen from the depths of the twilight,
> Pale ghostly angel so close, and retreating . . .
> Fumes of the marsh, foam of the shore,
> Pale wings of a dream, soul glimpsed in a reverie.[28]

But it was as an art critic, the role for which he is chiefly remembered today, that Aurier most explicitly followed Morice in associating Redon with new tendencies in the arts. In his well-known article of 1892, 'Les Symbolistes', he praises Redon, as well as Van Gogh and Gauguin, seeing him as an artist whose influence as a Symbolist was of primary importance. He identifies Redon's work with the general wave of idealism that he believes to be a formidable challenge to all positivist and materialist values in the arts:

> In vain does exclusively materialist art, the art of the scientific and the immediate, struggle against the attacks of a new, idealist and mystic art. Everywhere men are claiming the right to dream, the right to the pastures of the skies.[29]

The eclectic Morice had tended simply to develop Redon's reputation as a pessimist and Wagnerist. Aurier, however, is praising Redon's works as part of a more original and progressive advocacy of idealism. He claimed that Redon was a thinker whose work was hermetic and baffling but nonetheless contained themes of philosophical and metaphysical proportions. It was, he wrote, 'terrible and vertiginous work, the work of a poet and philosopher, distressing work of both drama and terror, and also of metaphysical negation and despair.'[30] Once again, a theorist of the arts had attributed to Redon doctrinal aims that were foreign to him, and by so doing had associated him with a theoretical position he did not occupy.

Nor did this pattern come to an end with Aurier. Following his early death in the autumn of 1892 his ideas remained influential in the group whose mouthpiece was the review he had helped to found and edit: *Le Mercure de France*. Rémy de Gourmont, in particular, who was entertaining similar idealist views to Aurier's, subsequently developed them in relation to various writers and artists, including Redon. In *Le Livre des masques* of 1896 he distinguished between his view of symbolist art and what he terms idealist or emblematic art. According to his definition, symbolist art is an abstraction from life, whereas emblematic art is the reverse, an abstraction that has taken on the forms of life. Redon's art is an example of the latter. Later Gourmont developed and clarified this theory. In *Le Problème du style,* he points out that this emblematic use of objective reality amounts to a form of metaphor. Once again, he takes Redon as an example:

> Mr Odilon Redon, who set out to make visible for us certain images of Baudelaire and Flaubert, has succeeded in this, despite his genius for mystery, only by sacrificing universal logic to the logic of the imagination. It is possible to illustrate Homer literally and make the text visual; any illustration of Flaubert, except for Odilon Redon's method, will never be anything but a stupid betrayal.[31]

Despite the literary bias of this view, Gourmont's criteria of individualism and metaphor were to win Redon's praise and gratitude:

> They [my drawings] are a sort of *metaphor*, said Rémy de Gourmont, placing them apart, distant from all geometric art. He sees in them a logic of the imagination. I believe that this writer said in a few lines more than everything that had been written about my first works in the past.[32]

By developing the interpretation of Aurier, Gourmont had not only again associated Redon's work with the idealist current of artistic theory, but had also arrived at a plausible attitude towards Redon's aims.

In 1896, another boost to Redon's reputation as an idealist was provided by the publication of *Le Mouvement idéaliste en peinture* by André Mellerio. Mellerio, whose later works about Redon remain to this day indispensable to any study of the artist, was already Redon's warm supporter. Since the mid-1880s he had in fact produced a wide variety of literary works, but in *Le Mouvement idéaliste en peinture* he showed himself to be an acute art critic and also an enthusiastic disciple of Aurier's and Rémy de Gourmont's idealism. He described an artist's creativity as being concerned with ideas rather than objective realities, using arguments similar to Gourmont's. He also claimed the idealist movement to be a general one embracing Neo-Impressionists, Nabis, Synthetists and La Rose+Croix, and having its sources in Puvis de Chavannes, Gustave Moreau, Gauguin and Redon. But it is Redon who occupied pride of place, for a lithograph by him appears as the frontispiece of the book.

Morice, Aurier, Gourmont, Mellerio and before them Wyzewa were, then, the outstanding theorists who associated Redon's work with the Wagnerist, synthetist and idealist developments of Symbolism. Their contribution to Redon's career was vital, for their influence was wide. It is true that they tended to distort Redon's aims in subjecting them to their theories. But they were nonetheless essential catalysts for the development of Redon's reputation among French Symbolists. Their activities represent one way, and a very substantial one, in which Redon's name and art were linked with successive stages of the evolution of Symbolism as they occurred.

Redon was far from alone among painters in becoming associated with writers during the late 1880s and early 1890s. Félix Fénéon described Gauguin at the time as having become 'the prey of *littérateurs*',[33] and the men of letters who influenced Gauguin's career were in many cases the same as those we encounter in tracing the critical reaction to Redon's work. But Redon was 'the prey of *littérateurs*' in a more extreme way than Gauguin. His involvement had begun earlier, would last longer, and had a more fundamental influence on his actual works than was the case with Gauguin. It took varying forms. On the one hand, his success in Belgium led to major commissions like the work for *Le Juré* or the first Flaubert album. This was a genuinely fruitful and mutually beneficial episode. On the other hand, his acclamation by Parisian theorists and journalists was in a sense less satisfactory, because the publicity it gave him was achieved at the cost of distorting his aims. Indeed, Redon generally avoided becoming part of the circles that produced such theories: the turbulent world of avant-garde journals and Symbolist reviews. He remained detached from such quarrels and

debates, having little to do with the groups of writers who showed interest in his work. During the winters, he did live in Paris, but would visit only a few friends, such as Hennequin, Huysmans and Mallarmé, and in the summers he returned to work alone at his family home, Peyrelebade, in the Médoc. Only for the summers of 1888 and 1889 did he break this pattern, when he went to live in the village of Samois on the Seine near Fontainebleau. There, and in neighbouring Valvins, he became part of a group of writers and artists who included Mallarmé. (It was there that Hennequin was drowned in the Seine in July 1888.) It was in such an intimately personal context rather than in the public bustle of Parisian circles that Redon welcomed contact with his admirers.

In 1888 Redon entered a reproach in his diary concerning his young supporters. 'People credit me,' he wrote, 'with too much analytical spirit. That at least is what emerges from the kinds of interest I feel among the young writers who visit me. On meeting me, I see them astonished.'[34] No artist can control the fate of his works once they have left his studio, and these intellectuals had attributed aims and qualities to Redon's works that were more analytical and precise than his aesthetic of suggestive ambiguity. Such a state of affairs was part and parcel of the continuing literary orientation of his career.

New Horizons in the Early 1890s

Change was an attractive and constant feature of Redon's career as an artist. Brought about by his individual development, by the intervention of outside forces such as patronage or successive contacts with 'cénacles', and by the influence of the more general evolution of the arts, new departures in his style occurred repeatedly throughout his life. At different times, however, changes occurred with varying rapidity, and the 1890s stand out as years of particularly intense change. With regard to both his style and the milieux he was encountering, Redon's evolution became more complicated and diversified than it had been before. New artistic horizons that were unfolding, events such as the important exhibition he held in 1894, his contacts with groups such as the Nabis, and the prospect of success in England, all created a new context in which Redon produced some of his finest 'noirs' and also emerged for the first time as a remarkable colourist.

From the 'noirs' to colour: the 1894 Durand-Ruel exhibition

Redon is sometimes described as an artist with two distinct styles: that of the 'noirs' and that of the late but highly productive colour period. While it is true, however, that the oil painting *Closed Eyes* of 1890 (Colour Plate 1) marks something of a point of departure in Redon's art, the moment when colour asserted itself as a medium no less expressive than black and white, there was no sudden break from one manner to the other. There was rather an entire decade during which 'noirs', pastels and oils coexisted, a period that saw also the slow progression from Redon's pessimistic works of the 1880s to the serene and even joyful products of his last years. The 'noirs' only gradually decreased in number, coming to an end at the turn of the century. And the fundamental unity that in fact embraces Redon's use of both black and white and of colour emerges clearly from his works of the time. *Closed Eyes* also exists in a lithograph version made at the same time as the painting. It is comparable not only to later colour pictures such as *Silence* (Plate 51) but also earlier 'noirs' such as the melancholic *Luminous Profile* (Plate 52), the more sinister *Figure in Armour* of 1891 (Plate 53), the later serene *Chimera* (Plate 81), or the many works in which the motif of closed eyes recurs.

Yet these two manners, the 'noirs' and the colour pictures, have often sown the seeds of confusion among critics. They did so already at the first exhibition at which Redon's gifts as a colourist became evident to all, the Durand-Ruel exhibition of March and April 1894. This was an important event in Redon's life, for it was his first retrospective exhibition. The catalogue for the show lists 124 exhibits and the actual number of works on display was even greater. The largest section was given over to drawings, which with the lithographs made up the bulk of the exhibition. Also present, however, were nine paintings and ten pastels. Pictures such as *Golden Cell* (Colour Plate 2) offered striking examples of Redon's

51 *Silence* c. 1911, oil on paper,
54 x 54.6cm. 21¼ x 21½ in. The
Museum of Modern Art, New York,
Lillie P. Bliss Collection

handling of colour. Never before had Redon publicly demonstrated the range of
his talents so forcefully. It was an occasion on which fellow artists, as well as
critics and patrons, could take stock of Redon's past achievements and also of
the changes operating in his style. Many articles were published about it, and on
7 April a group calling themselves Les Têtes de Bois held a banquet in Redon's
honour to which Paul Gauguin, Eugène Carrière and other painters were invited,
along with Redon's more literary supporters, such as Charles Morice, Jean
Dolent, Frantz Jourdain, and Alfred Vallette of *Le Mercure de France*.

Le Mercure de France provides an instance of the confused critical reaction to
the exhibition. It published an account of Redon's art by Camille Mauclair, a
comparative newcomer to the milieux of Symbolism. Some of his remarks were
reminiscent of Aurier's ideas. He wrote, for instance, that '*Dream Polyp, The Book
of Light, Waiting* . . . are not only symphonies in two colours of extraordinary
force, but also works thought out by a synthetist and spiritualist mind.'[1] Indeed,
so completely had he accepted the notion that Redon had created an art of
hermetic Symbolism, the product of a thinker, that he was utterly disconcerted
by the artist's growing interest in the intrinsic expressiveness of colour. He

79

52
Luminous Profile c. 1875, charcoal,
35 x 23cm. 13¾ x 9⅛ in. Musée du Petit
Palais, Paris

53
Figure in Armour 1891, charcoal,
50.7 x 36.8cm. 20 x 14½ in.
Metropolitan Museum of Art, New
York, Harris Brisbane Dick Fund

attempted, with no success, to extend the idea of Redon the thinker to works
such as *Golden Cell:*

> But I understand little the relationship between the colours and the drawing
> and subject: why blues here and gold there? People will tell me: because that
> pleased the painter. But this reason, which would be enough for me in the case
> of Monet or Renoir, does not satisfy me here: there is a motive and I do not
> quite grasp it.[2]

It was inconceivable to Mauclair that there existed no programme or motivation in Redon's use of colour other than its power of suggestion. The young critic had been so prejudiced by Redon's reputation amongst French and Belgian Symbolists that he could not see the colour works, or indeed the 'noirs', for what they were: that is, works of mystification and suggestion, and not of allegory or ideas.

Other critics, too, remained stubbornly faithful to their preconceptions about Redon's art. Alfred Paulet clung to a Decadent image of Redon in *La Famille,* describing him as 'a kind of Edgar Poe of the graphic arts'.[3] Frantz Jourdain also maintained this attitude:

> The audacious poet who has tried to materialize the unreal . . . to struggle against the vertigo of the unknown, he is perhaps hallucinated, but he is most definitely in earnest and sincere . . . At his side, carried away by his tormented and sickly imagination, we travel into a dark world of terror.[4]

This article was republished the following year in Jourdain's book *Les Décorés, ceux qui ne le sont pas,* so that the reputation given Redon at the time of *Homage to Goya* was proclaimed anew in 1895. Jean Lorrain's review of the exhibition went even further in having recourse to those doctrinal labels and received ideas that had multiplied around Redon's works over the years. His article, called 'Un Etrange Jongleur' ('A Strange Juggler') after Redon's lithograph of that name, reminds us in the space of a few pages of Redon's well-known connexions with Decadent, Wagnerist, Symbolist, idealist and other related tendencies.[5]

Some reviewers, nonetheless, were more appreciative of Redon's actual accomplishments and changing style. On 31 March the critic of *Le Rappel* declared: 'Leaving aside fantasy and mysticism, Odilon Redon is both an ardent colourist and a masterly draughtsman.'[6] And Thadée Natanson also expounded this attitude in *La Revue Blanche.*[7] Although even the introduction to the exhibition catalogue, written by André Mellerio, had encouraged the public to view Redon partly as a thinker, Natanson's review attributed his qualities to more technical considerations, such as Redon's transference to colour of the principle of suggestive textures that he had so successfully exploited in the 'noirs'. He rejected any literary interpretation of Redon's pictures, finding their expressiveness to be purely visual. Almost three years later, reviewing Redon's album *The Haunted House* in *La Revue Blanche,* Natanson would reiterate this view.[8] Despite the fairly literal interpretation that these lithographs constitute in relation to their source, Bulwer-Lytton's story *The Haunted and the Haunters,* Natanson here dismissed this link with literature as merely a pretext. He described the plates in luxuriant prose simply as intensely suggestive arrangements of black and white materials. When he praised Redon's Durand-Ruel exhibition of 1894 in this vein, it was the first time that the artist's work had been publicized in such specifically visual terms, and Redon was quick to encourage this unliterary account of his aims. As Natanson recalls in *Peints à leur tour,* it was Redon himself who suggested he might publish a lithograph in *La Revue Blanche,* adding his contribution to the graphic works that were a regular feature of the review.[9] This lithograph, *Pegasus,* in which the winged horse is shown pawing the ground in a brilliant light, is one of the most optimistic and resolute of his 'noirs'.

54
Maurice Denis *Homage to Cézanne*
1900, oil, 180 x 240cm.
71 x 95 in. Musée National d'Art
Moderne, Paris

Redon's association with *La Revue Blanche* was due in part to a welcome change in his circumstances—his growing closeness, that is, to the group of painters most clearly allied with the review: the Nabis. This recently formed group, whose concern with mystic aims, tempered by stylistic innovations derived from Gauguin, placed them in the vanguard of painting in the 1890s, included artists like Paul Sérusier (1863-1927), Pierre Bonnard (1867-1947), Edouard Vuillard (1868-1940) and Maurice Denis (1870-1943). The terms of Natanson's praise of Redon are to an extent a reflection of the prestige that Redon had won in the eyes of these young painters. The foundation of the Nabis group had had more to do with Gauguin than with Redon, but in the 1890s it was Redon who had become their champion and friend. Maurice Denis was to recall: 'Odilon Redon was one of the masters and one of the friendships of my youth . . . he was the ideal of the young Symbolist generation—our Mallarmé.'[10] Denis's painting of 1900 *Homage to Cézanne* (Plate 54) makes the same point. Although the title alludes to the Cézanne still life represented, it is the figure of Redon to

83

the left of the picture that dominates the scene. It is to him that the other figures portrayed, including most of the Nabi painters, are paying homage, as well as to Cézanne. At long last Redon was enjoying the admiration and companionship of a substantial group of painters. It was a pleasure he had had to wait for over a long period, since it had come only after his fiftieth year.

What the Nabis actually so admired in Redon was not only the technical quality of his works but also his ability to suggest the mysterious and the spiritual. Bonnard later summed this up succinctly: 'What strikes me most in his work is the coming together of two almost opposite qualities: very pure plastic substance and very mysterious expression. Our whole generation is under his charm and benefits from his advice.'[11] Maurice Denis wrote that Redon brought to the group 'an element of the mystic or esoteric'.[12] His art echoed their own preoccupation with the magical as well as their interest in more technical aspects of painting. They shared with Redon a rejection of the values of the Impressionists. Sérusier, in particular, was in agreement with Redon's attachment to idealist aims, and later related to Charles Chassé what the older painter had said to him about Impressionism: 'I refused to set out on the Impressionist tack for I found its ceiling too low.'[13] Sérusier attached great importance to Redon's friendship, referring to him as 'the finest figure of an artist I have known'.[14] Denis was implying a similar view when he stated that Redon was a kind of Mallarmé to the Nabis, 'the Mallarmé of painting'.[15] This group of painters came to frequent Redon's home and, in the physical absence of Gauguin, looked to him as something of an example, almost a figurehead. Not that Redon became a *chef d'école* as such. Not only were the Nabis themselves too individualist for this to happen, but it is clear that Redon regarded himself as the companion of the Nabis rather than in any sense their leader, despite being a generation older.

The Nabis added a further element to Redon's changing reputation and activities in the early 1890s, and one that received some publicity through Thadée Natanson and *La Revue Blanche*. But another former follower of Gauguin was also contributing to Redon's career at the time, one who would not have agreed with Sérusier's simple judgement that Redon 'was simply a painter, but he was a painter to an extraordinary degree'.[16] This was Emile Bernard. Bernard first met Redon through Emile Schuffenecker in 1889. He was already an admirer of the 'noirs', and quickly began to frequent Redon's studio. Bernard's support was precious to Redon because it forged a link with young painters, including those who had known Gauguin at Pont-Aven in Brittany, and also because he was an eloquent defender of Redon's work at a time when the 'noirs' were still widely neglected. Bernard himself recalled his advocacy of Redon's art in these terms: 'I was soon an apostle of the extraordinary charcoal drawings of my new friend. I wrote about him several times and I even managed to make him appreciated in my entourage.'[17] Their friendship, which was to be a lasting one, was cemented in this way by Bernard's activities as critic and writer. His views concerning Redon, however, were not limited to an appreciation of his aims and style; they included interpretations of his art that were excessive in their claims and contradicted to an extent the views of Sérusier or Natanson. In particular, an article entitled 'Odilon Redon' that he published in the review *Le Cœur* in September-October 1893, six months before the Durand-Ruel exhibition, included hyperboles of fanciful extravagance. It begins: 'When we entered "the Magician's" home we

were first of all struck by the affability of his gestures and the singular beauty of his forehead; . . . having gazed at "this soul of dark dreams" we saw extraordinary pictures.'[18] There follows a description of works by Redon, including evocations of languid women that are as close to the fashion of the time for Burne-Jones as to Redon's actual pictures. The article ends with three stanzas from Baudelaire's 'Bénédiction' followed by the odd declaration: 'Then we entered a cathedral.'[19] Although a little disconcerted by this unrestrained praise, Redon thanked Bernard for his article in a sincerely grateful letter.[20] Enthusiasm was welcome in whatever guise, even though that of Bernard was extreme to the point of bias and distortion. The mysticism of this article, after all, belonged not so much to the world of the Nabis as to that of La Rose + Croix, at whose first salon Bernard had exhibited. Joséphin Péladan, the organizer of the motley assortment of mystic painters that constituted La Rose + Croix, himself considered Redon to be eminently Rosicrucian. Redon was one of some eighty artists whom Péladan declared worthy of membership of his society when, in September 1891, he published his aims in Le Figaro. Redon had refused to participate in Rosicrucian activities, as had Puvis de Chavannes and others, probably because of the doctrine and rules of the society that Péladan had published.[21] But this did not exclude the possibility of Redon's being associated with La Rose + Croix, either through his influence on some painters who took part or through critical accounts of his works.

Bernard's article encouraging a Rosicrucian view of Redon's art might appear simply pretentious and ultimately irrelevant to the changes affecting Redon's style were it not for the fact that some of his output of the time is altogether compatible with Rosicrucian taste. Works such as Mystic Dialogue, or Pious Women (Plate 55) of the same year, positively favour such religious and mystic interpretations. Some works even became concretely associated with Rosicrucian and similarly mystic tendencies, for instance the charcoal and pastel drawing entitled Mystic Knight (Plate 56). Also known as Oedipus and the Sphinx, this utterly ambiguous work had probably been started a long time before, under the influence of Gustave Moreau. It was finished, however, in about 1890, and was shown in the spring of 1893 at the fifth exhibition of the Peintres-Graveurs.[22] The critic writing for Le Cœur, a review that was actively concerned with mysticism and the occult, was much impressed: 'Mr Odilon Redon,' he enthused, 'is exhibiting a capital work of the very finest, Mystic Knight. This drawing made me pause for a long time, and I felt vibrating within me the whole range of strange sensations from an unknown world.'[23] Indeed, so great was the interest aroused by the work at Le Cœur that a large reproduction of it was published in the number containing Bernard's article, accompanied by a poem inspired by it that had been written by the review's chief editor, Jules Bois. The identity of the work's owner was also revealed—Antoine de la Rochefoucauld. La Rochefoucauld had been a founder member of Péladan's Order of La Rose + Croix, but had become quickly disenchanted with it, transferring his allegiance and wealth to Le Cœur. It was through him, no doubt, that Mystic Knight had become associated closely with Le Cœur. Although Jules Bois was unsympathetic towards La Rose + Croix itself, his occultism belonging to what he considered religious truths as opposed to the vagueries of Symbolism and the arts, he did regard Le Cœur as the spearhead of a militant form of mysticism. The poem he

56
Mystic Knight or *Oedipus and the Sphinx* 1869/90, charcoal and pastel, 100 x 81.5cm. 39⅜ x 32⅛ in. Musée des Beaux-Arts, Bordeaux

based on *Mystic Knight* is consistent with such views. It takes the form of a dialogue between 'The Knight' and the sphinx-like figure on the right, here called 'The Chimera', by means of which Bois attaches to Redon's drawing a dialectic of sin and salvation that is a gratuitous addition to the picture's imagery. Despite the freedom of this interpretation, it was adopted by a number of critics.

Although it was without any obvious encouragement from Redon himself that *Mystic Knight* became involved in various mystic milieux of the early 1890s, it is clear that he was by no means indifferent to these circles. Not only are works

55 *Opposite*
Pious Women or *Window No. 19* c. 1892,, charcoal, 52 x 37cm. 20½ x 14⅝ in. Courtesy of the Art Institute of Chicago

such as *Pious Women* or the lithographs of *Dreams* (Plates 71 and 72) evidence of his own mystic leanings, but he also had personal contact with these currents. A close friend, Elémir Bourges, had been involved in the foundation of La Rose + Croix. Bourges's passion for religious and oriental philosophies had put him in the company of Péladan (although Péladan's taste for flamboyant publicity was foreign to Bourges's solitary way of life at Samois) and idealism and occultism were much discussed in a circle of which Redon was part. By way of such discussions and encounters, Redon was in touch not with any specific group such as La Rose + Croix but with individuals whose attitudes belong to the same general idealist tendency. And although the deliberate ambiguity of *Pious Women* or *Dreams* was intended to preclude interpretations of the kind that Bois attached to *Mystic Knight,* the idealism of such works is of a kind that is quite in harmony with prevailing mystic attitudes of the time.

A further example of these contacts concerns a commission Redon was offered in 1892. He was to provide scenery for one of two scenes from Edouard Schuré's play *Vercingétorix* that Paul Fort was intending to present at his avant-garde theatre.[24] The commission was not carried out, which is not surprising since the larger scale decorative side of Redon's art would only be developed after the turn of the century. Besides, the attitudes of Schuré and Redon towards legendary and mythological subject matter were different, and so collaboration was difficult. Although Schuré showed real enthusiasm for Redon's possible contribution to Paul Fort's production, it was in Gustave Moreau rather than Redon that he found a painter whom he believed to have depicted a true pictorial counterpart to his own investigation of religions and mythologies.[25] His enthusiasm for Redon in 1892 may indeed have resulted from a confusion in his mind between the art of Redon and what he believed Moreau's aims to be, for the reputations of the two painters had become entangled during the 1880s. These considerations apart, however, Redon's encounter with Schuré is a significant one. Schuré's *Les Grands Initiés* of 1889, that was so topical and influential in relation to the growth of theosophy, contained material that would have been of great interest to Redon. Moreover, there is a work from 1891 that may be compared with *Vercingétorix*. This is the lithograph *Druid Priestess* (Plate 57). Its evocation of the spiritual power of the Druid priestess provides a striking parallel with the great importance the Druidess figure is given in Schuré's play. While *Vercingétorix* is almost certainly not the source of *Druid Priestess,* common ground clearly existed between Schuré and Redon as regards their choice of subject matter.

At the time of the 1894 Durand-Ruel exhibition, Redon's aims and achievements as well as his reputation were more complex than Thadée Natanson would have had the public believe. *La Revue Blanche* was only one among many contexts to which his works of the time belonged. His activities had brought him into contact with milieux as varied as the Nabis and La Rose + Croix, and individuals as different as Emile Bernard and Edouard Schuré or the socialist Octave Mirbeau, who entered the ranks of Redon's supporters in the mid 1890s. Simultaneously, of course, Redon's connections and projects with Belgian Symbolists and French theorists of Symbolism were in the air, and the continuing survival of his Decadent image caused misunderstandings about his development. As the conditions and aims of Symbolism had grown and multiplied, so had Redon's career diversified richly. In Paris as well as Brussels

Colour 1 *Opposite*
Closed Eyes 1890, oil on canvas, 38 x 30cm. 15 x 11⅞ in. Galerie du Jeu de Paume, Paris

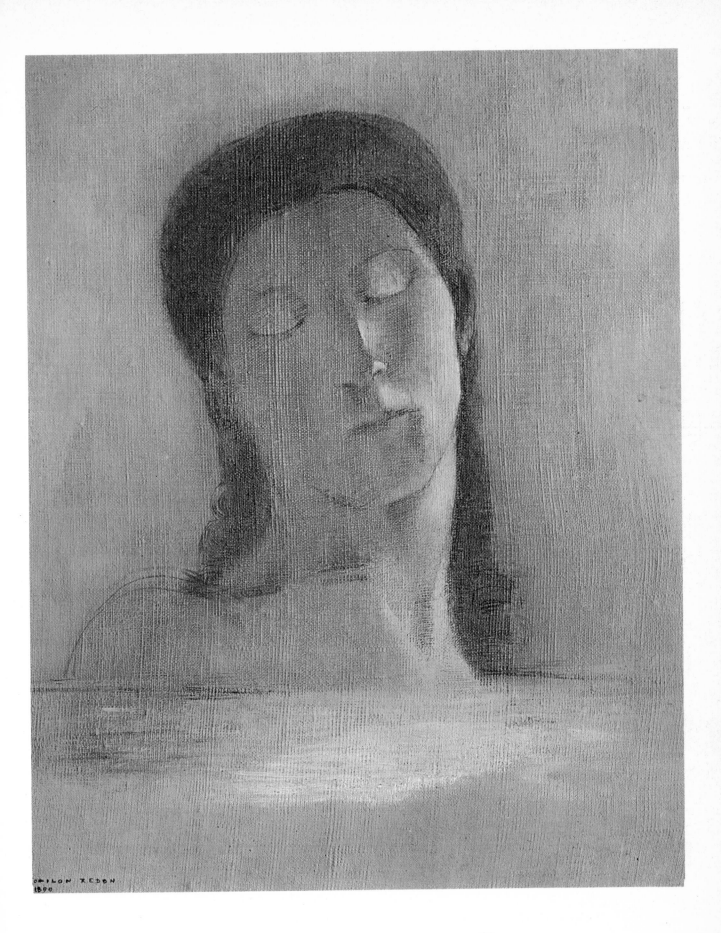

57
Druid Priestess 1891, lithograph,
23 x 20cm. $9\frac{1}{8}$ x $7\frac{1}{8}$ in. British
Museum, London

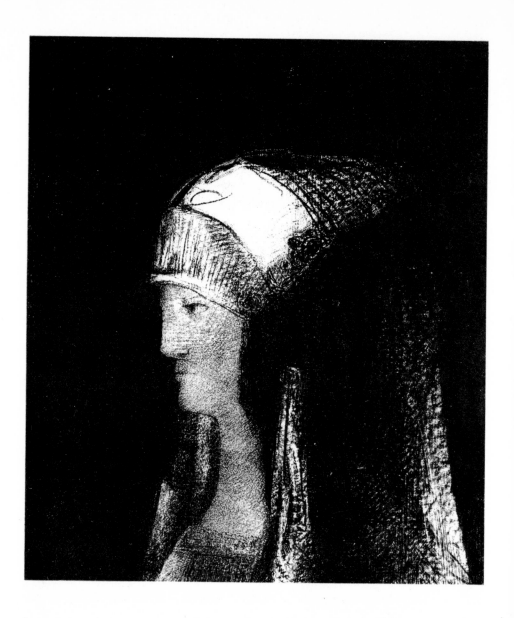

he now received commissions for frontispieces, producing lithographs for *A rebours* (*Against Nature*) in 1888, for Adrien Remacle's *La Passante* (*The Passing Soul*) in 1891, and for Ferdinand Hérold's *Chevaleries sentimentales* (*Lays of Knights and Love*) in 1893. Critical confusion over his art was complicated further by the success of younger artists who seemed at the time to echo Redon's aims. The Belgian Henry de Groux is an example. The fame of this painter in the early 1890s appears today out of all proportion to his meagre talents, but can be partly explained by the speed with which critics such as Charles Morice and Jules Destrée quickly associated him with a certain kind of art. They described his works in the same terms they had used for those of Redon, and thereby boosted the older artist's fame in a vicarious and not altogether helpful manner.

An attempt at expansion: England

As Redon's fame grew in the early 1890s, opportunities arose for making his work known to a wider audience. These included the development of his activities outside France. Of the new horizons that were opening to him abroad, one, namely Holland, was at an early stage and would emerge fully only later. Another belongs more specifically to the 1890s, and that is the possibility of success across the English Channel.

In June 1894 Redon announced to his Dutch friend Bonger that he had made some contacts in London and was planning to exhibit there the following year. Late in 1895, he indeed took part in an exhibition at Dunthorne's Rembrandt Gallery in Vigo Street, off Regent Street. The English, however, were more alarmed than enthusiastic about what they saw, as Redon himself remarked: 'I have fairly good reviews in the press, very respectful of technique but all the same a little surprised or alarmed.'[26] He did not find the success he had hoped for. In 1900 P. G. Konody was to write in an article, 'Odilon Redon and his World', that appeared in *The Idler*: 'Odilon Redon . . . is entirely unknown in England—unknown not only to the public at large, but also to the few eclectic spirits who endeavour to extend their knowledge of artistic progress beyond the boundaries of their native country.'[27] In view of this indifference, it may appear surprising that Redon was very optimistic at the prospect of the 1895 exhibition. He wrote to Bonger, 'I have an intuition that I will find success with the English.'[28] This optimism may be explained in the light of three perspectives: Redon's preconceptions about England, the potential appeal of his subject matter to English taste, and the earlier contacts he had had with Englishmen.

Redon's preconceptions about things English had undergone a change since his first recorded judgements on the matter. In the late 1870s he had praised England in his diaries as the country that had produced the finest and most vigorous writers of any country.[29] What he had in mind, presumably, was the work of Shakespeare or Byron, and also the way in which Delacroix had used subjects from English literature. Redon himself was to use Shakespearian themes: he represented Ophelia and Caliban several times (see Colour Plate 3). In the course of time, however, English writers and artists who were more contemporary had become popular among French and Belgian Symbolists. In 1882, Mallarmé had considered commissioning Redon to illustrate Swinburne, but Huysmans, acting as intermediary, had judged the project unsuitable. Subsequently, a number of Redon's friends and acquaintances fell under the spell of the Pre-Raphaelites. Such friends enabled him to encounter these English artists indirectly. In 1887, for example, Debussy used Gabriel Sarrazin's translation of Rossetti's poem 'The Blessed Damozel' to compose his *La Demoiselle élue* for voices and orchestra, the score of which was illustrated in 1893 by Maurice Denis. It was in 1893 that a performance of Debussy's piece enthused Redon so much that he sent the Symbolist composer one of his works by way of homage, and received in return a copy of Denis's score.[30] Also, Redon must have encountered the Pre-Raphaelites' paintings more directly on the occasions they had been on show in Paris. Perhaps he knew them as early as the 1867 Exposition Universelle; at any rate, he must have known of them through that of 1878 and Georges Petit's exhibitions of the early 1880s. They would have become increasingly familiar to him as Symbolist taste increased their stature in France. When Redon visited London in the autumn

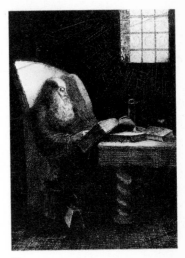

58
The Reader 1892, lithograph, 31 x 23.6cm. 12½ x 9¼ in. British Museum, London

On following pages
Colour 2
Golden Cell or *Blue Profile* c. 1893, pastel, watercolour and gold, 30 x 24.5cm. 11¾ x 9⅝ in. British Museum, London

Colour 3
Ophelia among the Flowers 1905, pastel, 64 x 91cm. 25¼ x 35⅞ in. Courtesy Marlborough Fine Art, London

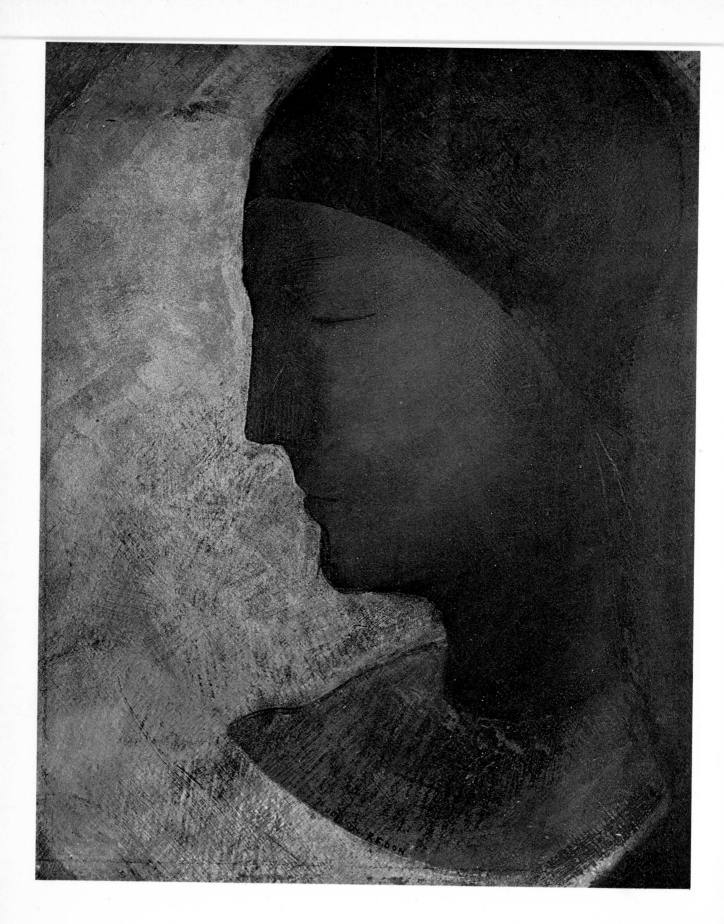

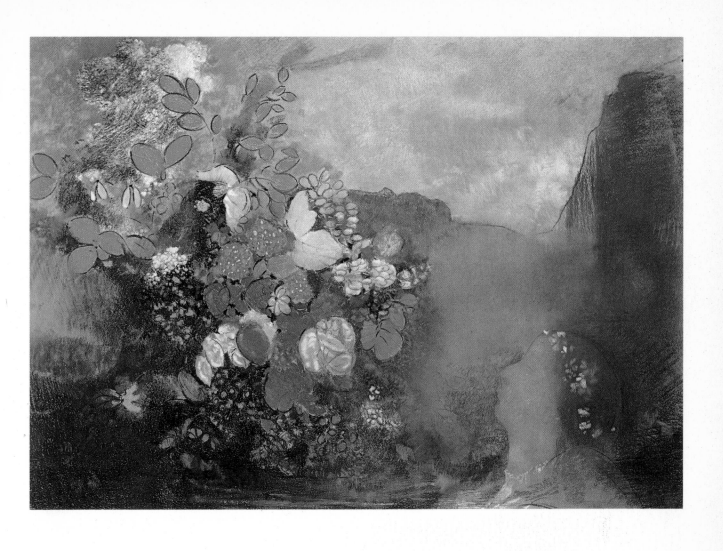

of 1895 to see his works exhibited, therefore, he was going to the capital where not only the Elgin marbles, which excited him greatly,[31] were to be seen, but also the art of the Pre-Raphaelites. It was this version of Englishness rather than the Shakespearian ideal he also knew that gave Redon grounds to believe that his work would be well received in England. Rossetti, in particular, had certain affinities with Redon, both in his dream-like female portraits and in his passion for the written word.

The English work on which Redon based a series of lithographs at about the time of the London exhibition has little to do with the Pre-Raphaelites. Bulwer-Lytton's *The Haunted and the Haunters* that René Philippon, a collector of Redon's works, was translating as *La Maison hantée*, is a ghost story that explains such fantastic phenomena by a spiritualist theory of the limitless powers of the will. The lithographs that Philippon commissioned from Redon appear rather slight to modern eyes, and even banal (Plate 59). Redon, impressed by the themes of fear and the supernatural, did take the work very seriously, but his representation of ghostly manifestations lacks any great power. Such an album was scarcely likely to bring Redon closer to English taste after his appearance at Dunthorne's Gallery. Indeed, the subject matter in his works that might have appealed to the English is rather a matter of French figures who were becoming known in England. The influence of Baudelaire and the Symbolists was becoming stronger there. Huysmans' *A rebours* had attracted some attention and Flaubert was increasingly widely read. The impact of Flaubert in England may account for an imaginative commission that Redon received in London in December 1895: the interpretation of James Thomson's poem 'The City of Dreadful Night'.[32] It is to be regretted that the commission was not carried out, for in both its imagery and its suggestion of fear and strangeness the poem is very close to some of Redon's lithographs based on Flaubert's *La Tentation de Saint Antoine*. Nor is this comparison without foundation, for Thomson, like Redon, had recognized in Flaubert's book real affinities with his own style. The patron who made the commission must have had the perception to understand this, and such an album, rather than *La Maison hantée,* would have made a fine climax to Redon's contacts with England.

When Konody claimed that Redon was entirely unknown to the English he was forgetting one individual who had been an exception to the rule a full decade before. This man was Arthur Symons. Symons had become a supporter of Redon's work in about 1890 in a way that had augured well for Redon's future in the English art world. In the late 1880s Symons, who had taught himself French, began on his own initiative to make contacts with Parisian intellectuals and to broaden his knowledge of the contemporary French arts. In September 1889 he made his first visit to Paris to visit the Exposition Universelle, accompanied by Havelock Ellis. The brief journey whetted their appetites and the following spring they returned together for a three-month stay. They contacted Charles Morice, then at the height of his fame, who acted as their guide to the avant-garde. One of the artists whom Morice took Symons and Ellis to see was Odilon Redon. Havelock Ellis recalls the visit to Redon's studio in his autobiography: 'I can see him still,' he wrote, 'the gentle quiet little man, producing large albums for our inspection, brooding tenderly over them with us, seeming to be warmed by our pleasure.'[33] Symons then wrote an article on Redon that was published in London

59 *Opposite*
'I saw a large pale light', *The Haunted House* 1896, lithograph, 23 x 17cm. 9⅛ x 6¾ in. British Museum, London

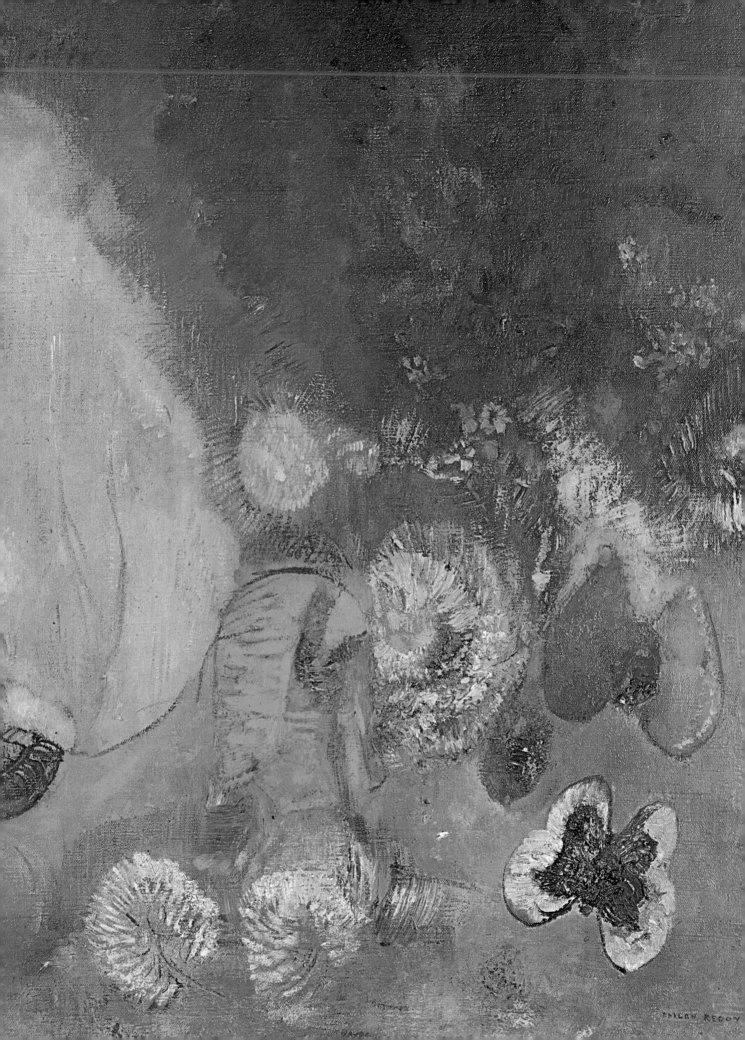

in *The Art Review* for July 1890. His interpretation of Redon's art is very eloquent, showing real sensitivity to its visual suggestiveness:

> A cunning arrangement of lines gives one the sensation of something without beginning or end: spiral coils, or floating tresses, which seem to reach out, winding or unwinding forever.[34]

He attempted to make Redon more accessible to English taste by drawing a parallel between Redon's visionary art and that of William Blake, and he called his article 'A French Blake: Odilon Redon'. When a French translation of the article appeared in *La Revue Indépendante* for March 1891, it must have been perplexing to Redon to find himself described as an artist of Darkness who could not equal Blake as a creator of Light. Symons in fact attached no lasting importance to the article. His real interest in the visual arts, culminating in his friendship with Rodin, belongs to later years. The most significant aspect of 'A French Blake: Odilon Redon' is perhaps the fact that a foreigner visiting Paris to learn about the avant-garde should rapidly have found himself in Redon's studio. The works of Redon were a part of Symons's initiation to French Symbolism, which would bear fruit in his influential work, *The Symbolist Movement in Literature*.

Redon's contacts with England make up a story of unfulfilled possibilities and disappointed hopes. But the events connected with the 1895 exhibition in London, and the reasons for Redon's optimism over it, are of considerable interest. His knowledge of English art, in particular of the Pre-Raphaelites, in addition to his encounters with Englishmen and with English subject matter, sheds real light on Redon's ambitions and activities in the 1890s.

From the monstrous to the serene

The more closely these years of change and new horizons in Redon's life are examined, the more fragmented and intricate they may appear to be. Yet any broad consideration of the works he produced at the time quickly throws into relief the more simple general change in his work whereby the black and white nightmarish pictures of the 1880s were being succeeded by an increasingly serene tone to which the colours of his pastels and oils made a rich contribution. This progression slowly put an end to a debate that had smouldered for some time around his work: a debate about the notion of expressive ugliness.

In 1891 Félix Fénéon disparagingly summed up the positions of the attackers and defenders of Redon's draughtsmanship in this way:

> The opponents of Mr Odilon Redon's art say that when Mr Odilon does not throw forms into confusion . . . he is the most insignificant of draughtsmen; but, the faithful reply, it would be wrong to conclude from that that he remains a mediocre artist when he teratologizes.[35]

Even Redon's defenders, Fénéon insinuates, justify his possible shortcomings by referring to his skill in the creation of monstrous forms. This account is scarcely objective. Fénéon, although he had praised *To Edgar Poe* lavishly in 1883,[36] had long since become the natural enemy of Redon's exploitation of suggestive ambiguity. His commitment to the art of Seurat and to Neo-Impressionism had made him hostile to any art that smacked of literature or Symbolist mystification.

Colour 4 *Opposite*
Red Sphinx 1910-12, oil,
61 x 50cm. 24 x 19⅝ in. Collection
Prof. Hans Hahnloser, Berne

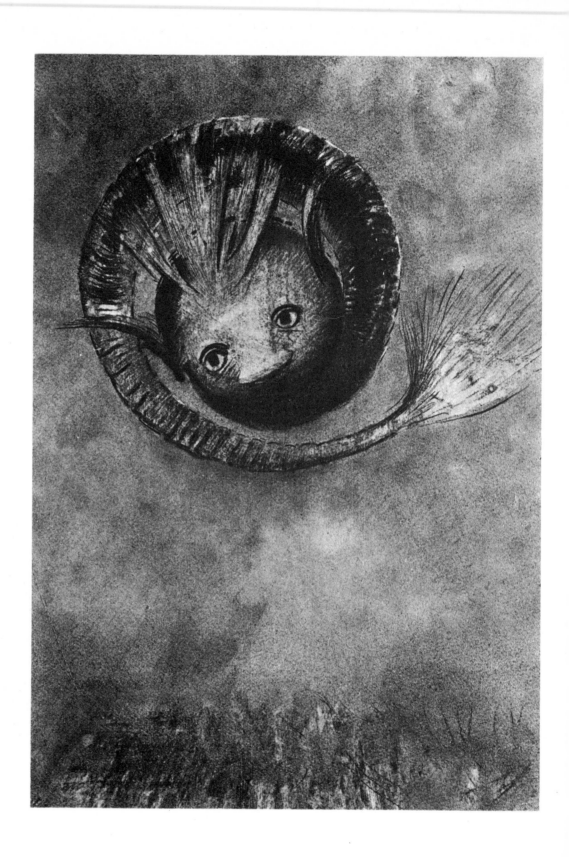

98

Yet he had put his finger on a topical issue by associating Redon's defenders with a taste for the monstrous. He may well have had in mind Huysmans' essay 'Le Monstre' from his collection of 1889, *Certains*. There, certainly, Redon had been praised as the creator of a new imagery of the monster. And Rémy de Gourmont would later give a similar description of Redon, showing a more emotional appreciation of his work than was implicit in his claim that it was idealist or metaphoric, by calling him, in *Le Livre des masques*, 'the master of retrograde forms, of fear, of amorphous swarming masses of beings that almost exist . . .'.[37] The interest of Aurier in Redon may also partly be put down to the taste for the grotesque and expressively ugly that is evident in his poetry.

But if some figures approved of what they considered to be Redon's depiction of the monstrous, others attacked him for what they saw as a cult of the ugly. Gustave Kahn did so in the case of a work that is far from being as grotesque as drawings like, say, *Fantastic Monster* (Plate 60), in which a baleful monster floats through undefined space. He dismissed the *Brünnhilde* lithograph of 1885 (Plate 35) in reproachful terms: 'Was Wagner's beautiful dream of the virgin made tender by suffering meant to lead to this ugliness?', he asked; 'To sum up, we repeat that Mr Redon is an intelligent artist, but we refuse him the right to set up ugliness as a principle.'[38] The legend of Redon the Decadent added substance to such a charge, and if confirmation were needed that this legend survived into the 1890s, it could be found in Redon's appearance in a satirical novel of 1895, Léon Daudet's *Les Kamtchatka*. This work includes a witty lampoon of two artists, Trouguin and Cardon, clearly modelled on Gauguin and Redon. Cardon is an improbably bohemian figure who produces pictures such as one portraying 'a white bridge's arch in pitch; above, a square eye; below, half a skull, cut like a slice of cheese and resting on its side.'[39] This parody of a Redon 'noir' harks back to Decadent pessimism and associates Redon's art categorically with the expressively ugly. By this time, however, someone more directly concerned had recorded his opinion on the question: Paul Gauguin. Taking Huysmans to task over 'Le Monstre', Gauguin had noted down that he did not see 'in what sense Odilon Redon makes monsters. They are imaginary beings. He is a dreamer, a man of imagination. Ugliness—a burning question and one that is the touchstone of our modern art and its criticism.'[40] While recognizing that the notion of ugliness was a burning issue, a vital topic for modern artists, he opts for an idealist interpretation of Redon's art, insisting on the human aspects of Redon's visionary creations, a view that comes close to neither of the attitudes that Fénéon described, and that might well have elicited Redon's own approval.

Yet even Gauguin's view does not wholly resolve the issue. By insisting that his creations were simply imaginary and dream-like rather than ugly, he was glossing over an unmistakable process of change in Redon's work. As his public career and personal life were being favoured by new and happier circumstances (in 1889, for instance, his son Arï was born), Redon's artistic style was undeniably coming to owe less and less to the monstrous and was beginning to assert an unprecedented optimism and serenity. The years around 1890, in fact, mark something of a transitional period in his art. They saw the disappearance of Redon's melancholic and at times grotesque products of the 1870s and 1880s and the emergence of the new tone that would permeate the major achievements of the last twenty-five years of his life.

60 *Opposite*
Fantastic Monster 1880-5, charcoal, 48 x 34cm. 18⅞ x 13⅜ in. Rijksmuseum Kröller-Müller, Otterlo

61
Woman and Serpent c. 1885-90, charcoal, 51 x 36cm. 20⅛ x 14⅛ in. Rijksmuseum Kröller-Müller, Otterlo

The Last 'Noirs'

Redon's activities in the 1890s were punctuated by the production of three albums of magnificent lithographs: *Dreams* of 1891, *The Temptation of Saint Anthony* of 1896, and *The Apocalypse of Saint John* of 1899. They were not the only albums he published at the time, but these high points of the last 'noirs' do span the decade as the culmination of the skill and endeavour that Redon had devoted to lithography. In addition, the developments from each album to the next demonstrate an evolution that sheds light on his charcoal drawings of the time, and indeed on all his works in the 1890s. *The Temptation of Saint Anthony*, in particular, is central among the last 'noirs' both in its treatment of subject matter and technical quality, and also by virtue of its sheer size, since it consists of no fewer than twenty-four lithographs. A more than worthy successor to Redon's two earlier lithograph albums on the same theme, *The Temptation of Saint Anthony* of 1888 and *To Gustave Flaubert* of 1889, its variety and masterly handling of the techniques of lithography make it one of Redon's finest achievements.

The late lithograph albums: Saint Anthony, religion, and mythology

The Temptation of Saint Anthony is one of Redon's favourite and most successful themes. The subject had been used in the past by many artists, ranging from the monstrous evocations of Bosch, Breughel or Grünewald, and its more recent status as something of a cliché in mid-nineteenth century French Salon painting, to the individual treatments of artists as different as Félicien Rops and Cézanne. But it was specifically Flaubert's literary adaptation of the theme, published in 1874, that interested Redon. Not only do the plates of the three *Temptation of Saint Anthony* albums, making up almost a quarter of all his lithographs, take their imagery from Flaubert, but many other works also use such motifs. This applies not only to a 'noir' such as *Buddha* of 1895 (Plate 64), which uses a quotation from Flaubert as a caption, but also to later colour works. Although the oil painting *Red Sphinx* (Colour Plate 4) is mainly remarkable for the lyrical fantasy of its rich reds and blues, it is also a colour counterpart to the Flaubert lithographs 'My gaze that nothing can deflect . . .' of 1889 (Plate 63) and 'I have sometimes caught sight in the sky . . .' of 1896 (Plate 70). Similarly, 'My irony surpasses all others!' from the album *To Gustave Flaubert* (Plate 62) also exists in the colour version *Green Death* (dated between 1905 and 1910),[1] in which the worm-like figure of death is given a green torso that contrasts intensely with a predominantly red background. The painting *Oannes* of 1910 (Plate 65) similarly repeats a motif that Redon had used in the Flaubert albums (Plates 47 and 67). These and other examples show the pride of place that the theme occupies in Redon's work.

The reason for Redon's attachment to Flaubert's *La Tentation de Saint Antoine* is that its subject matter corresponded amazingly to his own interest in

62
'Death: My irony surpasses all others!', *To Gustave Flaubert* 1889, lithograph, 26.2 x 19.7cm. 10½ x 7¾ in. British Museum, London

mythological, religious and monstrous imagery. He had first read the book in 1882, when Hennequin had shown it to him on seeing *Origins,* which was then in preparation. In this album Redon was using two main kinds of imagery, the mythological and the fantastic or monstrous, to produce an overall effect of disquieting visionary suggestiveness. Hennequin realized astutely that the Flaubert should prove a potentially rich source of motifs for Redon. The artist's letter of thanks to his young friend shows his full agreement: 'My thanks to you

101

for having made me read *La Tentation de Saint Antoine,* a literary marvel and a mine for me.'[2] He found in Flaubert's richly suggestive prose descriptions of deities belonging not only to the Christian world but to the mythologies of the ancients, of Egypt, the Near East and India. As well as the Christian saint and Christ himself, he encountered Buddha, Isis, the Sphinx, the Chaldean Oannes and many other religious figures. The visions of the saint included also fantastic and monstrous beings of unfamiliar and grotesque appearance. The strong visual impact of some of these monsters was due to Flaubert himself having used visual

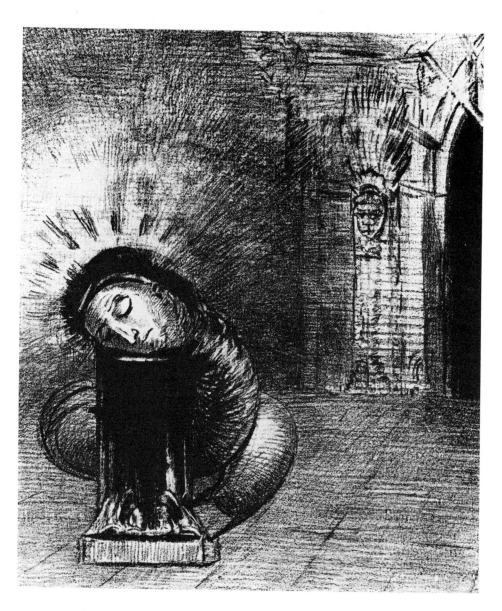

66
'A long chrysalis the colour of
blood', *To Gustave Flaubert* 1889,
lithograph, 22 x 18.5cm. $8\frac{5}{8}$ x $7\frac{1}{8}$ in.
British Museum, London

sources, a fact unknown to Redon. As Professor Seznec has shown,[3] Redon
selected a motif such as the figure of Death with a worm's body (Plate 62), or the
Knouphis, the long chrysalis whose human head rests on a short column (Plate
66), without realizing that Flaubert's prose was transmitting to him earlier visual
images of sometimes serious but also ephemeral origins, among them the
doodles of Maurice Sand as well as medieval art. It was the descriptive brilliance
of Flaubert's book, with its visionary richness and atmosphere of hallucinatory
anxiety, that enchanted Redon above all. He was not interested in the book's
ideas or themes. He saw it rather as a descriptive *tour de force* that coincided
marvellously with the direction his own ideas on subject matter were taking.[4]

To retrace Redon's actual choice of motifs for the three Flaubert albums is,

therefore, to discover both a confirmation of the nature of his debt to this source and also a revealing demonstration of his own preferences with regard to mythological and fantastic subject matter. He in fact made no attempt to select his motifs from all parts of the book, as might have been the case in conventional illustration. It is true that the albums respect the chronology of their source, each one beginning with a motif from Chapter I, and two of them, the first and third, ending as Flaubert does with a vision of Christ. Nonetheless, his preference for certain episodes is striking. More than half of the plates from the first two albums, and more than a third of all of them, refer to Flaubert's final chapter, containing the episodes of La Luxure and La Mort, of the Sphinx and the Chimera, and of the procession of monsters. None, however, refers to the long and fine episode in Flaubert of Apollonius and Damis, which lacks a good deal of the final chapter's variety and colour. The very short appearance of Oannes is used for three lithographs (see Plates 47 and 67); but the recurrent and less exotic figure of Hilarion is not represented at all. Striking, too, is the difference between his selections for the first two albums and those for the third. In 1888 and 1889, the anxious pessimism that was still dominant in his style led him to concentrate chiefly on nightmarish episodes taken from the end of the Flaubert, such as the figure of Death that appears in each of them (Plates 48 and 62). By 1896, however, when a new serenity had developed in his work, he had turned away from the horrific in favour of the splendidly mysterious and idealist, exemplified by figures such as Buddha. Some subjects are used in both the first two albums and the last one, but in these cases the strong contrast in the way they are treated again makes clear the change that had taken place. In 1888, Oannes is represented as he first appears to Anthony: as the absurd, grotesque figure, half man and half fish, that causes the saint much mirth (Plate 47). In 1896, however, he has become the awesome Chaldean deity (Plate 67) who proclaims, 'I, the first consciousness in chaos, rose from the abyss to harden matter, to determine forms.' In 1888, the Devil is represented as a threatening monster (Plate 46), whereas in 1896 he is the melancholic, seductive figure (Plate 69) whom Redon had found in a different part of Flaubert's text.[5] The episode of the Sphinx and the Chimera appears in all three albums (Plates 49, 63 and 70), but this too progresses from the horrific to the mysterious. Redon's choice and treatment of motifs from the Flaubert demonstrates in this way not only the enormous importance he attached to mythological, religious and fantastic subject matter but also the manner in which his attitude changed from viewing it as a vehicle for the grotesque and pessimistic to seeing it as an expression of a more serene and assertive idealism. Even a potentially sinister subject like 'The beasts of the sea . . .' (Plate 68) is treated in 1896 as a flowing composition rather than an evocation of monsters.

This change is consistent with the new conditions that affected Redon's position in the early 1890s, and is illustrated too by the album *Dreams* which, being published in 1891, occupies something of a transitional position between the first two and the third Flaubert albums. *Dreams* is not based on a literary source but its subject matter is comparable to the 1896 *Temptation of Saint Anthony* in that it makes free use of mythological and religious subject matter. The first lithograph is clearly an allusion to the Christian legend of Saint Veronica's veil (Plate 71), whereas the second, 'And yonder the astral idol, the apotheosis' (Plate 72), has to do with oriental subjects. In his catalogue Mellerio

67
'Oannes: I, the first consciousness in chaos, rose from the abyss to harden matter, to determine forms', *The Temptation of Saint Anthony* 1896, lithograph, 27.9 x 21.7cm. 11 x 8½ in. British Museum, London

68
'The beasts of the sea, round like water-skins', *The Temptation of Saint Anthony* 1896, lithograph, 22.2 x 19cm. $8\frac{3}{4}$ x $7\frac{1}{2}$ in. British Museum, London

69
'Anthony: What is the object of all this? The Devil: There is no object!', *The Temptation of Saint Anthony* 1896, lithograph, 31.1 x 25cm. $12\frac{1}{4}$ x $9\frac{3}{4}$ in. British Museum, London

70 *Opposite*
'I have sometimes caught sight in the sky of what seemed to be the forms of spirits', *The Temptation of Saint Anthony* 1896, lithograph, 26.1 x 18.2cm. $10\frac{1}{4}$ x $7\frac{1}{8}$ in. British Museum, London

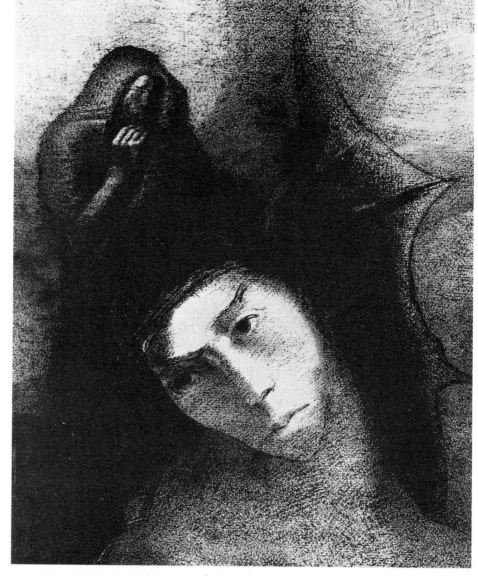

says of this second lithograph that the clothes of the god-like figure are Tibetan, and he identifies the large bow with Sagittarius.[6] But just such a bow plays a part in the exploits of both Krishna and Rama, so that Indian religious myth may well be another source. The motifs are left deliberately unidentified in the album itself. The other plates of the album, similarly, suggest various idealist and spiritual themes without being definitely associated with any of them. For example, 'Pilgrim of the sublunary world', in which a robed figure astride a rearing horse gazes up from the left-hand side of the lithograph towards a source of light in the opposite part, adds to the suggestion of the mystic quest of a pilgrim some elements of the flight into Egypt, implicit in the robed journeying figure, and also

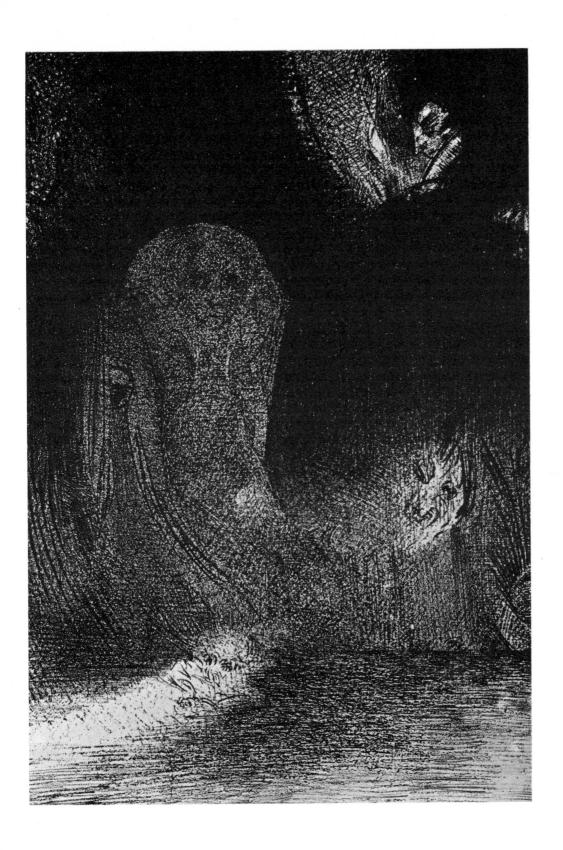

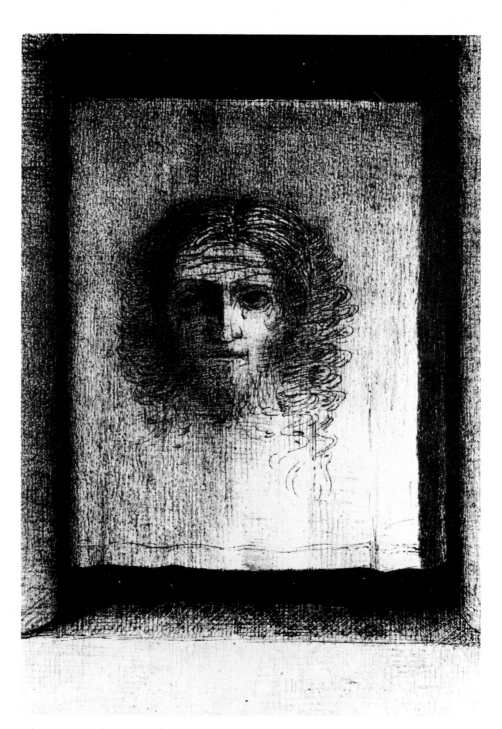

of Pegasus, a favourite theme of Redon's. Various religious and related subjects
are in this way brought together in *Dreams* in a deliberately confusing manner, so
that they combine together to suggest an affirmation of values that are mystic
and idealist without being attached to any definite context.

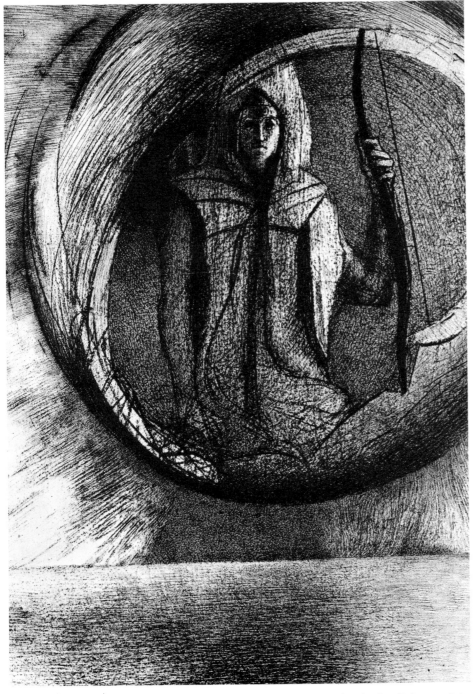

72
'And yonder the astral idol, the apotheosis', *Dreams* 1891, lithograph, 27.7 x 19.2 cm. 11 x 7½ in British Museum, London

In about 1895, Redon seems to have undergone some kind of religious crisis. Documentation of it is limited to a few vague indications in the artist's correspondence, but as Roseline Bacou has pointed out, it too seems to have had a generally mystic quality rather than a specific Christian emphasis. 'It is not a

question for Redon of adhering to a dogma,' writes Mlle Bacou, 'but of the consequences of a mystic experience.'[7] He was not to follow Huysmans in conversion to Catholicism, and his many works representing Christ are not intended to be explicitly Christian any more than those showing Buddha are Buddhist. Both, rather, provide images that are strongly but indefinitely spiritual, and comparable with other deities and mythological figures who occur in the 1896 *Temptation of Saint Anthony* and elsewhere. Such an attitude was not unusual in the 1890s. His contacts with the Nabis, the Rose + Croix and Schuré would have made Redon well aware of theosophical ideas and interests. Christ had become a highly popular subject in art and literature, being associated with a very wide spectrum of themes. And Redon's familiarity with Eastern gods and legends was far from being dependent on Flaubert's depiction of them. In his early life in Bordeaux, Clavaud had introduced him to ancient Indian texts at a time when translations of them were still something of a novelty.[8] Over the years this influence on French intellectual life continued to make its impression on him in various guises, and Redon later used such subject matter in a way that owes nothing to Flaubert. The large pastel *Buddha* of 1905 (Colour Plate 5) uses a very different visual model for Buddha from the Flaubert lithographs; it is more closely related to the tree motif that had already been characteristic of Redon for so long. The same is true of a representation of Buddha (Plate 73) seated in profile under a tree surrounded by a gloriously lyrical profusion of flowers.

Dreams and *The Temptation of Saint Anthony*, then, with their broad and unparticularized use of diverse religious and mythological sources, occur at a particularly crucial moment in the evolution of Redon's attitudes towards his subject matter. Although these treatments of such themes also look back to *The Fallen Angel* (Plate 7) and beyond, and forward to later pictures of Christ, Orpheus (Colour Plate 13) or Buddha, Redon's interpretation of religious subjects in the 1890s betrays more than a passing interest in contemporary attempts to bring world religions and mythologies together in some kind of synthesis. In August 1895 Redon wrote on a related topic in a letter to his friend Bonger:

> I believe that [art] will make the supreme contribution to science. It will bring about the awaited and glorious fusion between what belongs to the Christian heritage and what will stem from our modern truths. It is impossible to think otherwise when one understands what is beautiful and when one thinks according to the times.[9]

Schuré advocated a fusion of religion and science too, and believed that it would come about only 'through a new synthetic contemplation of the visible and invisible world, by means of intellectual Intuition and psychic Clairvoyance'.[10] The art of Redon was not explicitly scientific or even theosophical, but it was using a synthesis of varied religious and quasi-religious subjects that reflects the most up-to-date contemporary tendencies in that sphere.

The album entitled *The Apocalypse of Saint John* might appear to differ from *Dreams* and *The Temptation of Saint Anthony* in that its subject is purely Biblical rather than a synthesis of diverse religious elements. It does, however, resemble *The Temptation of Saint Anthony* in many respects. The similarity is a matter not only of individual lithographs such as 'And the devil that deceived them . . .' (Plate 75), in which the head of the devil recalls the Flaubert lithograph 'What is

73 *Opposite*
Buddha c. 1905, tempera screen, 161.5 x 122.5cm. 63$\frac{5}{8}$ x 48$\frac{1}{4}$ in. Bonger Collection, Almen

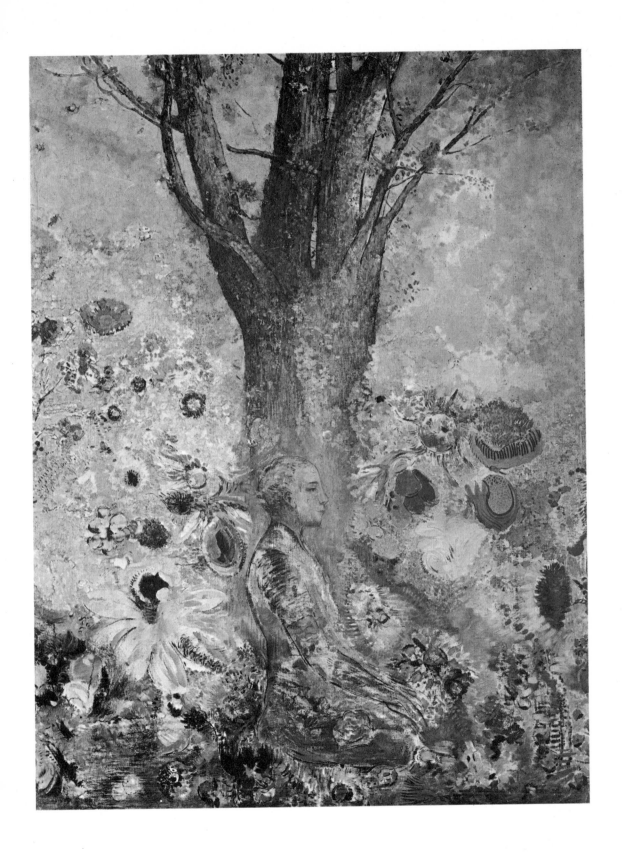

75
'And the devil that deceived them was cast into the lake of fire and brimstone, where the beast and the false prophet are', *The Apocalypse of Saint John* 1899, lithograph, 27.4 x 23.8cm. 10¾ x 9⅜ in. British Museum, London

the object of all this?' (Plate 69), but also of the overall conception of the work. At the centre of both albums is the figure of a saint who is also a visionary. This theme of the solitary visionary was not new in Redon's work, and had not been even at the time of the first Flaubert album. Already in 1885, *Homage to Goya* had represented the hallucinations of a kind of seer. The Saint Anthony albums had developed the theme. It occurs too in various other forms in the 1890s: Redon's representations of Saint Theresa, the Druid priestess, and so on. In *The Apocalypse of Saint John,* the visionary powers of Saint John the Divine are given special prominence, and the album ends with an interpretation of the text 'And I, John, saw these things, and heard them' (Plate 77). Just as the 1896 album opens with a portrayal of the head of Saint Anthony with the caption 'Help me, my God!' (Plate 76), so this lithograph closes the 1899 album, the saint figure in each

74 *Opposite*
Head of Christ c. 1895, charcoal, 51.5 x 37.4cm. 20¼ x 14¾ in. British Museum, London

76
'Saint Anthony: Help me, my God!',
The Temptation of Saint Anthony
1896, lithograph, 21.5 x 13cm.
8½ x 5⅛ in. British Museum, London

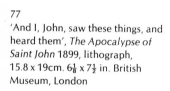

77
'And I, John, saw these things, and
heard them', *The Apocalypse of
Saint John* 1899, lithograph,
15.8 x 19cm. 6⅛ x 7½ in. British
Museum, London

case giving unity to the series of visions. The various motifs are presented in a
single, albeit loosely defined, perspective, so that the religious imagery is given
remarkable cohesion and the albums emerge as truly personal works of art that
affirm the visionary powers of the individual.

Even Redon's choice of motifs for *The Apocalypse* resembles the Flaubert
albums to a point. The Biblical text offered Redon evocative descriptions and
visual details that he exploited as he had done those of *La Tentation de Saint
Antoine*. An important difference, however, is that the Apocalypse lithographs
bear the influence of the woodcuts on that theme by Albrecht Dürer, an artist
greatly admired by Redon. Most of the texts he interprets were also used by

114

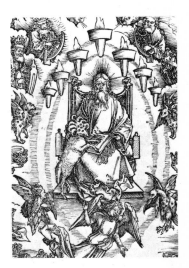

Dürer, or are taken from the same episodes. He does not attempt to match
Dürer's complexity of subject matter, but he does seem to select details from the
woodcuts as motifs for his own plates. For example, the lithograph that shows the
figure on a throne holding the book sealed with seven seals (Plate 78) is a
simplified version of part of Dürer's *Saint John and the Twenty-four Elders in
Heaven* (Plate 79). Redon has retained the rainbow and other details from the
Dürer and adapted them to his style. Quite apart from its similarity to the
Flaubert albums, therefore, *The Apocalypse of Saint John* is a tribute to an artist
whom Redon respected profoundly.

Even Albrecht Dürer, then, forms part of the religious world of the last 'noirs' in

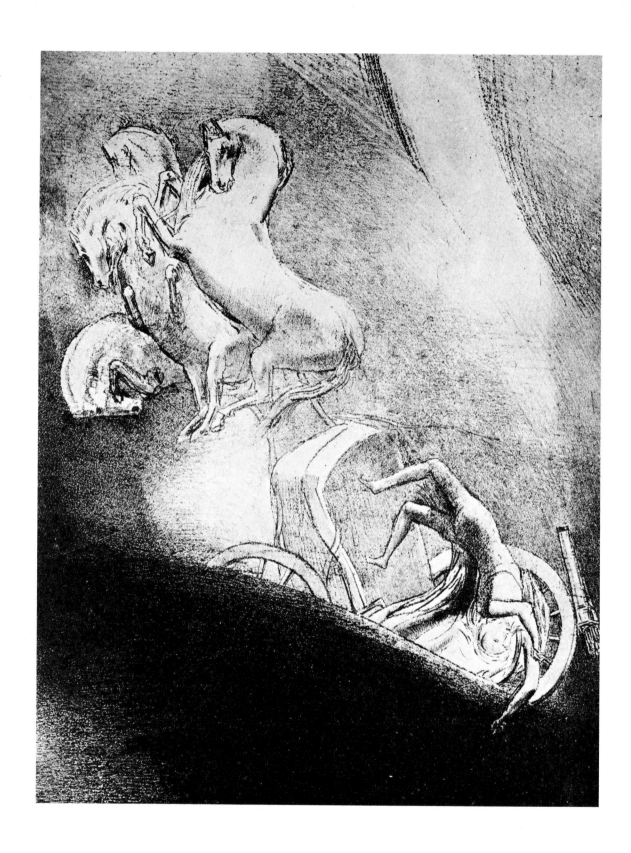

the imagery of this final series of lithographs. Redon's sources for his late albums were complex indeed, ranging from Dürer to Flaubert and from the Bible to Eastern religions. Yet his techniques and methods ruled out any possibility of unwelcome eclecticism. In simplifying and unifying the material he had encountered, by means of a pictorial synthesis of varied motifs, or the relating of a wide range of subjects to the experience of a solitary visionary, or more broadly by the general assertion of a personal tone of serenity, Redon demonstrated not only his awareness of theosophical and allied currents but also his skill in reconciling them with his own preoccupations and style.

The technical quality of these late albums also contributed enormously to this successful blending of varied sources. In addition to the intense richness of their textures and tonal gradations, these lithographs tended to become increasingly free in their conception and also, at times, more linear than earlier works by Redon. Not only does the sphere of 'And yonder the astral idol, the apotheosis' (Plate 72) occupy the picture space more imaginatively than some earlier comparable works, such as 'Blossoming' from In Dream (Plate 18), but other qualities of movement or the forceful arrangement of imagery, that had always been present in Redon's works, now flourish. 'He falls into the abyss, head downwards' of 1896 (Plate 80) or the depiction of the devil from The Apocalypse (Plate 75) are two examples among many of Redon's striking and confident handling of his subject matter. Similarly successful is 'The beasts of the sea . . .' or 'Then I saw in the right hand of him that sat on the throne . . .' (Plates 68 and 78), where Redon's use of line reaches an almost sketch-like freedom.

Redon's charcoal drawings of the time bear out his achievements as a draughtsman in the 1890s. Figure in Armour of 1891 (Plate 53) is less striking in its composition, for all the strangeness of its conception and the power of its textures, than the broader and more varied Profile of a Woman with Flowers (Plate 37). And this work in turn cannot match the startlingly free arrangement of subject matter and arabesque that we encounter in the later Chimera of 1902 (Plate 81). In this work, one of the latest and finest of the 'noirs', the motif of closed eyes is surrounded by a wonderfully suggestive play of tone and line. Such experimental and assertive virtuosity broke new ground in Redon's development. A similar freshness of approach is to be found in the last lithographs he made, the series of portraits of friends carried out after 1900. The portrait of Pierre Bonnard of 1902 (Plate 82) is typically delicate and sensitive in its touch, and demonstrates a further aspect of the change that had occurred in Redon's style since the 'noirs' of the 1870s and 1880s.

Vollard, Mallarmé and Flaubert

It was Ambroise Vollard who published The Apocalypse of Saint John, as well as being concerned in the production of the third Flaubert album. In the 1890s the patronage of Vollard was as precious to Redon as that of Deman had been in Belgium some ten years earlier. Later, Vollard was to collaborate with Redon by enlisting his aid over a projected edition of Flaubert's La Tentation de Saint Antoine that would contain the 1896 plates as well as some other contributions by Redon. This was eventually published only in 1938. Vollard's memoirs, Souvenirs d'un marchand de tableaux, record vividly his impressions of Redon the man as well as relating some details of joint projects such as this one. In Maurice

80 Opposite
'He falls into the abyss, head downwards', The Temptation of Saint Anthony 1896, lithograph, 27.8 x 21.2 cm. 11 x 8¾ in. British Museum, London

82
Portrait of Bonnard 1902, lithograph,
14.5 x 12.3cm. $5\frac{3}{4}$ x $4\frac{7}{8}$ in. British
Museum, London

Denis's painting *Homage to Cézanne* (Plate 54) Vollard in fact, like the Nabis, is
present at the gathering round Redon and the Cézanne still life. Indeed, the scene
of the group portrait is apparently Vollard's shop in the rue Lafitte. Such glimpses
of their encounters suggest that Vollard and Redon enjoyed a fruitful friendship,
and this is confirmed by some other activities of Redon's in the late 1890s.

Although Vollard was initially a highly successful picture dealer, he quickly
became interested in the publication of prints. He enthusiastically commissioned
lithograph albums from Bonnard, Maurice Denis, Fantin-Latour and others, as
well as instigating Redon's *The Apocalypse of Saint John.* Lithography was at the
time undergoing something of a renaissance. A means of expression that had in
recent years been used only by a minority of artists, including Redon, was being
turned to more and more widely. In 1889 the Société des Peintres-Graveurs had
been founded by Bracquemond and Guérard, giving impetus to an upsurge of
activity in engraving that included the brilliant emergence of colour lithography.
Chéret, Toulouse-Lautrec, Renoir, Vuillard, Bonnard and other artists all made

81 *Opposite*
Chimera 1902, charcoal,
54.5 x 39cm. $21\frac{1}{2}$ x $15\frac{3}{8}$ in. Musée
National du Louvre, Paris

119

83
Illustration of Mallarmé's *Un Coup
de dés jamais n'abolira le hasard*
1898, lithograph, 12 x 7cm. 4¾ x 2¾ in
British Museum, London

striking contributions to this vogue. Vollard's role in it included the production of
two large portfolios containing miscellaneous prints, by a variety of artists,
entitled *Les Albums de peintres-graveurs*. Redon contributed to each of these,
which appeared in 1896 and 1897, and made for the second of them one of only
two colour lithographs he ever made: *Beatrice,* a highly successful work that
bears comparison with the finest contemporary achievements in the medium.

Redon and Vollard also collaborated a year or two later over a less successful
but no less interesting project. In addition to exhibiting at Vollard's gallery in
1898 and 1901, Redon became involved at this time in the area of activity to
which Vollard turned after his early successes in the sphere of prints: the
production of illustrated books. Unfortunately, his judgement in this field did not
at first altogether match his understanding of contemporary painting. Selecting
the work of a key writer of Symbolism, Mallarmé, he conceived two projects. One
was that Vuillard should illustrate *Hérodiade;* the other that Redon should
interpret Mallarmé's late and exceedingly difficult poem, *Un Coup de dés jamais
n'abolira le hasard (A Throw of the Dice Never Will Abolish Chance).* Neither was
truly practicable, although, to do justice to Vollard, he fully compensated for this
error by his commission to Bonnard to illustrate Verlaine.[11] Vuillard apparently
never embarked upon his task, but Redon did produce four lithographs, although
one stone was lost on the way to the printers, so that only three have survived.
Mallarmé, Redon and Vollard had discussed the form the illustrated book should
take from the summer of 1897 onwards. The poet was insistent that the
lithographs should be in harmonious contrast with the inventive typography of
his work,[12] and Redon too was aware of the potential of relating his plates to the
original appearance of *Un Coup de dés,* whose hermetic phrases are arranged on
the page in visually significant patterns. But these considerations were peripheral
compared to the problem of finding motifs. Some of Mallarmé's vocabulary is
superficially related to Redon's preoccupations, but there is no descriptive
imagery that lends itself naturally to visual representation. Redon interpreted
details of the text such as the words 'ombre puérile', present in one lithograph as
a boy's head (Plate 83), but the result as a whole is disappointing. Such details
lacked any true similarity to Redon's style, so that the prospect of collaboration
between Mallarmé and Redon, two of the most outstanding figures in French
Symbolism, met with failure.

The fiasco of the *Coup de dés* project, however, did bring to a head a central
problem of many of Redon's lithographs, and that problem was their relationship
with a literary source. The failure of Vollard's commission poses not only the
question of why in itself it was not a success, but also why the *Juror* album, the
frontispieces and some other albums were so successful. It brings us back, above
all, to the superb quality of the FlauberÜ albums and the light they shed on
Redon's creativity.

Redon had in fact borrowed from Flaubert well before the first Flaubert album,
but without acknowledging his debt. The lonely and melancholic figure that
appears in both *Homage to Goya* (Plate 30) and *Night* (Plate 32) already
corresponds to the words of Flaubert's gymnosophist, used as a caption in 1896: 'I
plunged into solitude. I lived in the tree behind me' (Plate 84). In *Night* the
Chimera makes an appearance, but again there is no explicit reference to
Flaubert (Plate 33). This reluctance on Redon's part to reveal his sources was due

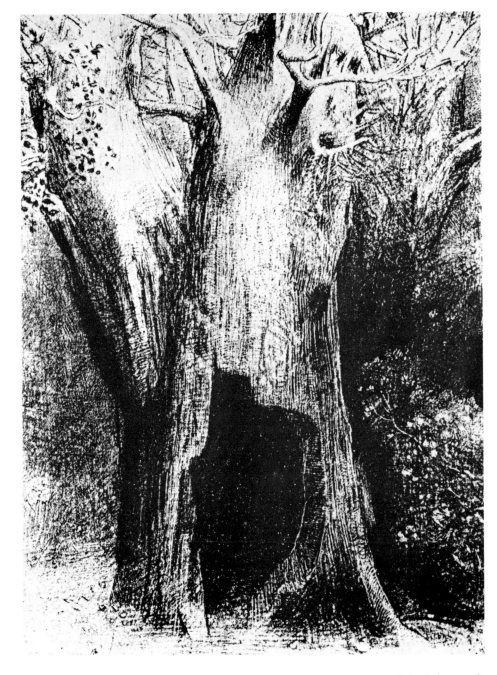

84
'I plunged into solitude. I lived in the tree behind me', *The Temptation of Saint Anthony* 1896, lithograph, 30 x 22.5cm. 11⅞ x 8⅞ in. British Museum, London

to the fact that he had not yet arrived at the original conception of the lithograph album that is first evident in *The Juror*. In that and subsequent albums, with the exception of *Dreams,* he created lithographs that were related to a literary caption but in a way that differs from literal illustration. In 1898 Redon was to try to describe this creative process. 'The term has yet to be found,' he wrote: 'I only see those of transmission, interpretation, and still they are not precise enough to

121

85
'The Old Woman: What do you fear? A broad black hole! It is perhaps empty?', *The Temptation of Saint Anthony* 1896, lithograph, 16.2 x 10.8cm. 6⅜ x 4¼ in. British Museum, London

86 *Opposite*
'She takes from her bosom a sponge that is quite black, and covers it with kisses', *The Temptation of Saint Anthony* 1896, lithograph, 19.3 x 15.3cm. 7⅝ x 6 in. British Museum, London

describe totally the result of some of my reading passing into my organized 'noirs'.[13] The literary source is transformed by a process of visual creation and invention. Much later, in 1910, Redon repeated his view to Claude Roger-Marx when refusing to undertake some illustrations, claiming that he could never be said to have illustrated a text, and insisting: 'I have simply proposed interpretations.'[14] It is in fact a characteristic of Redon's interpretations that they create a novel relationship between visual image and written word, and this is emphatically a strength rather than a weakness. Synthesis in the arts was an issue of the day, and Redon practised it in an original artistic style that blended with literature without being 'literary' in the pejorative sense.

Two features of the Flaubert albums might seem to contradict Redon's claim that this kind of art was the invention of a visual counterpart to his source as opposed to a simple representation of the literary. In the first place, the captions, like those of the other albums, are an integral part of Redon's means of expression, raising the problem of the presence in the work of an actual literary element. Besides giving continuity to the plates, their language complements the visual images. The words of Death in *To Gustave Flaubert* — 'My irony surpasses all others!' (Plate 62) — add a nebulous meaning that is not inherent in the lithograph. Elsewhere, the very vocabulary contributes to the effect: for example, emotive words such as 'effroyables', or indications of colours such as the green of the Chimera's eyes and sounds such as that of its barking (Plate 49). Yet it is precisely this element of discrepancy between text and image that heightens the suggestive aura they together create, rather than limiting their effectiveness. Text and image in no way explain each other, as in conventional illustration, and the result is an evocative tension between the two. This technique was already present in the captions of *To Edgar Poe* and was simply developed with time.

A second and more problematic feature is that a close knowledge of Flaubert's text is apparently indispensable for the lithographs to have their full effect. Take for example the lithograph from the third series (Plate 85) in which an old woman asks, 'What do you fear? A broad black hole! It is perhaps empty?' There is nothing in the album to indicate that the woman is about to reveal herself as Death, although this adds significantly to the force of her words and to the effect of the picture as a whole. Similarly, the black sponge held by a figur in another 1896 lithograph (Plate 86) only becomes fully suggestive when reference to a passage in the Flaubert, not represented by Redon, reveals that it is soaked with the blood of a handsome young martyr. Evidently, intimate knowledge of the Flaubert enhances the spectator's appreciation of the lithographs. What Mellerio astutely called the 'parallélisme corrélatif'[15] between Redon's literary sources and his lithographs seems to have become more a convergence than a true parallelism, and the original artistic creations that Redon described as 'the result of some of my reading passing into my organized 'noirs'' may seem consequently to be compromised by literary considerations. Prior knowledge of the Flaubert on the part of the spectator is not altogether necessary in viewing the lithographs but it is evidently helpful. Yet it was just such knowledge that Redon could safely assume to exist among his audience at the time he made the Flaubert albums. *La Tentation de Saint Antoine* was well familiar to the Symbolists and enjoyed a real vogue in the 1880s and 1890s. Furthermore, Redon's own use of this source had originated in Decadent literary milieux and had evolved through his contact with

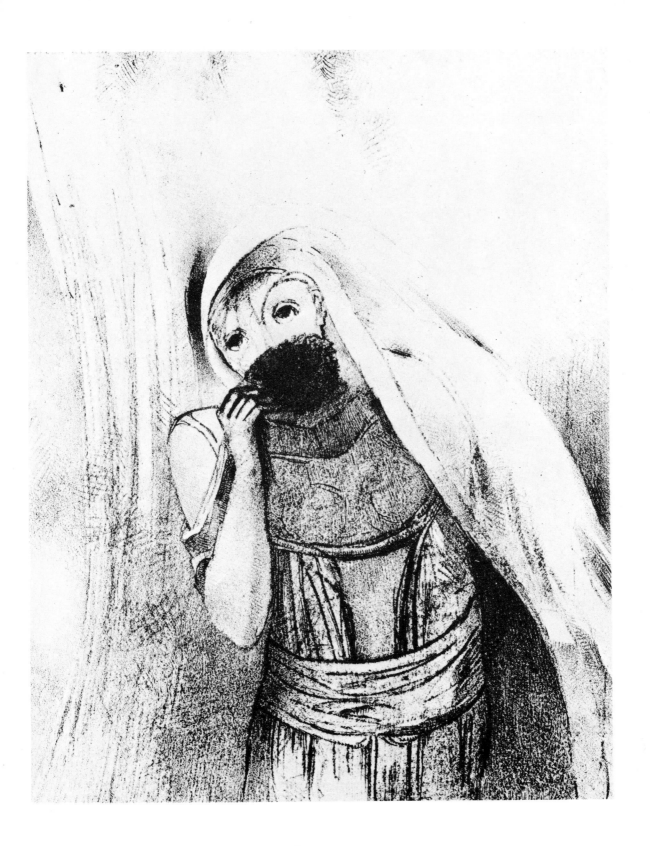

123

the Symbolists. The subtle relationship between text and image that he developed was in part a response to this particular feature of artistic taste and intellectual fashion that was much in evidence then but has gone today. For this reason, the later transformations of motifs from *The Temptation* into colour fantasies such as *Red Sphinx* or *Oannes* (Colour Plate 4 and Plate 65) appeal more directly to modern taste than their lithographic predecessors. The passage of time has tended to obscure the suggestive and original relationship between caption and image that is in fact typical of the Flaubert albums. By referring to the fashions and assumptions of the Symbolists, however, we can see that Mellerio's 'parallélisme corrélatif' is a fair description. Although the parallelism proved to be impossible in the case of Mallarmé's *Un Coup de dés* (because there was no real common ground between the poem and Redon's own characteristic use of imagery), in *La Tentation de Saint Antoine* on the other hand it is triumphantly effective.

The end of the 'noirs'

The project of illustrating *Un Coup de dés* was not only doomed to failure by its very nature but was also cut short before its completion by the death of Mallarmé in September 1898. It was never revived, and the plan of the poet's daughter Geneviève to promote a posthumous illustrated edition of his poetry also came to nothing.[16] Redon's close and lasting friendship with Mallarmé had failed to produce any true collaboration, although by finally drawing black on a white ground in the three lithographs, contrary to the poet's original wishes, Redon had given some hint of the technique by which Matisse would later successfully illustrate his work. Redon referred to Mallarmé as 'an ally in art',[17] and the term is accurate, for whereas mutual admiration allied them, they were also independent of one another. When they first met they were both already mature artists, and no mutual influence took place.

The death of Mallarmé was also a part of the more general disappearance of the conditions that Redon had known in the 1880s. Hennequin had been dead for some years. Huysmans was estranged from Redon, and even denied in conversation with Gustave Coquiot that he had ever really supported his art. 'I did not fall into the net' he insisted; 'but it was so amusing to speak of a man who deforms things as if he had a glass sphere full of water in his eye.'[18] In Belgium, active interest in his work had faded. The journalistic discussion of his art that had flourished in Paris, especially around 1894, had virtually ceased. When Emile Bernard proposed writing an article on him in 1899, Redon welcomed it as 'a break in the unanimous silence that reigns in writers' circles, where there is scarcely any concern with my case any more'.[19] Many of the circumstances that had served to integrate him with Symbolist 'milieux' were gone, just as Symbolism itself was waning.

Not that all Redon's contacts with avant-garde circles died away; Vollard and the Nabis remained positive elements in his career, and the painting *Homage to Cézanne* in which they figure was bought in 1901 by another prominent friend, André Gide. Gide is an example of a member of Mallarmé's 'mardis' who continued to be Redon's enthusiastic supporter for several years. Not only did he and Redon have friends in common, such as Maurice Denis, but the two men were repeatedly intrigued by the presence of common preoccupations in each other's work. Exactly when they met is not known, but in 1893 Gide sent Redon his

new book *Le Voyage d'Urien,* and the following year Gide lent a Redon charcoal drawing which he owned, *Wreathed Head,* for display at the Durand-Ruel exhibition. Gide explained in a letter to Redon the importance to him of this drawing: 'It is the only picture I have in the room where I work; other ones would disturb me; but this one . . . I need in order to work.'[20] This remark is directly relevant to the Symbolist *Voyage d'Urien,* which includes descriptions of indefinite floating forms, of sinister mysteries, and of other Redon-like imagery, such as swamps. No influence of particular 'noirs' by Redon is obvious, but *Le Voyage d'Urien* and the world of *Wreathed Head* are in real harmony with each other, as Gide realized. Before long, Gide became emancipated from this Symbolist imagery, turning to joyful and lyrical contemplation of nature in *Les Nourritures terrestres,* just as Redon was undergoing a parallel evolution in turning to colour and a greater emphasis on natural forms. On 3 May 1904, Gide noted in his diary: 'Over the two years I have known it, I have not stopped investigating the inexhaustible remark of Odilon Redon's, that aphoristic, axiomatic remark that he offers the young by way of advice, that maxim upon which his whole aesthetic seems to depend: "Enclose yourself with nature."'[21] Gide was no doubt fascinated by the fusion of observation of nature and self-expression implied in Redon's formula. Once again, the aspirations of Redon and Gide echoed one another. With time, however, the two men came to have less overlapping in their creative styles, and their continuing contacts came as a result of having friends in common rather than ideas to exchange. Nonetheless, the friendship of Redon and Gide was one of lasting mutual admiration and understanding, as is shown by their correspondence, a happy consequence of Redon's links with the young generation of Symbolists.

This feature of Redon's links with Gide, whereby the changes in his style encouraged rather than destroyed the sympathy existing between the two men, was somewhat the exception to the rule. On the whole, critical discussion and support of the 'noirs' was disappearing as the 'noirs' themselves disappeared, without any great deal of more up-to-date critical reaction taking their place. And the rare instances when the reputation of the 'noirs' was actually revived were not sufficient to disturb the general silence about his work of which Redon was complaining. Such revivals did, however, exist: for instance, in the first few years of the century the 'noirs' were once again associated with a progressive doctrine by a theorist of Symbolism, this time by Redon's friend and patron Adrien Mithouard.

Professionally a leading member of the Conseil Municipal de Paris, Mithouard was also a poet and man of letters who is chiefly remembered today as a founder of the influential review *L'Occident.* In this journal and in his prose works, he expounded a theory of the arts which amounts, broadly speaking, to a Christian interpretation of the importance of Symbolism and a fervent defence of the Western tradition as the culmination of all art, religion and philosophy. Like Charles Morice and other predecessors among the theorists of Symbolism, Mithouard explained such views with reference to many artists, including Redon. In his book *Le Tourment de l'unité* of 1901, he praised Redon as an example of what he saw as the striking simplification of style and means of expression achieved by some Symbolists. This simplification corresponded in Mithouard's mind to a mysterious synthesis of the material phenomena elsewhere defined by science, that resolved the secrets of the universe into a clarifying unity, a kind of

divine truth. In 1902, Mithouard's enthusiasm for Redon, already clear from the fact that he had commissioned a picture from him two years before, was stimulated further when he belatedly saw *The Apocalypse of Saint John*. The Christian in him was naturally delighted to discover such an interpretation of a Biblical subject.[22] Selecting for special attention the lithograph 'And there fell a great star from heaven . . .' (Plate 87), in which a mass of light is shown falling from among strange insects, he gave the album an important place in an essay, 'Le Blanc et le noir', which appeared in his book *Le Traité de l'Occident* of 1904 and which surveys art in black and white from the French tradition. In this essay he acclaims Redon's lithographs as a marvellous contemporary example of this western Christian tradition. He realizes that 'And there fell a great star from heaven . . .' is fundamentally ambiguous, but equates it with 'the elemental horror', a cosmic significance that echoes his own beliefs.

Redon does not in fact occupy any central position in Mithouard's writings. A number of artists are praised by him in similar terms, such as Gauguin and Maurice Denis. Nor was the form of this praise wholly appropriate, for Redon was neither specifically western nor Christian in his aims. But Mithouard's enthusiasm for *The Apocalypse* was not simply a personal and idiosyncratic interpretation. His Christian views contributed to the growing interest of Catholics in Redon's work. Catholics were among Redon's most consistent and sympathetic supporters of his later years, and especially at about the turn of the century. Mithouard's attitude is comparable to an extent with that of Emile Bernard or Maurice Denis, and to an even greater degree with that of Gabriel Frizeau, the Catholic patron whose close friends included not only Redon but also Paul Claudel.

Adrien Mithouard also contributed to Redon's reputation by publishing in his review *L'Occident* occasional reviews and articles that concerned the artist both directly and indirectly. Outstanding among these for its exclamatory and emotive praise was the article that Emile Bernard had promised Redon in 1899 and that finally appeared in *L'Occident* in May 1904. Unfortunately, Bernard's absence from France had not allowed him to keep abreast of the changes taking place in Redon's style, and his remarks rather anachronistically reproduce some of the passions and misunderstandings that had developed around Redon's work ten or even twenty years before. On the other hand, we are fortunate in that Redon recorded his disagreement with these aspects of Bernard's article in annotations that have since been published. Redon's replies to Bernard are brief and to the point. Where Bernard refers to him as 'this black soul', Redon answers that he is nothing of the kind: 'My soul is not black, for I glorify life which makes me love the sun, the flowers, and all the splendours of the external world.'[23] This insistence that his art stems from his love of the objective world, not from a melancholic subjectivity, extends also to questions of the supernatural: 'The supernatural,' he claims, 'does not inspire me. I simply contemplate the external world, and life.'[24] Where Bernard associates his drawings with the invisible and mysterious, Redon protests that 'My drawing stems from the visible. It gives form to immaterial beings by creating them according to the logic of the material.'[25] Throughout these annotations, Redon rejects the notion that his work is nightmarish or spiritualist, pointing out that down-to-earth observation of the natural world is the basis of his creativity. This feature of his work indeed stretches back through the whole of his career as an artist, but these annotations do tend to reflect

87
'And there fell a great star from
heaven, burning as it were a lamp',
The Apocalypse of Saint John 1899,
lithograph, 30.3 x 23.3cm. $11\frac{7}{8}$ x $9\frac{1}{8}$ in.
British Museum, London

Redon's position in 1904 rather than giving an overall view of his development over the years. They stress those elements in his art that came to the fore during the late colour period, such as the lyrical transformation of natural forms, and minimize those that had faded into the background, such as the suggestions of dream experience or the use of captions in lithographs. As well as being an effective riposte to Bernard's preconceptions, Redon's annotations constitute a personal *prise de position* belonging to the period after the disappearance of the 'noirs'.

The way in which Redon was reflecting on his own aims and the nature of his

127

style as the 'noirs' came to an end also emerges clearly from three absorbing letters that Redon wrote to André Mellerio in July, August and October 1898. Mellerio was already working on the catalogue of Redon's lithographs and etchings that would be published fifteen years later. The three letters are replies to his requests to Redon for information about his art. The first of the letters describes Redon's adoption of the lithograph album both as a means of expression and as a way of distributing his works more widely. It illuminates, among other issues, his attitude towards the notion of illustration, his reservations about the use of captions, and also his distrust of any analysis of the creative process. He insists that to speculate about the intricacies and implications of what were or were not his aims is irrelevant. More important, he considers, is the reaction the materials themselves provoke in the spectator:

> I should like to convince you that the whole thing is only a little oily black liquid, transmitted by the crayon and the stone onto a sheet of white paper, with the sole purpose of producing in the spectator a sort of diffuse and dominating attraction towards the obscure world of the *indeterminate*. And leading to thoughtfulness.[26]

In the second letter he returns to a similar point in trying to shed some light for Mellerio on his actual creative act as an artist. The materials he is using, he insists, have a fundamental influence on the kind of work he produces: 'A really sensitive artist does not invent the same creation with different materials, because he is differently impressed by them.'[27] Apart from this declaration and also his hint that the subconscious plays a certain role, Redon deliberately leaves a mystery around the subject of his working methods, turning for the rest of the letter to the more practical aspects of lithography. The third letter replies to Mellerios's request for information about his life and circumstances, to be included in the catalogue. Redon simply tells Mellerio that he has already started to set all this down in writings that are too lengthy for a letter. These writings were, in fact, an early version of 'Confidences d'artiste', the first and most remarkable section of Redon's posthumous book, *A soi-même*. After the publication of a similar but shorter piece in a review in 1894, the 'Lettre à Edmond Picard', to which he draws Mellerio's attention, Redon was setting about recording his early life and his preoccupations as an artist in an extended piece of skilfully suggestive prose. These three letters, written some six years before the annotations to Bernard's article, reveal that Redon was already in the late 1890s reviewing his position as an artist at a time when important changes were affecting it.

An event of 1897 had also contributed to Redon's awareness of a break with aspects of his past and the beginning of a new phase in his activities. This was the loss of the family estate in the Médoc, Peyrelebade, that had over the years been a constant stimulus to his work, the source of many of the 'noirs'. Its sale had been made necessary by family financial problems and quarrels that were distressing to Redon. Although he was able to maintain his contacts with the region, and in fact stayed at Peyrelebade in the summer of 1898 thanks to the generosity of its new owner, his letters of the time showed that he viewed this moment not only with optimism, as he worked increasingly with pastels and oils, but also with a certain regret over the passing of an era. Peyrelebade had, for an even longer time

than the 'cénacles' of Symbolism, been a substantial feature of his life and work. Its loss marked the end of the context to which many 'noirs' owed their genesis, and the moment of its disappearance from Redon's circumstances emphasized the way in which the 'noirs' were being replaced in his life by new concerns. In the slow development that led Redon from pessimism to optimism and from the 'noirs' to colour, the years 1897-98 in fact stand out as something of a watershed, the time when the 'noirs' finally seemed to be giving way to a new lyricism. In 1901 Redon asked rhetorically in a letter to Bonger in which he was describing the new decorative colour pictures he was working on: 'Where are the 'noirs' now?'[28] The 'noirs' already belonged to the past.

Colour

In 1913, before the tranquility of the end of his life was disturbed by the outbreak of war, Redon was able to look back over a period of joyfulness that had reigned in his art since the disappearance of his earlier pessimism and sadness:

> By ceaselessly making myself more objective, I have since learned, with my eyes more widely open to all things, that the life we unfold can also reveal joy. If the art of an artist is the song of his life, a solemn or sad melody, I must have sounded the key-note of gaiety in colour.[1]

The 'noirs' by this time had been replaced by the extraordinary colour works whose quantity as well as quality provided a wonderful conclusion to the experiments and developments of his artistic career. Redon had in fact been using colour right from the beginning. Skilful copies, such as that of a Delacroix lion hunt (Plate 88), and small landscape studies of the Breton coast or of Peyrelebade all crop up regularly throughout the course of his earlier life. But these works were predominantly of a private nature, remaining in the artist's collection without being exhibited. The more ambitious colour works, known to the public, were those that had come to the fore during the 1890s as Redon explored the potential of pastels and oils. In retrospect, they are an extension of his achievements in charcoal and lithography, since this contemporary of the Impressionists had come to colour via his understanding of black and white media. He had already shown in the 'noirs' what Sérusier called 'his love of light and shade',[2] and his gifts as a colourist had evolved through his handling of gradations of black and white tone values. In the final years of his life these gifts flourished as he turned to new techniques and new media, one of which was watercolour (see Colour Plate 12).

Redon's statement that a new objectivity accompanied this development towards colour does not mean that he ceased suddenly to be a subjective and visionary artist. He was never a literal imitator of the outside world like those artists he had so roundly condemned in his article on the 1868 Salon. His art remained essentially personal and, in his own term, 'poetic.' He did not even now set out to represent directly a visual perception or objective observation, but continued rather to depict the imaginary or visionary counterpart to his experiences. But these initial experiences had become less introspective and more joyfully attached to the objective forms around him, so that, although in fact he still often used some of the imagery of the 'noirs', the tone of his works affirmed a new spirit of optimism. There was a certain continuity in the themes and subjects to which he turned. The luxuriant pastel *Orpheus* of 1903 (Colour Plate 13) is the direct successor of *Head of Orpheus Floating on the Waters,* just as *The Winged Man* (Plate 89) recalls a drawing such as *The Fallen Angel,* and *Pegasus Triumphant* (Colour Plate 18), in which Pegasus has ceased to be captive or unable to fly, harks back to Redon's frequent earlier use of the Pegasus theme.

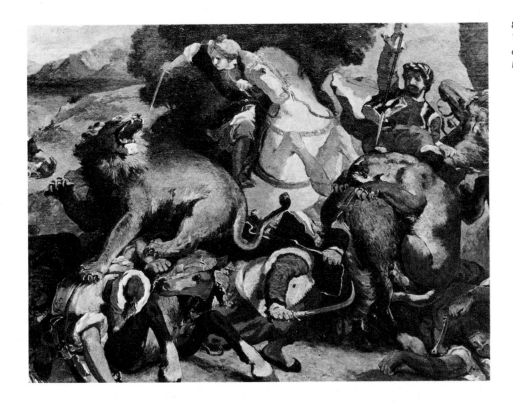

88
The Lion Hunt, after Delacroix
c. 1870, oil 46 x 55cm. 18⅛ x 21⅝ in.
Musée des Beaux-Arts, Bordeaux

89
The Winged Man c. 1890-5, oil,
33.5 x 24cm. 13¼ x 9½ in. Musée des
Beaux-Arts, Bordeaux

90
Cyclops 1898-1900, oil on panel,
64 x 51cm. 25¼ x 20⅛ in. Rijksmuseum
Kröller-Müller, Otterlo

But this resemblance between 'noirs' and colour works is accompanied by a change in the very substance of the pictures. The new realm of joyfulness underlying his creativity and his brilliantly inventive investigation of the properties of colour brought to old themes a new kind of expressiveness.

In works that are close to the imitation of objective forms, Redon's methods result in suggestions of a personal lyricism rather than the reproduction of his perceptions. His flower pictures, in which bouquets of magnificent and even imaginary blooms appear in profusely intense patterns, transmit Redon's experience of flowers rather than the literal appearance of the blooms themselves. Pastels and oils transform the subject he is treating into

arrangements of forms and textures that, like the 'noirs', are indefinitely suggestive and provoke a state of thoughtfulness. At times, this use of colour comes to dominate the expressive force of the picture so much that the actual subject becomes almost an irrelevancy. Redon's *Roger and Angelica* of about 1910 (Colour Plate 14), one of his very finest pastels, is a striking case of a work where the subject matter of the title is almost overwhelmed by an extravagantly rich colour fantasy. Yet it would be wrong, even here, to regard the subject as altogether irrelevant. Indeed, this picture resembles certain 'noirs' in that its subject matter calls to mind allied mythological themes, in this case Pegasus, Venus or Pandora, all used by Redon at about this time (see for instance Colour Plates 6 and 9). The legendary subject has not been excluded; it has simply been transformed by the force of colour into a work that is at the same time mythological and lyrically personal. And the same is true of other themes that recur in the colour pictures, such as the Cyclops (Plate 90), Saint Sebastian (Plate 91), the Chariot of Apollo (Plate 92) or the Sacred Heart (Plate 93).

Redon's understanding of the power of colour in transforming subject matter into a particular register of expressiveness made him the natural ally of a group of young painters whose preoccupations were not dissimilar. These men were the Fauves. He much appreciated Matisse and enjoyed a friendship based on strong mutual admiration with Kees van Dongen.[3] For similar reasons, he had no sympathy for what he believed to be the aims of the Cubists. In September 1912 he wrote to Gabriel Frizeau about Cubism:

> If it [Cubism] is passing away and does not contain, I believe, what is lasting, this is because it was born out of discussions and theoretical speculation, instead of coming to life through pure instinct. It was born from too many analyses, in Byzantium.[4]

He views Cubism as an aberration of doctrinaire speculators who have strayed from the kind of painting he would like to see return. 'Oh! a good invasion of savages,' he continues, 'would bring us back to healthy and natural painting. To real painting, such as it will always be. It is a kind of inborn, exquisite, and permissible sensuality; quite distant from formulae.'[5] These 'savages' had perhaps already invaded Paris in the shape of the Fauves, but Redon's thirst for sensuously and instinctively conceived colour pictures was evidently not satisfied. On the contrary, the time of this letter was also that of his murals for Fontfroide abbey, the most brilliant large-scale decorative colour works of his career (Colour Plates 15 and 16). And yet, as we shall see, such colour works are far from belonging to Fauvism, since the subject matter used in them is Redon's own, and contains echoes of the 'noirs'. Their imagery has been transformed by colour but is nonetheless reminiscent of Redon's imaginary world of the 1880s.

When Redon began, therefore, to confront the public at the turn of the century with his colour works, he was offering to them paintings that seemed both extraordinarily up-to-date and also somewhat old-fashioned. There was a degree of contradiction between his modern and even avant-garde use of colour and the fact that his pictures harked back recognizably to the Symbolist imagery that had come to the fore ten, even twenty, years before. He was at the same time an innovator seeking approval for the latest development of his style, and an established figure who was still linked with the black and white pictures on which

91
Saint Sebastian 1910, oil on canvas, 92 x 59.5cms. 36¼ x 23¾ in. Oeffentliche Kunstsammlung, Basel

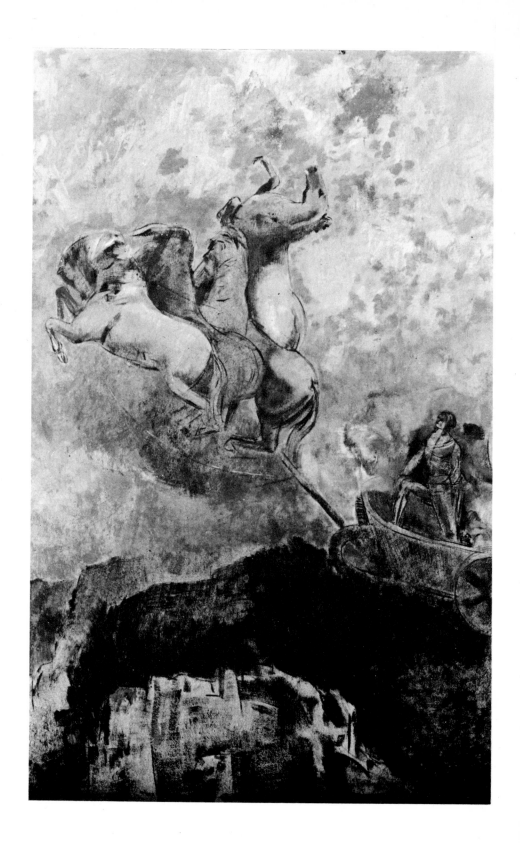

92
The Chariot of Apollo 1909, oil,
100 x 80cm. 39¾ x 31½ in. Musée des
Beaux-Arts, Bordeaux

his reputation had been founded. This was the context of his exhibitions of the turn of the century, of which potentially the most consequential one was the retrospective of his work at the 1904 Salon d'Automne.

The Salon d'Automne

Redon's reputation was already being further consolidated before his appearance at the Salon d'Automne. He had been the object of a kind of homage at the March 1899 Durand-Ruel exhibition, that had aimed to bring together the various tendencies in contemporary art, and where his work had been presented as the achievement of an independent but prestigious leader of modern painting. Collectors had begun to buy his work more freely, and Redon was pleasantly surprised by this popularity. His fame had been enhanced in France and abroad by his participation in the Centennale de l'Art Français at the 1900 Exposition Universelle and by his inclusion in the Vienna Secession Exhibition of 1903. In 1903 also, Redon was made Chevalier de la Légion d'Honneur after his contribution to an exhibition of French art in Indo-China, and in 1904 this recognition by the State culminated in the purchase for the Luxembourg Museum of the painting *Closed Eyes* (Colour Plate 1). The stage seemed set at last for substantial success when the Salon d'Automne of 1904 opened with sixty-four works by Redon on show.

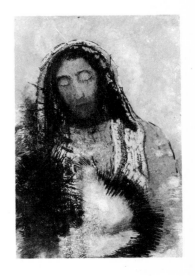

93
The Sacred Heart c. 1895, pastel, 60 x 45cm. 23⅝ x 17¾ in. Musée National du Louvre, Paris

The Salon d'Automne had been founded in 1903. Its president and chief organizer was Frantz Jourdain, who had for many years been the champion of independent, controversial artists like Redon. This new, liberal salon was vigorously opposed by the Establishment Société Nationale des Beaux-Arts and by its president Carolus Duran, but nonetheless, and despite internal divisions, it was an immediate success. With Eugène Carrière as figurehead and Huysmans, Verhaeren and other prominent figures among its supporters, it quickly established itself. The President of the Republic in person opened the second exhibition, which took place, to the dismay of some, in the Grand Palais, usually the domain of less progressive exhibitions. Ironically, however, the triumph of this move from the Petit Palais, where the first exhibition had been held, was in part responsible for what was a disappointing response to Redon's contribution. The intention of these early Salon d'Automne exhibitions was to bring together the works of the new up-and-coming generation and those of their immediate precursors and heroes. In 1903 a small number of pictures by Gauguin were on show, a foretaste of the large Gauguin retrospective in the 1906 exhibition. In 1904, the move to the larger facilities of the Grand Palais enabled the organizers to more than double the number of exhibits in the previous year's exhibition, taking the total to over two thousand, and to include no fewer than six retrospective shows of the work of older artists. Besides Redon, there were rooms devoted to Cézanne, Puvis de Chavannes, Renoir, Toulouse-Lautrec and Legros. In addition, the contributions of some of the younger artists were considerable; Georges Rouault, for example, had over forty works on show. There was therefore a diversity of interest at the salon that detracted from the attention paid to any individual. Redon's sixty-four works were in fact almost drowned among the variety and rich interest of this very large exhibition.

Redon's pictures failed to impress too because of the presence of his 'noirs'. He exhibited not only ten paintings and twenty-one pastels, but also eighteen

94
Homage to Gauguin 1904, oil,
66 x 55cm. 26 x 21⅝ in. Galerie du
Jeu de Paume, Paris

Colour 5 *Opposite*
Buddha c. 1905, pastel, 90 x 73cm.
35⅜ x 28¾ in. Musée National du
Louvre, Paris

lithographs and fifteen drawings. Some critics who reviewed his work once again
relied all too readily on familiar clichés about the 'noirs', rather than accounting
for the new developments in Redon's style. 'Odilon Redon is perhaps a great
Romantic who has strayed amongst us,' one of them wrote. 'Certainly, he is a
close relation of Baudelaire, from whom he takes the best of his inspiration. With
him, literature oppresses painting.'[6] These lines are more relevant to the early
1880s and show no understanding of Redon's achievements at the turn of the
century. Not all critics were so obtuse. One observer who recognized the colour
pictures for what they were was Roger Marx, who praised Redon generously,
saying that 'The walls are adorned, thanks to him, with the sumptuousness of

oriental carpets, with the luxuriant vegetation of an ideal Paradise.'[7] But neither of these reactions was in fact typical of the critical response to this Redon retrospective. Most of the press maintained silent indifference as far as he was concerned, an anti-climax that led Redon to remark to Bonger with some bewilderment and disappointment, 'As for me, I must be the object of an immense misunderstanding.'[8] True acclaim by public and critics was still not his.

This setback was an important moment for Redon because it set the seal on the conditions and circumstances he would know in his last years. The Salon d'Automne was far from being his only opportunity to exhibit. In March 1903, for example, he had shown fifty pictures, including twenty-five pastels and fifteen paintings, at Durand-Ruel's gallery, a larger number of colour works than had been on show in the 1904 retrospective. But the Salon d'Automne provided a focal point of modern painting that might under better conditions have boosted the status of his work, as it would do in the cases of Gauguin and Cézanne. This liberal and progressive organization offered opportunities for publicity and contact with the public that recalled the ambitions of Les Indépendants, founded just twenty years beforehand. It came, in fact, in the line of those alternative and non-Establishment exhibiting societies, such as La Libre Esthétique as well as Les Indépendants, to which Redon had already turned in the past without great success. In 1907 it even recaptured some of the spirit of Les XX by instituting a literary section. And, as in the case of its precedents, Redon's participation was without long term prospects as well as being a disappointment in the short term. After 1904 his most notable contact with the Salon d'Automne was in 1908 when he contributed an article to the catalogue on the occasion of a Rodolphe Bresdin retrospective. Such an event, however, did little to compensate for the failure of the 1904 exhibition to raise his reputation to one of wide and public recognition. As had been the case already in the early 1880s, the public at large remained indifferent to Redon; while those individuals who greatly admired his colour works, such as Roger Marx and certain young painters, had had the opportunity the previous year to see an even larger assembly of them at Durand-Ruel's gallery, and had already formed their judgement on the basis of that.

The 1904 Salon d'Automne, therefore, marked the moment when the increasingly public orientation of Redon's career at the turn of the century was reversed, bringing it back to a more private and intimate scale. During his last years, for all their successes and relative prosperity, Redon's most enthusiastic audience tended to consist not of the public or of the Establishment or even a wide section of painters, but of certain patrons, artists and writers who were his friends as well as his admirers. In the absence of the fame he had desired, he turned again to the understanding of individuals and small groups. And these cirucumstances, in fact, provided something of an extension of the conditions from which he had benefited in the milieux and 'cénacles' of the eighties and nineties.

Flowers

If the presence of the 'noirs' at the 1904 Salon d'Automne obscured in part the novelty of Redon's use of colour, one theme was present in the pastels and paintings that was more topical and forward-looking. This was flowers. Redon had made flower studies at various times throughout his career, but the theme

was now taking on a new significance. 'These fragile scented beings, admirable prodigies of light', as he later described them,[9] were providing him with a motif through which to develop the joyful and spiritual transformation of natural forms that is characteristic of so many of his colour works. He not only painted bouquets but also incorporated flowers into other subjects, such as portraits (see Colour Plates 7 and 8). He associated flowers with a delicate but fundamental kind of artistic expression. When in 1903 he described Gauguin's ceramics, it was to flowers that he compared them, 'flowers of a primeval region, where each flower would be the type of a species, leaving to succeeding artists the task of providing varieties by affiliation.'[10] Flowers were becoming a theme of primary importance to Redon, both as motifs for experimentation with colour and as the expression of a personal lyricism. The subject contributed greatly to his reputation at the end of his life. It was widely and repeatedly considered a distinguishing feature of his style, and in the literary circles with which he continued to have fruitful contact it gave his art an essential topicality.

In March 1906 Redon gave a spur to his identity as a painter of flowers by making the theme dominant at the exhibition he held in that month at Durand-Ruel's gallery. Of forty-five paintings and pastels on show, well over half represented flowers. Redon's correspondence of the time makes it clear that this emphasis was altogether intentional, and that he was now presenting himself specifically as a flower painter. Sixteen works on show were all simply called *Flowers* and many others provided variations on this theme: *Rose and Marguerite, Flowers in a Cup, Geranium, Faded Tulips* and so on. Only eight works were not paintings and pastels, three of these being drawings, one a photograph[11] and the remainder etchings and lithographs. Redon had clearly decided to make himself a reputation not only as a colourist but also as the creator of the brilliant flower compositions that constitute both a natural continuation of his earlier preoccupations and at the same time one of his crowning achievements. One unforeseen consequence of this general policy, however, was the appearance early in 1907 of an enthusiastic article about Redon that rapidly became the centre of some controversy, and gave a stimulus to his reputation that was a mixed blessing. This appeared in Paul Fort's important review *Vers et Prose*. It was written by the poet Francis Jammes and was entitled 'Odilon Redon, botaniste'.

Jammes and Redon had by then known each other for some time, an initial link between them having been forged by a curious coincidence in their backgrounds. Jammes, although a generation younger than Redon, had encountered during his early life in Bordeaux a stimulating friend of the artist's own youth, Armand Clavaud. Apart from benefiting from Clavaud's lectures at the Bordeaux Natural History Museum, Jammes used to visit him with the young painter Charles Lacoste, discovering thanks to this admired and respected scientist not only topics of botany and literature, but also the works of Redon, whose lithographs decorated his flat.[12] In 1889, at the age of twenty, Jammes contacted Redon with a view to using him as a stepping-stone to fame, and from 1895 onwards, having abandoned this plan and embarked on his career as a poet independently, he began to exchange works with him, creating a bond of mutual respect and interest between himself and the older man. Jammes's letters of the time to Redon bear witness to his passionate admiration for lithographs such as *Buddha, The Smiling Spider* and *Captive Pegasus*. In 1900 Jammes finally met Redon in the

On following pages
Colour 6 *Left*
Pandora c. 1910, oil, 143 x 62.2cm.
56½ x 24½ in. Metropolitan Museum
of Art, New York, Bequest of
Alexander M. Bing

Colour 7 *Top right*
Portrait of Violette Heymann 1909,
pastel, 72 x 92.5cm. 28⅜ x 36⅜ in.
Cleveland Museum of Art, Hinman
B. Hurlbut Collection

Colour 8 *Bottom right*
Evocation of Roussel 1912, oil,
73 x 54cm. 28¾ x 21¼ in. National
Gallery of Art, Washington D. C.,
Chester Dale Collection

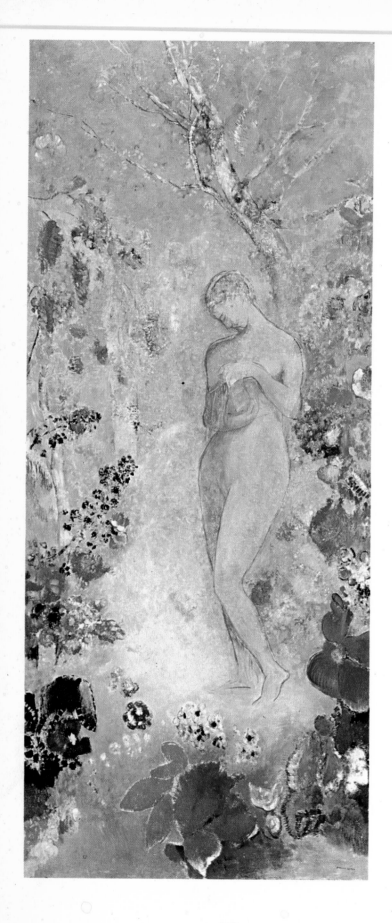

95
Head with Flowers c. 1895, oil,
52.1 x 47cm. 20½ x 18½ in. Private
collection, U.S.A.

Parisian salon of Arthur Fontaine, a prominent collector and friend to artists and writers, although professionally more concerned with affairs of government. This meeting marked the beginning of a period of jovial and harmonious friendship between the two men. Their correspondence became informal and lively, and during the summers they enjoyed each other's company in the region of Bordeaux, where the companionship of Lacoste, Gide, Déodat de Séverac and other mutual friends contributed to the mood of conviviality. Only the growing spiritual crisis in Jammes's life, that led to his return to the Catholic church in 1905, clouded this atmosphere.

During the years when Jammes was emerging from obscurity to be a leading poet of his generation, he witnessed largely at first hand the development of Redon's colour style as the 'noirs' finally disappeared, as well as encountering his pastels and paintings in the collections of friends such as Fontaine. 'I was for

years enveloped,' he wrote, 'thanks to Fontaine, in the flowers, the meteors . . . of Odilon Redon.'[14] In his article 'Odilon Redon, botaniste' it is this process of change that provides him with his main theme. Using his memories of 'noirs' encountered in early years and of flowers seen later in Redon's studio, which he compares to a garden, he relates the progression from the 'noirs' towards colour to Redon's experience of a change from suffering to happiness. He examines this

96
Etruscan Vase 1900-05, tempera on canvas, 81 x 59cm. 32 x 23¼ in. Metropolitan Museum of Art, New York, Maria De Witt Jesup Fund; from the Museum of Modern Art, Lillie P. Bliss Collection

theme in a style in which factual information is totally dominated by evocative description. The result is an intentionally poetic interpretation, in which the accent is on the artist's sensibility, and on the way in which Redon's art, with its deliberately naive spirituality and contemplation of nature, appeals to Jammes's own poetic temperament. The subjective bias of the article cannot have been surprising to Redon, since Jammes's attitude to his works had always been freely enthusiastic rather than studiously accurate. In 1902 Jammes had written a truly weird description of Redon's portrait of Mme Fontaine (Plate 97), in which the

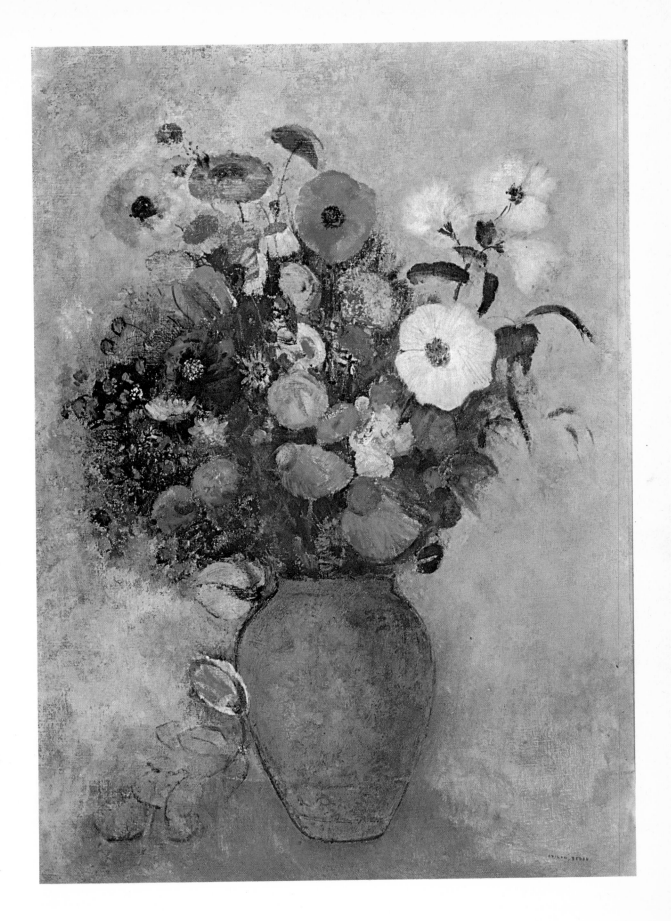

147

collector's wife is shown embroidering in the midst of floral decoration. He describes the pastel in these terms:

> This lace shawl, its outline like sea-wrack, draped down like the umbel of a jelly-fish . . . this mud from which there rises, for we are certainly underwater, a froth of stone flowers that engarland the working water nymph—all this is Redon, and of the finest kind.[15]

This passage was part of a letter to Arthur Fontaine that the collector decided to read to Redon himself, as he told Jammes in his reply. The transformation of a fine pastel portrait into an underwater fantasy may well not have pleased Redon, but on the other hand the degree of lyrical enthusiasm displayed by Jammes can hardly have failed to impress him. And the same qualities stand out in the article 'Odilon Redon, botaniste'. Like the support of other writers of former years, Jammes's praise represented a distortion of Redon's art, but it also contributed to the modernity and topicality of Redon's style by enthusiastically allying it with the novel and progressive tendencies in the arts that he himself was advocating. The disappearance of the 'noirs' had brought virtually to an end the association of Redon with those broad features of the arts, such as the literary avant-garde or the theories of Symbolism, that had helped to orientate his career for better or for worse. Francis Jammes had restored this aspect of Redon's reputation by his poetic acclamation of the flower pictures.

The misunderstandings that resulted from Jammes's account of Redon's art, however, go further than this general poeticized distortion. They also turn upon what has become known as the Quarrel of the Rose. Jammes's article ends with an exchange of words with a rose about Redon's achievement: ' "You seek the secret of his genius?" she asked . . . And I bowed my head. "I do not know and he himself does not know," she said. Then she fell silent.' Jammes's intention was no doubt to suggest poetically that Redon's art was not open to analysis, but the declarations of the rose go so far as to imply strongly that Redon himself was mystified as to his own mastery, being simply a prey to his own subconscious. Not surprisingly, Redon objected to this, since it amounts to a serious contradiction of his whole aesthetic, just as he had objected to very similar remarks in Emile Bernard's article about him of 1904, which may have influenced Jammes. The rose was in fact wrong in that Redon was very much aware of what he was doing and was an accomplished craftsman rather than the instrument of subconscious forces beyond his control.

The Quarrel of the Rose itself was a brief and inconsequential affair compared with the importance of the questions it had raised. It began in February 1907, when the article was published, and continued into March, and the issue is clearly reflected in Redon's correspondence of the time. The artist's first reaction was one of irritation. He remarked to Bonger on 8 February, 'Have you read Jammes's *Vers et Prose*? I scarcely approve of the rose's words.'[16] And to Frizeau in Bordeaux he announced that his annoyance was tempting him to write a reply to the article entitled 'Ce que dit ma rose'.[17] He did not do so, however. He quickly regained his composure and asked of Frizeau on 31 March, 'What misunderstanding do you mean concerning Jammes? . . . I have received compliments from all sides about his article. About the remark at the end, someone replied to me that it was a final poetic image. And I remained pensive . . .'.[18]

Behind his denial that there was any kind of quarrel with Jammes was his awareness, perhaps, that Frizeau himself was sympathetic towards Jammes's position. He was also stating the truth of the matter, however, for any threat of a real breach between Jammes and himself had been avoided by Arthur Fontaine, who had written to Jammes on 24 February that the disagreement had been painful to him. 'Perhaps, on the eve of an exhibition,' he suggested, 'Redon had in mind 'art criticism' rather than poetry. Hence an involuntary half misunderstanding.'[19] Fontaine was no doubt right that the forthcoming important sale of his work in March 1907 had made Redon sensitive to publicity. Fontaine's role as peace-maker quickly dampened any hot tempers. But it is clear that the growing distance between Redon and Jammes at the time went deeper than this quarrel; it was largely a matter of religious and artistic differences that had been accentuated by Jammes's growing involvement in Catholicism.

The Quarrel of the Rose was, therefore, a comparatively small incident whose importance lies not in the fact that Redon and Jammes had an altercation, but in the way in which the publication of 'Odilon Redon, botaniste' led readers of *Vers et Prose* and intellectuals in artistic centres such as the homes of Frizeau and Fontaine to reflect on questions of the subconscious and the nature of artistic creation with reference to Redon's flower pictures. The publication of Jammes's article not only contributed to the topicality of Redon's flowers by associating them with his own literary innovations, it also brought to a head a feature of his reputation that had already affected him and would also continue to do so: the role of the subconscious in his creativity. Even after his death, the issues surrounding Jammes's article lived on when Redon's work was again associated with the notion of an uncontrolled subconscious by critics who took to calling it Surrealist in the interests of topicality or for want of a better term. The actual artists and writers of Surrealism seemed, in fact, far less inclined to make such a judgement, despite André Breton's interest in the art of Gustave Moreau. And one Surrealist who deeply admires Redon, the painter André Masson, explained in an article of 1957 that he regarded him as a great colourist, a creator of textures, and denied that his attitude towards the subconscious had anything in common with the Surrealist programme.[20]

Even if we did not have a record of Redon's reactions to the views of Jammes and Bernard to substantiate our knowledge of his opposition to the notion of an uncontrolled subconscious (an attitude already implicit in the evident technical control of works such as the flower pictures), then Redon's radical disagreement with them on this question would still have been clear from his deep admiration for a writer about art whom he discovered early in 1904. In February of that year, he declared with some excitement to Bonger:

> Oh! what fine words. There is nothing to add; it is complete. It rectifies all the criticism of today. Reading it communicated to me that ferment I was talking to you about just now, that something which results from communion, faith, certainty.[21]

The author who so enthused Redon was not a contemporary, but Leonardo da Vinci. In October 1903 *La Revue Bleue* had published Joséphin Péladan's translation of Leonardo's farewell speech of 1499 to his pupils in Milan. Péladan was turning to Leonardo as a guide for the future amidst the confusion of the

On following pages
Colour 12 *Top left*
Woman with Outstretched Arms
c. 1910-14, watercolour, 17 x 20cm.
6¼ x 7⅞ in. Musée du Petit Palais,
Paris

Colour 13 *Bottom left*
Orpheus c. 1903, pastel,
70 x 56.5cm. 27½ x 22¼ in. Cleveland
Museum of Art, Gift from J. H. Wade

Colour 14
Roger and Angelica c. 1910, pastel,
91.5 x 71cm. 36 x 28 in. Museum of
Modern Art, New York, Lillie P. Bliss
Collection

151

contemporary scene, and Redon too was certainly struck by the relevance to modern art of declarations such as this:

> He who believes that the aim of art is to reproduce nature will paint nothing lasting: for nature is alive, but she has no intelligence. In a work of art, thought must complement and replace life; otherwise you will only see a physical work that has no soul.[22]

Historical considerations apart, these words resemble Redon's attitude towards the Impressionists. Leonardo's advice on techniques of suggestion similarly brings to mind Redon's use of the ambiguous. 'Do not concern yourself with making your expression precise,' he wrote; 'the enigmatic attracts man and holds his attention.'[23] And Leonardo's comments on the relationship between nature and the expression of the ideal are especially relevant to Redon's Symbolist style:

> Disciples, you must start scientifically with the body which is known in order next to proceed to the soul which is the unknown. A master, on the contrary, will start with the idea, and will proceed to give it expression and a suitable form.[24]

These words correspond extraordinarily to Redon's techniques of studying nature as a prelude to representing the fantastic and of creating the visual counterpart to a state of mind. Such declarations, in addition to Leonardo's insistence on deliberate method, are far closer to Redon's own beliefs than the mystic preconceptions of Bernard's article of 1904 or the mysterious utterances of Jammes's somewhat ridiculous rose. They throw light on Redon's actual methods as an artist whereas Bernard and Jammes attempted mistakenly to ascribe his creativity to some sort of a surrender to mysterious forces.

On balance, Jammes's contribution to Redon's career was undoubtedly welcome to the artist, since it gave topicality to his work at the time of the important sale to which Arthur Fontaine had referred in appeasing Jammes. However, before the time for this event arrived, another striking article about Redon was published. This appeared in *La Revue Illustrée* and was signed 'Marius-Ary Leblond'. And although of less importance than Jammes's article, it contributed to the situation of Redon's flower pictures at this time by describing them in the light of a different perspective: that of exoticism and primitivism.

'Marius-Ary Leblond' was the pseudonym of the brothers-in-law Marius Athénas and René Merlo, who had arrived in Paris at the turn of the century from the French colony of La Réunion to plunge themselves into literary journalism and the prolific production of critical works and novels. Among the many forms of literary expression to which they turned successfully was art criticism, their interest in painting being lively and wide. Their views, however, tended to owe less to the aims of the artists concerned than to their own ideas, in which their exotic colonial background was blended with an admiration for eighteenth-century primitivism. Writing in close and harmonious partnership, they advocated a politically radical awareness of contemporary problems tempered by a moral optimism harking back to Rousseau. The important review they founded in 1911, *La Vie,* set out initially to expound the ideals of political internationalism and moral improvement. In the world of art, they readily interpreted Gauguin in the light of their version of primitivism, and attempted to

practise internationalism by publishing *Peintres de races,* a volume of essays studying painters from a variety of lands, in which Gauguin is made to represent the South Seas.

The article on Redon that 'M.-A. Leblond' published in *La Revue Illustrée* for 20 February 1907 faithfully reflects their ideas. Passing rapidly over the 'noirs', they evoke lavishly the exoticism, lyricism and orientalism of the colour pictures. Their insistence on the spiritualized atmosphere of Redon's use of colour is at times reminiscent of Catholic interpretations. They wrote, for instance, that 'the cardinal originality of Redon is to have given us a sort of theogony of colours.'[25] However, they are associating this spirituality not with Christian thought, but with their personal ideal of an exotic Eden of primitive happiness, writing of the source of inspiration behind Redon's oriental and flower pieces that 'It is India, or in a more general manner, tropical Asia. Vast, lit up in the waves of its forests by the brilliance of its birds and fruits, we imagine [this source] . . . as the eternal paradise of the most divine flora on earth.'[26] As in the case of Jammes, their writing is hardly doctrinal. On the contrary, the article forms an exaggeratedly rich stream of metaphor and vague description that is perhaps unpalatable today but was at the time admired by many, including Redon. Opting, like other critics of the time, for lyrical and emotive criticism rather than an analytical or instructive style, they were aiming at a kind of transposition of Redon's art that would communicate its aims suggestively. Redon himself, who already knew 'M.-A. Leblond', was delighted with the texture of their writing, which he described as 'fine, almost mystic, extraordinarily rich in meaning'.[27] He also wrote of the article that it 'appears at a turning point for me. I read it with the joy of having known how to live.'[28] He associated the tone and themes of the piece with the fact that he had successfully effected a change in his style and was now having the satisfaction of witnessing its acclamation by members of the young generation. Following the 'flower' exhibition at Durand-Ruel's gallery of one year before, the article by 'M.-A. Leblond' had contributed to the consecration of Redon as a colourist. Their article was quite as 'poetically' biased as that of Jammes, but no rose spoke out of turn, and Redon was able to greet their praise without reservations or regrets.

After this essay, Athénas and Merlo, still using their pseudonym, repeatedly praised and publicized Redon, and also built up a collection of paintings in which his work was predominant. It was in their revue *La Vie* that Redon's fine autobiographical 'Confidences d'artiste' was first published in France in 1912, as part of a feature entitled *Hommage à Odilon Redon,* to which many artists and writers were invited to contribute. Extracts from Redon's correspondence appeared in the same review. When *Lettres d'Odilon Redon* was published in book form in 1923, 'M.-A. Leblond' wrote a preface for it. They provided prefaces, too, for important exhibitions of his work in 1934, 1942 and 1951. After Athénas's death in 1953, Merlo ('Ary') began to prepare a book about Redon, extracts of which appeared in a review.[29] His own death in 1958, however, cut short the completion of this. Such consistent support of Redon's art shows the important role 'M.-A. Leblond' assumed in interpreting and popularizing Redon's works over the years, and the high point their friendship marked in Redon's contacts with young critics and writers towards the end of his life. And their article of 1907 was particularly precious to Redon because of the strength of its praise and the

publicity it gave him at the time of the 1907 sale.

This large and important sale of Redon's works took place in Paris on 11 March. Redon's motives for holding it were largely financial. The loss of Peyrelebade had been only one event in the long and drawn-out complications of his family's financial difficulties. The tensions and unpleasantness to which they led were a weight on his mind, and he saw the sale as an opportunity to raise rapidly a substantial sum of money and so contribute to some improvement in the situation. Fifty-three works were up for sale, with the accent largely on flower pictures. It was an occasion, therefore, on which his bouquets of flowers could enjoy further publicity as well as bolstering the family finances. The day before the sale, all the pictures were on display to the general public, and of the visitors who came to the sale rooms that day, one in particular recorded his enthusiasm in no uncertain terms. This was Alain-Fournier, the future author of *Le Grand Meaulnes* who went to see Redon's pictures with his sister Isabelle, herself an amateur watercolourist. He and Isabelle were amazed at the simplicity and strange quality of movement in the compositions they saw. He wrote in a letter to his close friend Jacques Rivière that what they noticed above all was 'that miraculous arrangement, that mysterious balance of colours which makes a masterpiece of a few specks, petals and marks scattered over grey paper—but scattered according to certain hidden calculations'.[30] Alain-Fournier went on to compare these achievements to Gauguin and to Japanese art, which he then greatly admired. He did not buy any works at the sale, although Isabelle was present at it, but his enthusiasm is symptomatic of the further boost this event gave to the reputation of Redon's flower pictures.

By the spring of 1907, then, three events had followed each other in rapid succession: the articles of Jammes and 'M.-A. Leblond', and the sale, all of them adding to Redon's growing status as a colourist and a painter of flowers. Alain-Fournier, however, had already had his attention drawn to Redon's art shortly before these three events, and in a most significant manner. In December 1906 he received a letter from Jacques Rivière describing the dazzling works he had seen in the home in Bordeaux of a collector of paintings named Gabriel Frizeau. Rivière had headed his letter 'The Riches of Frizeau' and praised in truly ecstatic terms the works he had seen by Gauguin and Redon. The latter he described as 'subtle, harmonious, with darkly radiant colours and the ocellated patterns of a peacock'.[31] With time Rivière became a frequenter of Frizeau's Bordeaux home, encountering there not only wonderful pictures but also prominent figures who were friendly with Frizeau, one of whom was Redon. He met Redon in April 1909, and the two men discussed the Fauve painters, especially Matisse, Van Dongen and Friesz. Thanks to Frizeau, Rivière had received a more comprehensive initiation into the art and personality of Redon than Alain-Fournier had encountered in Paris, the supposed centre of French artistic life.

Redon's reputation was clearly being spread, therefore, not only by exhibitions and events in the capital, but also by the less conspicuous influence of a collector of his works who was also a friend. Nor was Frizeau's case an isolated one. Arthur Fontaine is another example of the collectors who were affecting the course of Redon's career. Redon referred affectionately to such lovers of the arts who were also his patrons and friends as 'mes amateurs', and they played an important role in the artist's last years.

The 'friends of my mind'

In his *Souvenirs d'un marchand de tableaux* Ambroise Vollard records a telling statement by Redon about his 'amateurs': ' "Those who buy my work," he would say, "are the friends of my mind." '[32] He regarded these collectors not simply as buyers but as companions who were associates in his life as an artist. Through them he not only received commissions and support, but he also enjoyed exchanges of ideas with both the men themselves and with the other artists and writers who were in contact with them. Their number included René Philippon, who had commissioned *The Haunted House,* and Maurice Fabre, who had written an article about Redon as early as 1886, as well as Arthur Fontaine, the close friend of Jammes who had intervened in the Quarrel of the Rose. But the three outstanding 'amateurs' or friends of his mind were André Bonger, Gabriel Frizeau, and Gustave Fayet.

Despite being absent from France in his native Holland for long periods of time, André Bonger (1861-1934) was perhaps the closest of Redon's friends over the last twenty or so years of his life. The fine correspondence between the two men bears witness to Bonger's status as confidant in Redon's life.[33] To this Dutch friend Redon wrote many absorbing declarations about his position and aims as an artist. When he made a drawing of Bonger in 1904 (Plate 98), Redon dedicated it 'A Monsieur A. Bonger—en souvenir affectueux', and this work shows something of the esteem as well as the affection that Redon felt for him.

Bonger had first come to France in 1879 at the age of eighteen, attracted by Paris and his interest in French intellectual and literary life. Through the Dutch community in Paris, he met Théo Van Gogh, whose brother-in-law he was to become when his younger sister married Vincent's brother in 1889. Through Théo Van Gogh, Bonger developed a lively interest in Impressionism and in other tendencies in contemporary French painting. He got to know the young Emile Bernard, whose lifelong friend he was to be. And it was through Bernard, in turn, that Bonger met Redon in 1891, at the time when Emile Bernard was beginning to spread Redon's reputation amongst his friends. In 1893 Bonger began to buy works by Redon, building up what was perhaps the finest single collection of Redon's work that has existed. Bonger's collection of paintings, dominated by Redon and Bernard but also containing works by Van Gogh and Cézanne, is today still to a great extent intact, a fine record of Bonger's perceptive taste. Having returned to Holland, where his work as a lawyer scarcely made him a rich man, he nonetheless dedicated much money and energy to Redon's art, boosting its reputation in Holland by his contributions to various exhibitions of his work. More than any other man outside France, he understood and supported Redon admirably, proving himself to be outstandingly a friend of his mind.

Gabriel Frizeau (1870-1938) was not such a close friend to Redon as Bonger, although similarities exist between the two men in the quality of their collections and the interest of their correspondence with Redon. But even if he was not such a close friend, Frizeau contributed quite as much to Redon's career in the sense that he was not only an individual admirer of Redon, but also the centre of a 'cénacle' of artists and writers, whereas Bonger was a more solitary figure. Through Bonger, Redon received primarily understanding, encouragement and support from a patron; through Frizeau, he also received publicity among French

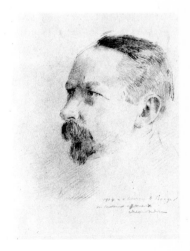

98
Portrait of André Bonger 1904, red chalk, 22 x 17cm. 8⅝ x 6⅝ in. Bonger Collection, Almen

155

intellectuals and hence a rich contribution to his situation as an artist over the last fifteen years of his life. This outstanding patron was the constant companion of a large number of writers and artists, including, as we have seen, Redon and Jammes; it was to Frizeau's wife Lucie that 'Odilon Redon, botaniste' was dedicated. He was not himself a creative artist, and his publications amount only to a handful of brief articles. Indications of his role in the arts, however, are to be found in the memoirs of Jammes, and the publication in 1952 of his correspondence with Jammes and Claudel finally lifted the discreet veil that had surrounded his activities. He gave help, advice and friendship to many artists and writers, making a significant contribution to the arts, especially in these years before the First World War. And his magnificent collection of paintings, dominated by the work of Gauguin and Redon, impressed all who visited him in Bordeaux, the town from which he rarely stirred.

Born in 1870, Frizeau was the school-friend in Bordeaux of Francis Jammes and Charles Lacoste, and it was at the lycée there also that, under the impact largely of the theory of evolution, he lost the serene Christian faith of his childhood. This loss of religious faith was the first major event of his life. Afterwards came years of restlessness and travel, following sterile law studies, during which he adopted the Symbolist and anarchist attitudes of his generation. During this period, his passion for art, literature and music became strong. In 1897 Charles Lacoste reintroduced him to Jammes, with whom he had lost contact. The poet's friendship was to be close and profound, but he quickly impressed Frizeau not only through his own work but through the revelation of that of Claudel. This encounter with the books of the Catholic writer was decisive in bringing Frizeau back to Catholicism. When Frizeau eventually met Claudel in 1905, his reconversion to religious faith was accomplished, as was that of Jammes, and the three men took communion together.

In 1905 also, Frizeau met Gide through the intermediary of Jammes, and was much intrigued by him. But his interest in Gide inevitably conflicted with his admiration for Claudel, the writer of Les Nourritures terrestres belonging to the tastes of his youth rather than his aspirations as a Catholic. He therefore condemned Gide's work for its lack of religious asceticism at the same time as responding to its richness. And it is a similar conflict that emerges from Frizeau's attitude towards Gauguin and Redon, his favourite painters. He interpreted Redon's art as being implicitly Catholic, whereas he associated Gauguin with an attractive but pagan sensuousness. Frizeau formed this view of Redon's work soon after he became acquainted with both him and his art through Charles Lacoste in 1903. This was a critical moment in his slow return to Catholicism, and Redon influenced him through works that contributed to the ascendency in his mind of the ascetically spiritual over the sensuously primitive. Not that Frizeau adopted an artificially simplified opposition between Redon and Gauguin. The idealism of Gauguin's Where do we come from? What are we? Where are we going? provided an apt centrepiece for his collection, and the joyful contemplation of nature inherent in some of Redon's pictures, especially the flower studies, was scarcely consistent with Frizeau's religious preoccupations. Nonetheless, in attributing a broadly Catholic interpretation to Redon's work, Frizeau had taken his support for Redon a stage further than that of Bonger. Although he was distorting Redon's actual aims in a way the Dutchman avoided

doing, Frizeau was contributing a further regeneration of topicality to Redon's art. Like Mithouard before him, he was advocating the relevance of Redon's style to new tendencies in Catholicism.

The loose and wide 'cénacle' of which Frizeau was the centre encompassed a far broader range of writers and artists than Jammes, Claudel and their friends. The many younger figures who frequented his home included the future poet Saint-John Perse and the young painter André Lhote, who was able to study Gauguin in Frizeau's collection before discovering Cézanne in Paris. To all these men Redon's work became familiar, and it was this limited audience, rather than the public at large, which provided him with an arena in which to achieve a certain success and renown. André Bonger, to an extent, became a part of this world, as did the third outstanding 'amateur' of these years, Gustave Fayet. Fayet, however, illustrates a further feature of this pattern of events: the commissions which were sometimes offered to Redon by 'amateurs'. In particular, the name of Fayet is inseparable from one of Redon's greatest achievements: his murals for the Abbey of Fontfroide.

Fontfroide

Gustave Fayet, a year older than Frizeau, was, like other 'amateurs', a remarkable collector, patron and friend to a variety of artists. A friend of Daniel de Monfreid, he corresponded directly with Gauguin, whose works he bought along with those of Redon, the Nabis and other important painters of the time. His friendship with Redon was profound, being founded on mutual enthusiasms, such as their common admiration for the writing of André Suarès, as well as on Fayet's lasting passion for all aspects of Redon's art. They first met in Paris, but the most fruitful terrain of their association with one another was the medieval Cistercian abbey of Fontfroide, a few miles south of Narbonne, that Fayet had bought in 1908 with a view to restoring it and living there. This old abbey quickly became a centre for artists, writers and musicians whose visits continually brought into existence a changing but animated community, and these visitors included Redon. In 1910 the coming together of Redon, Fayet and Fontfroide resulted in a highly successful commission: that Redon should decorate the library of the abbey with large decorative panels. This work was duly carried out between the spring of 1910 and the autumn of 1911, and it is not only a wonderfully successful artistic creation but also one of the key works of Redon's whole œuvre.

Three elements make up this work: *Night, Day* and *Silence*. The first two are large compositions dominating the two longer walls of the fairly small rectangular library. They each consist of a kind of triptych, having a central panel and two flanking panels. *Silence* appears over the doorway in a third wall, opposite the fourth where a window admits the extraordinarily clear and intense light of this part of southern France. But it is the nature of Redon's subject matter as well as this harmonious arrangement that is at once striking. *Night* (Colour Plate 15), bearing the same title as the lithograph album of 1886, brings to life once more the world of the 'noirs'. A tree, whose dark presence relates sombrely to the clear but somewhat subdued blue and red flora of the side panels, is the central feature of a mysterious and disquieting scene where floating heads and strange figures, many incorporating portraits of members of Fayet's family, inhabit a world of anxious, imaginary forms and of beautifully delicate creations

in which natural phenomena have been transformed into textures of visionary strength and resonance. The whole is suggestively reminiscent of Redon's early imagery and preoccupations as the artist who had created the darkly evocative 'noirs' as a personal expression of both dream-like pessimism and idealist attachment to the natural world. The scale of *Night* naturally far surpasses that of any of the 'noirs' and its freedom and breadth of conception belong to Redon's last manner, but at the same time this triptych provides a convincing and resplendent representation of Redon's recollection of his own artistic past.

On the opposite wall to this work, *Day* (Colour Plate 16) provides a contrasting scene that is nonetheless in harmony with *Night*. Where the tree stands in *Night* as a reminder of the role this motif played in Redon's whole output, *Day* shows another favourite subject: the horse. Four horses are shown surging and rearing with vital energy in an aura of yellow light against a background of scarcely defined ethereal mountains. The chariot they are pulling identifies the subject as the chariot of Apollo or Phaethon, themes frequently represented by Redon, after the example of Flaubert and indeed of Delacroix, especially in late colour pictures such as the oil painting of 1909, now in Bordeaux (Plate 92). These horses are also reminiscent of Redon's use of the Pegasus theme, whereby he represented the flying horse initially as weak and impotent, as in *Captive Pegasus* (Plate 9) or *Origins* (Plate 27), but later as triumphant and vigorous, as in the 1907 *Pegasus Triumphant,* now in the Kröller-Müller Museum, Otterlo (Colour Plate 18). *Day,* then, is an affirmation of life force, of creative energy and of vigorous optimism, the keynotes of Redon's late colour period. That *Day* shows the essence of Redon's late style is confirmed by the side panels, where a profuse and unrestrainedly joyful wealth of flowers takes the lyrical tone of his smaller bouquets to a point of extreme intensity. *Day* thus contrasts with *Night* by celebrating the optimism that accompanied the disappearance of the 'noirs', and is also the complement and counterpart to the more sombre mural, demonstrating the continuity in Redon's past development as well as the changes that had taken place.

Silence is a far smaller and less imposing work than *Night* and *Day,* but it too contributes to the way in which the Fontfroide library brings together the quintessence of Redon's art. The motif of a head whose lips are sealed in silence behind an admonitory finger or fingers was far from being an invention of Redon's; Professor Reff has pointed out, as one precedent among several, Auguste Préault's *Silence* of 1843.[34] Among Symbolists also, the theme and notion of silence was common enough in works like Camille Mauclair's *Art in Silence* or in Mallarmé, where it accompanies the evocation of absence. In Redon's work, silence occurs in different forms, ranging from the pictorial setting of Pascal's phrase, 'The eternal silence of these spaces makes me afraid' (Plate 99), a pessimistic and fearful drawing of the 1870s, to the serene *Silence* of about the same time as the Fontfroide decorations, now in the New York Museum of Modern Art (Plate 51). But it is only the latter of these that is comparable with *Silence* at Fontfroide. Silence here is not associated with fear or pessimism, but with the suggestion of reflective and spiritual experience. Silence negates the intrusions of the contingent and objective world, giving rein to that undefined state of thoughtfulness that the idealist art of Redon seeks to provoke. In this respect, silence is comparable to another important theme of Redon's later

works, the theme of closed eyes. Both silence and closed eyes indicate that Redon is concerned with the mind rather than the senses, the solitary reflections of the individual rather than the recording of objective phenomena. The colours and flora that surround the head of the Fontfroide *Silence* are, like those in *Night, Day* or the 'noirs', agents of the mind; the world to which they belong is the personal, visionary sphere of Redon's imagination, and not the natural realm in which they have their source. In its theme, therefore, *Silence*, like *Night* and *Day*, is something of a statement of Redon's aims as an artist as well as being a boldly evocative work in its own right. These decorations for Fontfroide, executed by Redon when he was more than seventy years old, are an effective summing up of his achievements as an artist, both in their themes and their superb technical quality.

Redon's talent for decorative work on a comparatively large scale had not been at all apparent during the time of the 'noirs'. The non-fulfilment of the *Vercingétorix* commission for scenery at Paul Fort's theatre in 1893 is just one indication of Redon's predilection for small-scale works. Indeed, he turned down the possibility of another theatrical project at the time of the Fontfroide decorations by refusing to provide scenery for the Ballet Russe. Redon was most enthusiastic about Diaghilev's ballet, which enjoyed immense success in Paris from 1909 onwards. The poet André Salmon includes two separate accounts in

99
The Eternal Silence of these Infinite Spaces 1878, charcoal, 22.5 x 27.5cm. 8⅞ x 10⅞ in. Palais des Beaux-Arts, Paris

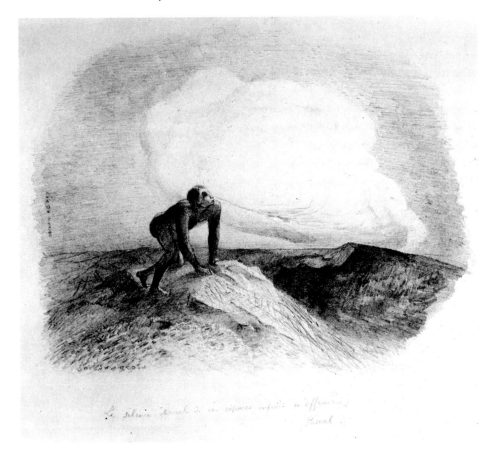

159

his memoirs of an evening he spent watching the ballet in Redon's company, calling it an unforgettable occasion and mentioning especially a commentary which Redon provided on the performance.[35] Redon was certainly enthusiastic about the work for which he was asked to supply a set, Nijinsky's interpretation of Debussy's *L'Après-midi d'un faune*. He became peripherally involved in the controversy surrounding the choreography of this production, judged by some to be immoral. Redon did not intervene actively in this quarrel, as Rodin did, but Diaghilev, writing in *Le Figaro*, quoted a letter from Redon in which the artist congratulated Nijinsky on a remarkable realization of Mallarmé's ideas.[36] Nonetheless, Redon's defence of the Russians did not lead him to participate in their projects, and a reason for this may lie in a characteristic of his art: the importance he gives to rich detail. The visitor to the library of Fontfroide Abbey quickly finds himself not only going back and forth between *Night, Day* and *Silence* to compare their imagery and thematic content, but also alternating between viewing the overall effect of the works and delighting in the suggestive power of a myriad of details that become apparent on close observation. The images and use of colour operate both on the large scale and on the small scale that is Redon's more habitual mode of expression. Close examination of any part of the murals reveals an apparently inexhaustible richness of detail, in which small areas of colour are juxtaposed with an intensity that is hardly perceptible from a distance. Decoration of this kind gives an effect not so much of large-scale murals as of essentially small-scale works that have been developed and inflated to fulfil the requirements of a decorative commission. Even the 'noirs', and certainly many pastels, had already been decorative in the sense that they depended largely on a subtle arrangement of suggestive textures, and it is this feature of his work that Redon developed skilfully at Fontfroide. Such a conception of decorative art could not have functioned in the context of a theatre set where small detail is of little use, and Redon's refusal of the *L'Après-midi d'un faune* project is hardly surprising.

Redon's other decorative works arose chiefly out of similar conditions and aim at similar effects. This side of his talent only emerged when 'amateurs' began to commission decorative works from him at the turn of the century, providing direct precedents for Fayet's project. The first example of this was in 1900, when Redon's patron the baron Robert de Domecy ordered panels from him. Other commissions followed soon, such as the one he carried out in 1902 for the widow of his friend the composer Ernest Chausson. Screens, too, became a part of this decorative production, such as the fine *Red Screen* (Colour Plate 19) he made for Bonger in 1906-08. This magnificent screen shows Pegasus rearing triumphantly in a wealth of colour dominated by reds, and shows a characteristic blend of fine detail and harmonious general conception. The very fine quality of such murals and screens led Gustave Geffroy, then director of the Gobelins, to commission from Redon designs for furniture, some of which were executed. Redon's talents, nourished by fruitful contact with the 'amateurs', were even at this late stage branching out in new directions.

The end of an epoch

In December 1914, when the advent of war had dispersed his friends and cast gloom over France, Redon wrote to a young companion:

How distant art is, my dear Aubry! Mine is part of an epoch that is ending, no doubt, but I should like to have contributed to the opening of the new one which will be yours . . . I should like my life to continue long enough for me to catch a glimpse of it, the prelude of the new beginning.[37]

He did not see the return of peace, since he died in the middle of the war, in July 1916. Contrary to his wishes, his life did not continue long enough to enable him to glimpse the artistic innovations that would come with the end of hostilities. Just before the war came, however, he did have contact with a young generation whose activities were to flourish in later decades. Already 'our Mallarmé' to the Nabis, he attracted around his person, for example at the regular Friday gatherings at his Parisian home in the Avenue de Wagram, a number of young artists, writers and musicians. Their number included figures who have subsequently been largely forgotten, such as the musician Florent Schmitt, or the exotic figure of Lucie Delarue-Mardrus, the poetess, painter, dramatist and student of Arab culture, who in 1903 had composed a poem, 'Fresque', which describes Redon's murals for Mme Chausson.[38] Some of them, such as 'Marius-Ary Leblond', had for several years been at the heart of Redon's career. Others, however, were newer to Redon's circle and they responded to his work in a way that constituted a final phase of the critical reaction to the 'noirs' and colour works. And although they were not of the Symbolist generation, these figures turned to Redon's Symbolist art as a highly topical phenomenon of real relevance to their own situation.

The young man to whom the letter about 'an epoch that is ending' was addressed is an example. His name was Georges Jean-Aubry. A close friend of Redon and a frequent caller at his home in the years before the First World War, Jean-Aubry is chiefly remembered today as a perceptive critic of music, art and literature, and as the translator into French of Joseph Conrad. When he became a part of Redon's circle, his activities as critic and commentator on the arts stood him in good stead. His knowledge and critical insights helped to satisfy to an extent Redon's untiring curiosity about new developments in the arts, an aspect of character which Jean-Aubry himself remarked on:

Very often he would question us about recent books or new music, about an unknown artist whose character he had heard sketched, and a few days later, this tireless and calm old man had read the book, seen the pictures, heard the compositions and was speaking to us about them with eager clarity.[39]

He, and other young men, were constantly amazed at Redon's receptiveness to novel ideas and trends. Like Maurice Denis before him, Jean-Aubry consequently compared the painter to Mallarmé.[40]

The strength of Redon's friendship with Jean-Aubry lay largely in their common interests and enthusiasms. Their mutual friends, for example, included the pianist Ricardo Viñes, Bonnard, Vallotton and Ravel, and both men admired the work of Suarès, whose work Jean-Aubry lectured on at the 1912 Salon d'Automne. Their association resulted from shared artistic tastes and social 'milieux' and gave rise to little in the way of projects or co-operation. After the First World War, Jean-Aubry did publish articles about Redon, but he never made any major study of him. The same characteristics apply to Redon's contacts with another rising star of the young generation, Jean Cocteau. Among the common passions of

On following pages
Colour 15 *Top*
Night 1910-11, tempera, 200 x 650cm. 78 x 256 in. Abbaye de Fontfroide

Colour 16 *Bottom*
Day 1910-11, tempera, 200 x 650cm. 78 x 256 in. Abbaye de Fontfroide

Redon and Cocteau was Diaghilev's Ballet Russe. Cocteau was the author of a libretto for Diaghilev, *Le Dieu bleu,* and the companion of other enthusiasts such as J.-E. Blanche and Reynaldo Hahn. In 1913 he hailed their production of Stravinsky's *Sacre du printemps* as a work that surpassed Gauguin and Matisse in its controlled brilliance, 'an organised Fauve work'.[41] In the same year, he expressed to Redon similar admiration for the painter's flower pictures. 'Your butterflies and your bouquets,' he wrote, 'exchange their gleaming pollen and brilliant powders, and it is always this same miracle of a waking dream that is offered us by the least literary and most poetic of geniuses.'[42] Cocteau's enthusiasm for Redon, however, was short-lived. His praise of him belongs to the fashionable brilliance of pre-war Parisian society, and seems superficial compared with the sincere admiration of Jean-Aubry.

A more substantial admirer of Redon amongst young poets was André Salmon. In his memoirs, *Souvenirs sans fin,* Salmon recalls that he had got to know Redon in 1910 or 1911, subsequently visiting him at his flat, 'the light apartment where the painter and his wife received me'.[43] Some years before encountering the man, however, Salmon had become an admirer of Redon's work. The friend of Paul Fort, he had been an editor of *Vers et Prose* from its inception, and had therefore read 'Odilon Redon, botaniste' and no doubt knew of the Quarrel of the Rose. However, Salmon was by no means simply a follower of Jammes in his attitude towards Redon. His personal interest in painting was strong, and he became a companion of the Cubists. Even his poetry is often allied to visual arts, as in the volume *Peindre* of 1921 with its poems about painters and painting and its portrait of Salmon by Picasso. Redon does not in fact appear in *Peindre* but he does occupy a place of honour in an earlier critical work about contemporary painting by Salmon, *La Jeune Peinture française* of 1912.

La Jeune Peinture française aims not to give a comprehensive account of modern painting or even to define its aims but to put the record straight with regard to what Salmon knew from personal experience to have happened. The opening chapter is about the Fauves, especially Matisse, and the second concerns Salmon's own view of Cubism. Also, he surveys young figures such as Picabia and Lhote under the general title 'L'Art vivant', and deals finally with landscapists, including Charles Lacoste, and twentieth-century women artists, such as Marie Laurencin. But before undertaking this personal account of new painting, he hails Redon in his preface as the emancipator who had made these developments, especially Fauvism, possible: 'Allow me,' he says, 'to set at the head of this work praise to a liberating master, to whom everyone owes as much as to Delacroix, Courbet, Manet, Renoir, Seurat, Toulouse-Lautrec, Van Gogh, Degas, Cézanne, etc. I mean Odilon Redon.' He comments on the fact that, like Mallarmé, Redon was a key figure who had not gained wide renown. Developing this comparison, he draws a parallel between the way in which Mallarmé and Redon transform their subject matter into strangely moving effects, finding a stylistic analogy between a Mallarmé sonnet and a Redon flower painting. Turning to his personal knowledge of Redon the man, he describes him as a hospitable ageing bourgeois, who paints in the sober drawing-room of his Paris flat. He points out that Redon was a retiring individual who did not seek to exhibit a great deal. Finally, he repeats his assertion that Redon was a liberator of painting who helped to make Fauvism possible: 'This master is one of the surest of emancipators. Thirty years

before it was formulated, he made 'pure painting', and I doubt whether without his discoveries as a colourist Fauvism, already dated but still fertile, could ever have happened.' And it is on an even higher note of praise, hailing Redon as the prince of painters, that Salmon ends this preface to his account of new French art.

Salmon repeated his praise of Redon in a eulogistic article of 1913, but he paid little attention to the artist's work in later years. His writings are valuable for the picture they give of Redon, but his contribution to the painter's late career was cut short by the end of a peace that for Redon, as for France itself, was the end of an epoch. Redon's evolving progress as an artist virtually came to a close with the end of pre-war conditions, two years before his death. When he died, the young companions of his last years were already dispersed. One of the few notices of his death in the press was a homage from an older friend, Emile Bernard, who had changed his attitude since the article of 1904. This time he praised Redon not as an artist of the sickly subconscious, but as a strong-willed colourist.

The features of Redon's colour works and of the time when he was producing them had been rich and varied. The last fifteen years of his life, in particular, form a magnificent conclusion to his career as an artist. The circumstances and conditions of this time and the critical reaction that accompanied his exploration of colour media clearly fall into something of a pattern. Redon's failure to achieve wide success even through the Salon d'Automne led him to continue to rely on a small audience of supporters. This audience still included a number of writers, although Redon did not give deliberately literary features to his colour works as he had to some 'noirs'. The poetic criticism of Jammes or 'M.-A. Leblond' and, to an extent, of Salmon gave his work a topicality that had certain literary ingredients. His 'amateurs', the friends of his mind, provided an essential complement to this enthusiasm through their patronage, in the form of buying and commissioning substantial works. The friendships of Redon's last years tended to spring from his private world rather than the public worlds of Parisian exhibitions and fashion. Redon's exhibitions of his last years were by no means prestigious affairs; they took place sometimes through dealers and sometimes through the activities of a friend, such as Bonger in Holland. The resemblance between this situation and the conditions he had known in the 1880s and 1890s is unmistakable. Just as his colour and flower pictures were the natural development of his Symbolist art from the 'noirs', so did the circumstances of his last years evolve out of his initial integration into the world of the Symbolists. And just as the fashions and vestiges of Symbolism finally encountered radical change in the conditions of 1914, so did the involvement of Redon with the Symbolists finally come to an end as Europe was plunged into war.

On following pages
Colour 17 *Left*
Vase of Flowers c. 1914, pastel, 75 x 59cm. 29½ x 23¼ in. Musée du Petit Palais, Paris

Colour 18 *Top right*
Pegasus Triumphant c. 1907, oil on cardboard, 47 x 63cm. 18½ x 24¾ in. Rijksmuseum Kröller-Müller, Otterlo

Colour 19 *Bottom right*
The Red Screen 1906-8, tempera, three panels, each measuring 168 x 74cm. 66⅛ x 29⅛ in. Bonger Collection, Almen

Epilogue

> . . . I think I have created an expressive, suggestive, indeterminate art. Suggestive art is the irradiation of divine plastic elements, brought together, combined with a view to causing dreams that are enlightened and exalted by it, while giving rise to thought.[1]

Here, as so often in *A soi-même,* Redon used evocative formulations in an attempt to define his own art. The words he uses are intentionally imprecise, but their appropriateness may be judged by testing them against one of the works painted at about the time they were written, for instance *The White Butterfly* (Plate 100). The imagery of this picture brings together long-established motifs in Redon's *oeuvre:* the tree and the woman's profile hark back to the 'noirs', while the flowers and the butterfly are characteristic of Redon's late style. The unity of the work consists, as Redon implies, in the way these separate elements are brought together suggestively and ambivalently in a carefully balanced visual design. Subject matter and treatment combine to produce a complex effect that is both disorientating and stimulating. Phenomena of the observed world have been transformed into an imaginary scene that suggests a state of mind without in any way circumscribing it.

The White Butterfly can be thought of too as belonging to the Symbolist world of which Redon was part. The genesis of such a work is related to the milieux in which Redon had been involved, as indeed is his formulation of artistic aims. Redon's preoccupations and achievements as an artist are inseparable from the context out of which they were born. In retrospect, the years around 1880 were vital in the establishment of that context. The pattern of events that dominated the rest of his career came into being when Redon was adopted by the Decadents after his failure to achieve success through the official Salon. His distance at the time from fellow painters (despite his lasting closeness to Bresdin and circumstances like the foundation of Les Indépendants) contributed much to this turn of events. Only when Redon became the companion of the Nabis did he really enter into harmonious association with contemporary artists. By that time, the pattern of failure and success through which he had become integrated with the world of Symbolist writers and critics was firmly established. His friendship with Sérusier or Bonnard did little to counteract his involvement with a Symbolist world dominated by the writings of Hennequin and Huysmans, the theories of Morice and Aurier, the projects associated with Les XX in Belgium and the new horizons opened by men such as Schuré. Redon's contacts with painters eventually blossomed, but so also did the Symbolist conditions with which his art and career had become inextricably entwined.

The way in which Redon was seeking to orientate himself in about 1880 is illustrated in the reflections he noted down at the time about other artists who were creating an idealist art, men such as Gustave Moreau. These private writings

100
The White Butterfly c. 1910, oil,
63.5 x 48.9cm. 25 x 19¼ in. Ian
Woodner Family Collection, New
York

168

remained unpublished in his lifetime but now form part of *A soi-même*. Moreau is praised as a gifted colourist; his watercolours remind Redon of Delacroix to a point, and this recalls to us in turn Redon's own debt to that painter. But there is another feature of Moreau's paintings that Redon admires just as much. This is his interpretation of myths. Selecting in particular Moreau's representation of Phaethon, he praises him for the way he makes an ancient myth modern, fresh and original.[2] There is an evident overlap here with Redon's own interest in mythology. Both men turned to Phaethon, Orpheus, Salome and other legends with a view to making them part of their personal means of expression. Yet there are differences between Moreau and Redon, in this as in other matters. Redon did not pursue the type of detail and richness one finds in Moreau, and he goes further than him in imparting a new significance to mythological sources. For all his interest in the older painter, Redon pursued a course of his own that was not closely allied to Moreau's.

Fantin-Latour, on whose advice Redon turned to lithography, is an artist to whom we might expect him to have been more closely sympathetic. Redon's writings about him in the early 1880s, however, are somewhat hostile. While giving fair praise to Fantin-Latour's skilful use of colour, he strongly criticizes his borrowing of subject matter from Wagner or Berlioz. To seek to produce a so-called musical effect, in the sense of a vague, freely suggestive impression, was already an aim of Redon's. But Fantin-Latour's experiments in that direction displeased Redon, who proceeded to compare the painter's shortcomings unfavourably with the achievements of another artist, Jean-Charles Cazin.[3] Redon's remarks about Cazin in the early 1880s are highly enthusiastic.[4] He was impressed by the blend of technical expertise and poetic invention in Cazin's canvases, and was probably impressed also by the fact that Cazin was achieving real success at the Salon. This success contrasted with his own failures and he no doubt found comfort in the fact that a fellow idealist painter was managing to impress the public. Cazin's actual pictures, however, which were large scale paintings, sometimes on Biblical subjects, were quite distant from Redon's 'noirs'. Redon placed Cazin alongside Puvis de Chavannes, another painter whose style he admired deeply, despite its lack of resemblance to his own: 'Cazin, Puvis are the only ones who make us forget the city street,' he wrote.[5] Of Puvis de Chavannes he wrote also that he has managed 'to paint his dream, and to create a work that is imitated and that will live on; he has found a style.'[6]

Gustave Moreau, Cazin and Puvis de Chavannes all certainly provided encouraging examples for Redon in about 1880, but his distance from them as well as his appreciation of them lies behind all these writings from *A soi-même*. He was reflecting on their art with reference to questions with which he himself was deeply concerned: the use of the mythological, the problem of success, the creation of a personal idealist style. However, the advancement of his own ambitions in these spheres came about not through any fruitful association with these painters, but by way of that teeming complex world of 'cénacles', reviews and avant-garde projects that has so aptly been called 'the Symbolist mêlée'.

Appendix: Redon's prose poem captions

The original French of Redon's prose poem captions for *Origins, Homage to Goya* and *Night* is given below (see pp. 44-51).

Les Origines (1883)

Quand s'éveillait la vie au fond de la matière obscure / il y eut peut-être une vision première essayée dans la fleur. / Le polype difforme flottait sur les rivages, sorte de Cyclope souriant et hideux / La Sirène sortit des flots, vêtue de dards / le Satyre au cynique sourire. / Il y eut des luttes et de vaines victoires / l'aile impuissante n'éleva point la bête en ces noirs espaces. / Et l'homme parut, interrogeant le sol d'où il sort et qui l'attire, il se fraya la voie vers de sombres clartés.

Hommage à Goya (1885)

Dans mon rêve, je vis au Ciel un VISAGE DE MYSTERE / la FLEUR du MARECAGE, une tête humaine et triste / Un FOU dans un morne paysage. / Il y eut aussi des ETRES EMBRYONNAIRES / Un étrange JONGLEUR. / Au réveil j'aperçus la DEESSE de l'INTELLIGIBLE au profil sévère et dur.

La Nuit (1886)

A la VIEILLESSE, / l'homme fut solitaire dans un PAYSAGE DE NUIT, / l'ange perdu ouvrit alors des AILES NOIRES: / la CHIMERE regarda avec effroi toutes choses, / les prêtresses furent en ATTENTE, / et le chercheur était à la RECHERCHE INFINIE.

Chronology

Oh! my biography is not at all difficult; I have never been anywhere. The events that left their mark on me happened, in days gone by, in my head.

Odilon Redon in a letter to Bonger, 9 June 1894

1840 Odilon Redon born at Bordeaux on 20 April.
 His childhood is spent at Peyrelebade, his family's estate in the Médoc.
1847 A stay in Paris during which Redon visits museums.
1851 He begins school in Bordeaux, an unhappy experience.
1855 He begins drawing lessons with Stanislas Gorin.
1857 The approximate time of his attempt and failure to become a student of architecture.
1860 Redon exhibits at the Salon des Amis des Arts de Bordeaux, where his works will be shown intermittently for years to come.
1864 He meets Rodolphe Bresdin in Bordeaux. In Paris he becomes briefly and disastrously a pupil of Jean-Léon Gérôme.
1868 Redon publishes his 'Salon de 1868' in *La Gironde*. By now he has had contact with Corot, Chintreuil and Fromentin.
1869 He publishes an article on Bresdin in *La Gironde*.
1870 He takes part in the Franco-Prussian War.
 He receives a decorative commission for a chapel at Arras, probably carried out but since destroyed.
1874 The year of the first Impressionist exhibition.
 Redon becomes a member of Mme de Rayssac's salon.
 Bertrand Redon, the artist's father, dies.
1875 Redon works at Barbizon (May) and in Brittany (July).
1878 He exhibits one charcoal drawing at the Salon. Previously he had exhibited one etching at the 1867 Salon, and he will later exhibit lithographs at the Salons of 1885, 1886 and 1889.
 He makes his first visit to Holland.
1879 Publication of the first lithograph album, *In Dream*.
1880 He marries Camille Falte on 1 May.
1881 At *La Vie Moderne* he holds his first one-man exhibition.
1882 His second exhibition takes place at *Le Gaulois*.
 Publication of the second lithograph album, *To Edgar Poe*.
 Redon establishes contacts with Huysmans and Hennequin.
1883 The lithograph album *Origins* is published.
1884 The founding of Les Indépendants.
 The publication of *A rebours*.
 Léo Redon, the artist's younger brother, dies in November.
1885 Marie Redon, the artist's sister, dies in January.
 Rodolphe Bresdin dies.
 The lithograph album *Homage to Goya* is published.
 Redon meets Stéphane Mallarmé.

1886 Birth of the artist's first son, Jean, who dies in infancy.
The lithograph album *Night* is published.
Redon exhibits in Brussels with Les XX, and in Paris at the last Impressionist exhibition.
Jean Moréas publishes his manifesto of Symbolism in September.

1887 *Le Juré (The Juror)* is published in Brussels as a book and in Paris as a lithograph album.

1888 *The Temptation of Saint Anthony,* Redon's first Flaubert lithograph album, is published.
Verhaeren's *Les Soirs* appears with a frontispiece by Redon.
Redon spends the summer at Samois, on the Seine near Valvins, Mallarmé's retreat.
The death of Hennequin.

1889 Arï, the artist's second son, is born in April.
To Gustave Flaubert, the second Flaubert lithograph album, appears.
Redon exhibits with the Peintres-Graveurs, and will do so annually until 1893.
He spends a second summer at Samois.
Huysmans publishes *Certains,* Charles Morice *La Littérature de tout à l'heure* and Schuré *Les Grands Initiés.*
Redon's Belgian projects continue.

1890 Redon exhibits with Les XX again.
Reproductions of his drawings *Les Fleurs du mal* appear in Brussels.
Arthur Symons and Havelock Ellis visit Redon in Paris.
The death of Armand Clavaud.

1891 The lithograph album *Dreams* appears.
In Brussels Jules Destrée publishes *L'Œuvre lithographique de Odilon Redon.*

1892 First of the salons of the Rose + Croix, which continue annually until 1897.

1894 Major Redon exhibition at Durand-Ruel's gallery, March-April.
First salon of La Libre Esthétique in Brussels. Redon exhibits here, as he will too in 1895, 1897 and 1909.
In Holland he exhibits with the Haagsche Kunstkring, May-June.
Publication in August of Redon's 'Lettre à Edmond Picard'.

1895 Redon takes part in àn exhibition in London.

1896 Publication of two lithograph albums: *The Haunted House* and *The Temptation of Saint Anthony,* the third Flaubert album.

1897 Sale of the family estate at Peyrelebade, where he stays for some months.
The beginning of the project to provide lithographs for Mallarmé's *Un Coup de dés.*

1898 A Redon exhibition at Vollard's gallery.
The deaths of Stéphane Mallarmé, Gustave Moreau and Puvis de Chavannes.

1899 Redon has an important place at the exhibition of young painters held at Durand-Ruel's gallery.
The Apocalypse of Saint John, the last lithograph album, is published.

1900 A Redon exhibition at Durand-Ruel's gallery.
Maurice Denis paints *Homage to Cézanne,* which is also a homage to Redon.
Redon meets Francis Jammes.
1901 A Redon exhibition at Vollard's gallery.
Redon begins important decorative commissions.
1903 Another Redon exhibition at Durand-Ruel's gallery.
The founding of the Salon d'Automne.
The death of Gauguin.
1904 A Redon retrospective at the Salon d'Automne, where he will exhibit again
in 1905, 1906 and 1907 with far fewer works.
1906 The Redon exhibition at Durand-Ruel's gallery in which flower pictures
predominate.
1907 Francis Jammes publishes 'Odilon Redon, botaniste'.
A sale of Redon's works takes place on 11 March.
1909 An important Redon exhibition in Amsterdam, at the Larensche
Kunsthandel.
1910-11 Redon carries out Fayet's commission for decorative works at
Fontfroide Abbey.
1912 The review *La Vie* publishes 'Hommage à Odilon Redon', with a wide
range of contributions.
1913 Redon's works are highly successful at the Armory Show in the United
States.
The publication of André Mellerio's catalogue of Redon's lithographs and
engraved work.
1914 When war breaks out, the artist's son Arï leaves to fight in the French
forces.
1916 Odilon Redon dies in Paris on 6 July.

Select Bibliography

This bibliography is far from exhaustive and aims simply to list the principal relevant works. At the time of its preparation, two important publications about Redon were imminent: firstly, the welcome reappearance in France of Roseline Bacou's fine account of Redon's life and work; and secondly, the long-awaited publication of Redon's correspondence with André Bonger, edited by Roseline Bacou. Both these works would naturally have been included here if they had been published in time.

The chief studies of Redon

Bacou, Roseline *Odilon Redon,* 2 vols, Geneva 1956
Berger, Klaus *Odilon Redon. Fantasy and Colour,* translated from the German by
Michael Bullock, London. 1st German edn Cologne 1964
Cassou, Jean *Odilon Redon,* Milan 1972. French edn Paris 1974

Destrée, Jules *L'Œuvre lithographique de Odilon Redon. Catalogue descriptif*, Brussels 1891

Fegdal, Charles *Odilon Redon*, Paris 1929

Mellerio, André *L'Œuvre graphique complet d'Odilon Redon*, Paris 1913
Odilon Redon, peintre, dessinateur et graveur, Paris 1923

Redon, Arï *Lettres de Gauguin, Gide, Huysmans, Jammes, Mallarmé, Verhaeren . . . à Odilon Redon,* with notes by Roseline Bacou, Paris 1960

Roger-Marx, Claude *Odilon Redon et son œuvre*, Paris 1924

Sandström, Sven *Le Monde imaginaire d'Odilon Redon — étude iconographique*, Lund 1955

Selz, Jean *Odilon Redon,* Paris 1971

Writings by Redon

'Salon de 1868': three articles, dated 17 May, 31 May and 27 June, and published in the Bordeaux newspaper *La Gironde* on 19 May 1868 ('Le Paysage: MM Chintreuil, Corot et Daubigny'), 9 June 1868 ('MM Courbet, Manet, Pissaro (sic), Jongkind, Monet') and 1 July 1868 ('MM Fromentin, Ribot, Roybet')

'Rodolphe Bresdin. Dessins sur pierre, eaux-fortes, dessins originaux': article in *La Gironde,* 10 January 1869

'Lettre à Edmond Picard' (15 June 1894), *L'Art Moderne,* Brussels, 25 August 1894, pp. 268ff.

Contribution to 'Quelques opinions sur Paul Gauguin', presented by Charles Morice, *Le Mercure de France,* November 1903, pp. 428-30

'Rodolphe Bresdin, 1822-1885': preface to catalogue of Bresdin retrospective at the Salon d'Automne, Paris, October-November 1908

'Van Odilon Redon' in *Van Onzen Tijd,* Amsterdam 1909: first publication of the text later known, after minor changes, as 'Confidences d'artiste'

'Confidences d'artiste': part of 'Hommage à Odilon Redon', *La Vie,* 30 November, 7 December and 14 December 1912

'Quelques lettres d'Odilon Redon', *La Vie,* November 1916, pp. 348-50, and December 1916, pp. 381-3

A soi-même. Journal (1867-1915). Notes sur la vie, l'art et les artistes, with an introduction by Jacques Morland, Paris 1922. New edn Paris 1961

Lettres d'Odilon Redon, 1878-1916. Publiées par sa famille avec une préface de Marius-Ary Leblond, Paris and Brussels 1923

Lettres de Vincent van Gogh, Paul Gauguin, Paul Cézanne, J.-K. Huysmans, Léon Bloy, Elémir Bourges, Milos Marten, Odilon Redon, Maurice Barrès, à Emile Bernard, Tonnerre 1926. 2nd edn Brussels 1942

'Des Lettres inédites d'Odilon Redon (à Emile Hennequin)', presented by Auriant, *Beaux-Arts,* 7 and 14 June 1935

Other important works about Redon and his context

Angrand, Pierre *Naissance des artistes indépendants, 1884,* Paris 1965

Aurier, G.-Albert 'Les Symbolistes', Revue Encyclopédique, 1 April 1892, pp. 475-86
Œuvres posthumes, with a preface by Rémy de Gourmont, Paris 1893

Bacou, Roseline Catalogue to Redon exhibition at the Orangerie des Tuileries, Paris, October 1956-January 1957
'Unité de l'œuvre d'Odilon Redon', *La Revue des Arts,* October 1956, pp. 133-8
Bacou, Roseline and Roger-Marx, Claude *Odilon Redon à l'Abbaye de Fontfroide,* No. 9 in the series 'Chefs-d'œuvre de l'art', Paris, Milan and Geneva 1970
Beauclair, Henri and Vicaire, Gabriel *Les Déliquescences, poèmes décadents d'Adoré Floupette,* Paris 1885. 4th edn 1923
Berghe, E. van den *Jules Destrée: l'avocat, le politique, l'artiste,* Brussels and Paris 1933
Bernard, Émile 'Odilon Redon', *Le Cœur,* September-October 1893, p. 2
'Odilon Redon', *L'Occident,* May 1904, pp. 223-34
'Odilon Redon', *La Vie,* August 1916, pp. 227-9
de Bois, J. H. *L'Œuvre graphique de Odilon Redon,* 2 vols, The Hague 1913
Bonger-Van der Borsch van Verwolde, F.W.M. 'Odilon Redon aux Pays-Bas': catalogue to Redon exhibition at the Gemeentemuseum, The Hague, May-June 1957
Chassé, Charles *Les Nabis et leur temps,* Lausanne and Paris 1960
Coulon, Marcel 'Une Minute de l'heure symboliste: Albert Aurier', *Le Mercure de France,* 1 February 1921, pp. 599-640
Coquiot, Gustave *Les Indépendants, 1884-1920,* Paris 1920
Daudet, Léon *Les Kamtchatka,* Paris 1894
Deffoux, Léon *J.-K. Huysmans sous divers aspects,* with four illustrations by Redon, Paris 1927
Delsemme, Paul *Charles Morice, un théoricien du Symbolisme,* Paris 1958
Destrée, Jules 'Odilon Redon', *La Jeune Belgique,* 1 February 1886, pp. 131-45
Les Chimères, with frontispiece by Redon, Brussels 1889
Dickinson, Frank 'Some lithographs by Odilon Redon', *Victoria and Albert Museum Yearbook,* No. 1, pp. 137-44, London 1969
Doin, Jeanne 'Odilon Redon', *Le Mercure de France,* 1 July 1914, pp. 5-22
Dolent, Jean *Monstres,* Paris 1896
Fénéon, Félix *Œuvres plus que complètes,* edited by J. Halperin, Geneva 1970
Fontainas, André 'Odilon Redon', *Le Mercure de France,* 16 August 1916, pp. 577-88
Geffroy, Gustave 'L'Art moderne des Gobelins', *Les Arts,* October 1916, pp. 14-19
Van Gelder, Dirk 'Rodolphe Bresdin et Odilon Redon. Réflexions sur les rapports d'amitié entre le maître et l'élève, *Het Nederlands Kunsthistorisch Jahrboek,* 1966, pp. 265-304
Gilkin, Iwan *La Damnation de l'artiste,* frontispiece by Redon, Brussels 1890
Ténèbres, frontispiece by Redon, Brussels 1892
La Nuit, Paris 1897
Girou, Paul 'Des décorations oubliées de Redon à Fontfroide', *Beaux-Arts,* 25 November 1938
Gourmont, Rémy de *L'Idéalisme,* Paris 1893
Le Livre des masques: portraits symbolistes, gloses et documents sur les écrivains d'hier et d'aujourd'hui, 2 vols, Paris, 1896 and 1898
Le Problème du style, Paris 1938
Henkel, M.D. 'Die Sammlung A. Bonger in Amsterdam', *Der Cicerone,* Leipzig, December 1930, pp. 597-603

Hennequin, Emile *Contes grotesques,* translated from E. A. Poe, cover illustration
 by Redon, Paris 1882
Hérold, A.-Ferdinand *Chevaleries sentimentales,* frontispiece by Redon, Paris 1893
Huysmans, Joris-Karl *L'Art moderne,* Paris 1893
 A rebours, Paris 1884. Recent edn 1961
 Croquis parisiens, 2nd edn Paris 1886
 Certains, including 'Le Monstre', Paris 1889
 Lettres inédites à Jules Destrée, edited by Gustave Vanwelkenhuyzen, Geneva
 1967
Jammes, Francis 'Odilon Redon, botaniste', *Vers et Prose,* December 1906-
 February 1907, pp. 29-36
 L'Amour, les Muses et la chasse, Paris 1922
 Les Caprices du poète, Paris 1923
Janneau, Guillaume 'Le Dernier Romantique: Odilon Redon', Chapter XI of *Au
 chevet de l'art moderne,* Paris 1923
Jean-Aubry, G. 'Odilon Redon'. *La Renaissance de l'art français,* August 1920,
 pp. 328-34
Johnson, Una E. *Ambroise Vollard, éditeur, 1867-1939. An appreciation and
 catalogue,* New York 1944
Jourdain, Frantz *Les Décorés. Ceux qui ne le sont pas,* Paris 1895
Jourdain, Frantz and Rey, Robert *Le Salon d'Automne,* Paris 1926
Jullian, Philippe *Dreamers of Decadence: Symbolist Painters of the 1890s,*
 translated by Robert Baldick, London 1971
 The Symbolists, London 1973
Konody, P. G. 'Odilon Redon and his world', *The Idler,* April 1900, pp. 139-51
Laprade, Albert *Gaston Redon, architecte; 1853-1921,* Paris 1957
Leblond, Ary Four articles in *Arts et Spectacles:* 'J'ai vu Odilon Redon face à face
 avec Rembrandt', 24-30 October 1956; ' "Mon ami Mallarmé" par Odilon
 Redon', 31 October-6 November 1956; ' "Huysmans, mon grand frère" par
 Odilon Redon', 7-13 November 1956; 'Odilon Redon et Francis Jammes:
 histoire d'une amitié et d'une brouille', 14-20 November 1956
Leblond, Marius-Ary 'Odilon Redon', *La Revue Illustrée,* 20 February 1907,
 pp. 155-60
 Peintres de races, Brussels 1909
Legrand, F.-C. 'Le Groupe des XX et son temps', preface to exhibition catalogue,
 Brussels 1962
 'Evocation des XX et de la Libre Esthétique', preface to exhibition catalogue,
 Brussels, April-July 1966
 Le Symbolisme en Belgique, Brussels 1971
Lehmann, A. G. 'Un Aspect de la critique symboliste: signification et ambiguité
 dans les Beaux-Arts', *Cahiers de l'Association Internationale des Etudes
 Françaises,* Paris, June 1960
 The Symbolist Aesthetic in France, 1885-1895, Oxford 1968
Lethève, Jacques 'Les Salons de la Rose-Croix', *Gazette des Beaux-Arts,* December
 1960, pp. 363-74
Loize, Jean 'Un Inédit de Gauguin', *Les Nouvelles Littéraires,* 7 May 1953
Lorrain, Jean 'Un Etrange Jongleur' in *Sensations et souvenirs,* Paris 1895,
 pp. 213-20

Marx, Roger 'Le Salon d'Automne', *Gazette des Beaux-Arts,* December 1904,
 pp. 458-74

Masson, André 'Redon: mystique with a method', *Art News,* New York, January
 1957, pp. 41-3 and 60-2

Mattenklott, Gert 'Zum sozialen Inhalt von Redons ''monde obscur de
 l'indeterminé'' ', pp. 207-19 of Odilon Redon, *Selbstgespräch,* a German
 version of *A soi-même* translated by Marianne Türoff, Munich 1971

Mauclair, Camille 'Exposition Odilon Redon chez Durand-Ruel', *Le Mercure de
 France,* 1 May 1894, pp. 94-5

Maus, Madeleine *Trente années de lutte pour l'art: 1884-1914,* Brussels 1926

Maus, Octave 'Odilon Redon', anonymous review in *L'Art Moderne,* 21 March
 1886, pp. 92-3

Mellerio, André *Le Mouvement idéaliste en peinture,* frontispiece by Redon, Paris
 1896

 La Lithographie originale en couleurs, Paris 1898

 'Trois peintres-écrivains: Delacroix, Fromentin, Odilon Redon', *La Nouvelle
 Revue,* April 1923, pp. 303-14

Mirbeau, Octave 'L'Art et la Nature', *Le Gaulois,* 26 April 1886. Partly reprinted in
 Beaux-Arts, 26 April 1935, p. 2

Mithouard, Adrien *Le Tourment de l'unite,* Paris 1901

 Traité de l'Occident, Paris 1904

Morice, Charles *La Littérature de tout à l'heure,* Paris 1889

 'Odilon Redon', No. 386 of *Les Hommes d'Aujourd'hui,* Paris 1890

Mornand, Pierre *Emile Bernard et ses amis,* Geneva 1957

Moueix, J.-F. 'Un Bordelais Amateur d'art éclairé: Gabriel Frizeau', *La Vie de
 Bordeaux,* 11 October 1969, pp. 1 and 4

Mourey, Gabriel 'Trois Dessins d'Odilon Redon', *La Feuille Libre,* 24 April 1890

Museum of Modern Art, New York Catalogue to exhibition of works by Redon,
 Moreau, and Bresdin, 1961-62

Natanson, Thadée 'Exposition Odilon Redon', *La Revue Blanche,* May 1894,
 pp. 470-2

 'Un Album d'Odilon Redon', *La Revue Blanche,* February 1897, p. 140

 Peints à leur tour, Paris 1948

Pach, Walter *Queer Thing, Painting. Forty years in the world of art,* New York and
 London 1938

Pascal, Jean *Le Salon d'Automne en 1904,* Paris 1904

Pasquier, Alex *Edmond Picard,* Brussels 1945

Petit Bottin des lettres et des arts, Paris 1886

Picard, Edmond *Pro arte, littérature,* Brussels 1886

 Le Juré: monodrame en cinq actes, with Redon's illustrations, Brussels 1887

 El Moghreb al Aksa: une mission belge au Maroc, frontispiece by Redon,
 Brussels 1889

Redon, Arï 'Odilon Redon dans l'intimité, *La Revue des Arts,* October 1956,
 pp. 130-32

Reff, Theodore 'Cézanne, Flaubert, St Anthony, and the Queen of Sheba', *The Art
 Bulletin,* June 1962, pp. 113-25

 'Redon's *Le Silence:* an iconographic interpretation', *Gazette des Beaux-Arts,*
 1967, pp. 359-68

'Images of Flaubert's Queen of Sheba in Later Nineteenth-century Art' in *The Artist and the Writer in France. Essays in honour of Jean Seznec*, edited by F. Haskell, A. Levi and R. Shackleton, Oxford 1974

Régnier, Henri de 'Mallarmé et les peintres', *L'Art Vivant*, 1 and 15 April 1930, pp. 265-6 and pp. 307-8

Remacle, Adrien *La Passante. Roman d'une âme*, frontispiece by Redon, Paris 1892

Reverseau, Jean-Pierre 'Pour une étude du thème de la tête coupée dans la littérature et la peinture dans la seconde partie du XIX siècle', *Gazette des Beaux-Arts*, September 1972, pp. 173-84

Rewald, John 'Quelques notes et documents sur Odilon Redon', *Gazette des Beaux-Arts*, 1956, pp. 81-124

Post-Impressionism from van Gogh to Gauguin, 2nd edn New York 1962

Rivière, J. and Alain-Fournier *Correspondance, 1905-1914*, 4 vols, Paris 1926-8. New edn 2 vols, Paris 1948

Rod, Edouard 'Emile Hennequin et la critique scientifique' in *Nouvelles Etudes sur le dix-neuvième siècle*, 2nd edn Paris 1899

Roger-Marx, Claude 'Odilon Redon ou les droits de l'imagination', *Feuillets d'Art*, No. 5, April 1920, pp. 33-9

'Les Tentations de Saint Antoine', *La Renaissance*, March-April 1936, pp. 1-48

'Odilon Redon, peintre et mystique', *L'Œil*, May 1956

'Les Tentations de Saint Antoine de Redon', introduction to *La Tentation de Saint Antoine de Flaubert, illustrations de Odilon Redon*, Paris 1969

Rookmaaker, H. R. *Synthetist Art Theories*, Amsterdam 1959

Salmon, André *La Jeune Peinture française*, Paris 1912

'Odilon Redon', *L'Art Décoratif*, January 1913, pp. 5-20

Propos d'atelier, Paris 1922. 2nd edn 1938

Souvenirs sans fin, 3 vols (1903-8; 1908-20; 1920-40), Paris 1955, 1956 and 1961 respectively

Schuré, Edouard *Vercingétorix, drame en cinq actes*, Paris 1887

Sérusier, Paul *ABC de la peinture*, 3rd edn Paris 1950

Seznec, Jean 'The Temptation of Saint Anthony in Art', *Magazine of Art*, New York, Vol 40, No.3, March 1947, pp. 87-93

Nouvelles études sur La Tentation de Saint Antoine, London 1949

'Odilon Redon and Literature' in *French Nineteenth-Century Painting and Literature*, edited by U. Finke, Manchester 1972

Symons, Arthur 'Odilon Redon', *La Revue Indépendante*, March 1891, pp. 390-6

Verhaeren, Emile *Les Soirs*, frontispiece by Redon, Brussels 1888

Les Débâcles, frontispiece by Redon, Brussels 1888

Flambeaux noirs, frontispiece by Redon, Brussels 1891

La Vie 'Hommage à Odilon Redon', many contributors, 30 November 1912, pp. 129-37 and 7 December 1912, pp. 186-7

Werner, Alfred Introduction to *The Graphic Works of Odilon Redon. 209 Lithographs, Etchings and Engravings*, New York 1969

Recently published:

Le Symbolisme en Europe, catalogue to exhibition at the Museum Boymans-van Beuningen, Rotterdam and the Grand Palais, Paris 1975-6

List of Illustrations

27.5 x 20.3cm. $10\frac{7}{8}$ x 8 in. British Museum, London

26 'There were struggles and vain victories', *Origins* ('Il y eut des luttes et de vaines victoires', *Les Origines*) 1883, lithograph, 28.9 x 22.2cm. $11\frac{3}{8}$ x $8\frac{3}{4}$ in. British Museum, London

27 'The powerless wing did not raise the beast at all into those black spaces', *Origins* ('L'aile impuissante n'éleva point la bête en ces noirs espaces', *Les Origines*) 1883, lithograph, 29.5 x 22cm. $11\frac{5}{8}$ x $8\frac{5}{8}$ in. British Museum, London

28 'In my dream I saw in the sky a face of mystery', *Homage to Goya* ('Dans mon rêve, je vis au ciel un visage de mystère', *Hommage à Goya*) 1885, lithograph, 29.1 x 23.8cm. $11\frac{1}{2}$ x $9\frac{3}{8}$ in. British Museum, London

29 'The marsh flower, a human and sad head', *Homage to Goya* ('La fleur du marécage, une tête humaine et triste', *Hommage à Goya*) 1885, lithograph, 27.5 x 20.5cm. $10\frac{7}{8}$ x $8\frac{1}{8}$ in. British Museum, London

30 'A madman in a bleak landscape', *Homage to Goya* ('Un fou dans un morne paysage', *Hommage à Goya*) 1885, lithograph, 22.6 x 19.3cm. $8\frac{7}{8}$ x $7\frac{5}{8}$ in. British Museum, London

31 'On waking, I saw the Goddess of the Intelligible with her severe and hard profile', *Homage to Goya* ('Au réveil, j'aperçus la Déesse de l'Intelligible au profil sévère et dur', *Hommage à Goya*) 1885, lithograph, 27.6 x 21.7cm. $10\frac{7}{8}$ x $8\frac{1}{2}$ in. British Museum, London

32 'The man was alone in a night landscape', *Night* ('L'homme fut solitaire dans un paysage de nuit', *La Nuit*) 1886, lithograph, 29.3 x 22cm. $11\frac{1}{2}$ x $8\frac{5}{8}$ in. British Museum, London

33 'The chimera looked at everything with terror', *Night* ('La chimère regarda avec effroi toutes choses', *La Nuit*) 1886, lithograph, 25 x 18.5cm. $9\frac{3}{4}$ x $7\frac{1}{4}$ in. British Museum, London

34 *Parsifal* 1892, lithograph, 32.2 x 24.2cm. $12\frac{5}{8}$ x $9\frac{1}{2}$ in. British Museum, London

35 *Brünnhilde (Brunnhilde)* 1885, lithograph, 11.8 x 10cm. $4\frac{5}{8}$ x 4 in. British Museum, London

36 *Brünnhilde, Twilight of the Gods (Brunnhilde, crépuscule des dieux)* 1894, lithograph, 38 x 29.2cm. 15 x $11\frac{1}{2}$ in. British Museum, London

37 *Profile of a Woman with Flowers (Profil de femme avec fleurs)* c. 1895 charcoal, 52 x 36.5cm. $20\frac{1}{2}$ x $14\frac{3}{8}$ in. British Museum, London

38 *In the Corner of the Window* or *The Accused (Dans l'angle de la fenêtre)* c. 1886, charcoal, 53.4 x 37.2cm. 21 x $14\frac{5}{8}$ in. Museum of Modern Art, New York

39 'A man of the people, a savage, passed beneath the horses' heads', *The Juror* ('Un homme du peuple, un sauvage, a passé sous la tête des chevaux', *Le Juré*) 1887, lithograph, 18.3 x 13.6cm. $7\frac{1}{4}$ x $5\frac{3}{8}$ in. British Museum, London

40 'She shows herself to him, dramatic and grandiose with her hair like a druid priestess's', *The Juror* ('Elle se montre à lui, dramatique et grandiose avec sa chevelure de prêtresse druidique', *Le Juré*) 1887, lithograph, 19.2 x 14.3cm. $7\frac{1}{2}$ x $5\frac{5}{8}$ in. British Museum, London

41 'The sinister command of the spectre is fulfilled. The dream has ended in death' *The Juror* ('Le commandement sinistre du spectre est accompli. Le rêve s'est achevé par la mort', *Le Juré*) 1887, lithograph, 23.8 x 18.7cm. $9\frac{3}{8}$ x $7\frac{3}{8}$ in. British Museum, London

42 'The Idol' ('L'Idole'), frontispiece to Verhaeren's *Les Soirs (Evenings)* 1887, lithograph, 16.2 x 9.4cm. $6\frac{3}{8}$ x $3\frac{3}{4}$ in. British Museum, London

43 *The Poet (Le Poète)* c. 1887 charcoal, 51 x 36cm. $20\frac{1}{2}$ x $14\frac{1}{8}$ in. Museum Plantin-Moretus, Antwerp

44 Frontispiece to Gilkin's *La Damnation de l'artiste (Damnation of the Artist)* 1890, lithograph, 19 x 12.5cm. $7\frac{1}{2}$ x $4\frac{7}{8}$ in. British Museum, London

45 Frontispiece to Gilkin's *Ténèbres (Darkness)* 1892, lithograph, 19.8 x 12.3cm. $7\frac{3}{4}$ x $4\frac{3}{4}$ in. British Museum, London

46 'It is the devil, carrying beneath his two wings the seven deadly sins', *The Temptation of Saint Anthony* ('C'est le diable, portant sous ses deux ailes les sept péchés capitaux', *La Tentation de Saint Antoine*) 1888, lithograph, 25.4 x 20cm. 10 x $7\frac{7}{8}$ in. British Museum, London

47 'Next there appears a curious being, having a man's head on a fish's body', *The Temptation of Saint Anthony* ('Ensuite, paraît un être singulier, ayant une tête d'homme sur un corps de poisson', *La Tentation de Saint Antoine*) 1888, lithograph, 27.5 x 17cm. $10\frac{7}{8}$ x $6\frac{3}{4}$ in. British Museum, London

48 'It is a skull, with a wreath of roses. It dominates a woman's torso of pearly whiteness', *The Temptation of Saint Anthony* ('C'est une tête de mort, avec une couronne de roses. Elle domine un torse de femme d'une blancheur nacrée', *La Tentation de Saint Antoine*) 1888, lithograph, 29.6 x 21.3cm. $11\frac{5}{8}$ x $8\frac{3}{8}$ in. British Museum, London

49 'The green-eyed chimera turns, barks', *The Temptation of Saint Anthony* ('La chimère aux yeux verts tournoie, aboie', *La Tentation de Saint Antoine*) 1888, lithograph, 27.5 x 16cm. $10\frac{7}{8}$ x $6\frac{1}{4}$ in. British Museum, London

50 'Ceaselessly the demon stirs at my side' ('Sans cesse à mes côtés s'agite le démon'), from the drawings for *Les Fleurs du mal,* 1890, print, reproduced by the Evely Process, 21.4 x 18cm. $8\frac{3}{8}$ x $7\frac{1}{8}$ in. British Museum, London

51 *Silence (Le Silence)* c. 1911, oil on paper, 54 x 54.6cm. $21\frac{1}{4}$ x $21\frac{1}{2}$ in. Museum of Modern Art, New York

52 *Luminous Profile (Profil de lumière)* c. 1875, charcoal, 35 x 23cm. $13\frac{3}{4}$ x $9\frac{1}{8}$ in. Musée du Petit Palais, Paris

53 *Figure in Armour (L'Armure)* 1891, charcoal, 50.7 x 36.8cm. 20 x $14\frac{1}{2}$ in. Metropolitan Museum of Art, New York

54 Maurice Denis *Homage to Cézanne (Hommage à Cézanne)* 1900, oil, 180 x 240cm. 71 x 95 in. Musée National d'Art Moderne, Paris

55 *Pious Women* or *Window No. 19 (Pieuses Femmes* or *Fenêtre No. 19)* c. 1892, charcoal, 52 x 37cm. $20\frac{1}{2}$ x $14\frac{5}{8}$ in. Art Institute of Chicago

56 *Mystic Knight* or *Oedipus and the Sphinx (Le Chevalier mystique* or *Œdipe et le Sphinx)* 1869/90, charcoal and pastel, 100 x 81.5cm. $39\frac{3}{8}$ x $32\frac{1}{8}$ in. Musée des Beaux-Arts, Bordeaux

57 *Druid Priestess (Druidesse)* 1891, lithograph, 23 x 20cm. $9\frac{1}{8}$ x $7\frac{7}{8}$ in. British Museum, London

58 *The Reader (Le Liseur)* 1892, lithograph, 31 x 23.6cm. $12\frac{1}{4}$ x $9\frac{1}{4}$ in. British Museum, London

59 'I saw a large pale light', *The Haunted House* ('Je vis une lueur large et pâle', *La Maison Hantée)* 1896, lithograph, 23 x 17cm. $9\frac{1}{8}$ x $6\frac{3}{4}$ in. British Museum, London

60 *Fantastic Monster (Monstre fantastique)* c. 1880-5, charcoal, 48 x 34cm. $18\frac{7}{8}$ x $13\frac{3}{8}$in. Rijksmuseum Kröller-Müller, Otterlo

61 *Woman and Serpent (Femme et Serpent)* c. 1885-90, charcoal, 51 x 36cm. $20\frac{1}{8}$ x $14\frac{1}{8}$ in. Rijksmuseum Kröller-Müller, Otterlo

62 'Death: My irony surpasses all others!', *To Gustave Flaubert* ('La Mort: Mon ironie dépasse toutes les autres!', *A Gustave Flaubert)* 1889, lithograph, 26.2 x 19.7cm. $10\frac{1}{2}$ x $7\frac{3}{4}$ in. British Museum, London

63 'The Sphinx: . . . My gaze that nothing can deflect, passing through objects, remains fixed on an inaccessible horizon. The Chimera: As for me, I am light and joyful', *To Gustave Flaubert* ('Le Sphinx: . . . Mon regard que rien ne peut dévier, demeure tendu à travers les choses sur un horizon inaccessible. La Chimère: Moi, je suis légère et joyeuse', *A Gustave Flaubert)* 1889, lithograph, 28.2 x 20.2cm. $11\frac{1}{8}$ x 8 in. British Museum, London

64 *Buddha (Le Buddha),* with a caption from Flaubert: 'I was taken to schools. I knew more than the scholars' ('On m'a mené dans les écoles. J'en savais plus que les docteurs') 1895, lithograph, 32.4 x 24.9cm. $12\frac{3}{4}$ x $9\frac{3}{4}$ in. British Museum, London

65 *Oannes (Oannès)* c. 1910, oil, 64 x 49cm. $25\frac{1}{4}$ x $19\frac{1}{4}$ in. Rijksmuseum Kröller-Müller, Otterlo

66 'A long chrysalis the colour of blood', *To Gustave Flaubert* ('Une longue chrysalide couleur de sang', *A Gustave Flaubert)* 1889, lithograph, 22 x 18.5cm. $8\frac{5}{8}$ x $7\frac{1}{8}$in. British Museum, London

67 'Oannes: I, the first consciousness in chaos, rose from the abyss to harden matter, to determine forms', *The Temptation of Saint Anthony* ('Oannès: Moi, la première conscience du chaos, j'ai surgi de l'abîme pour durcir la matière, pour régler les

formes', *La Tentation de Saint Antoine*) 1896, lithograph, 27.9 x 21.7cm. 11 x 8½ in. British Museum, London

68 'The beasts of the sea, round like water-skins', *The Temptation of Saint Anthony* ('Les bêtes de la mer rondes comme des outres', *La Tentation de Saint Antoine*) 1896, lithograph, 22.2 x 19cm. 8¾ x 7½ in. British Museum, London

69 'Anthony: What is the object of all this? The Devil: There is no object', *The Temptation of Saint Anthony* ('Antoine: Quel est le but de tout cela? Le Diable: Il n'y a pas de but!', *La Tentation de Saint Antoine*) 1896, lithograph, 31.1 x 25cm. 12¼ x 9¾ in. British Museum, London

70 'I have sometimes caught sight in the sky of what seemed to be the forms of spirits', *The Temptation of Saint Anthony* ('J'ai quelquefois aperçu dans le ciel comme des formes d'esprits', *La Tentation de Saint Antoine*) 1896, lithograph, 26.1 x 18.2cm. 10¼ x 7⅛ in. British Museum, London

71 'It was a veil, an imprint', *Dreams* ('C'etait un voile, une empreinte', *Songes*) 1891, lithograph, 18.8 x 13.3cm. 7½ x 5¼ in. British Museum, London

72 'And yonder the astral idol, the apotheosis', *Dreams* ('Et là-bas l'idole astrale, l'apothéose', *Songes*) 1891, lithograph, 27.7 x 19.2cm. 11 x 7½ in. British Museum, London

73 *Buddha (Le Buddha)* c. 1905, tempera screen, 161.5 x 122.5cm. 63⅜ x 48¼ in. Bonger Collection, Almen

74 *Head of Christ (Tête de Christ)* c. 1895, charcoal, 51.5 x 37.4cm. 20¼ x 14¾ in. British Museum, London

75 'And the devil that deceived them was cast into the lake of fire and brimstone, where the beast and the false prophet are', *The Apocalypse of Saint John* ('Et le diable qui les séduisait, fut jeté dans l'étang de feu et de soufre, où est la bête et le faux prophète', *L'Apocalypse de Saint Jean*) 1899, lithograph, 27.4 x 23.8cm. 10¾ x 9⅜ in. British Museum, London

76 'Saint Anthony: Help me, my God!', *The Temptation of Saint Anthony* ('Saint Antoine: Au secours, mon Dieu!', *La Tentation de Saint Antoine*) 1896, lithograph, 21.5 x 13cm. 8½ x 5⅛ in. British Museum, London

77 'And I, John, saw these things, and heard them', *The Apocalypse of Saint John* ('C'est moi, Jean, qui ai vu et qui ai ouï ces choses', *L'Apocalypse de Saint Jean*) 1899, lithograph, 15.8 x 19cm. 6⅛ x 7½ in. British Museum, London

78 'Then I saw in the right hand of him that sat on the throne a book written within and on the back, sealed with seven seals', *The Apocalypse of Saint John* ('Puis je vis, dans la main droite de celui qui était assis sur le trône un livre écrit dedans et dehors, scellé de sept sceaux', *L'Apocalypse de Saint Jean*) 1899, lithograph, 32.2 x 24.3cm. 12¾ x 9½ in. British Museum, London

79 Albrecht Dürer *Saint John and the Twenty-four Elders in Heaven* (detail) 1498, woodcut, 39.4 x 28.1cm. 15½ x 11 in. British Museum, London

80 'He falls into the abyss, head downwards', *The Temptation of Saint Anthony* ('Il tombe dans l'abîme, la tête en bas', *La Tentation de Saint Antoine*) 1896, lithograph, 27.8 x 21.2cm. 11 x 8⅜ in. British Museum, London

81 *Chimera (Chimère)* 1902, charcoal, 54.5 x 39cm. 21½ x 15⅜ in. Musée National du Louvre, Paris

82 *Portrait of Bonnard (Portrait de Bonnard)* 1902, lithograph, 14.5 x 12.3cm. 5¾ x 4⅞ in. British Museum, London

83 Illustration of Mallarmé's *Un Coup de dés jamais n'abolira le hasard* (*A Throw of Dice Never Will Abolish Chance*) 1898, lithograph, 12 x 7cm. 4¾ x 2¾ in. British Museum, London

84 'I plunged into solitude. I lived in the tree behind me', *The Temptation of Saint Anthony* ('Je me suis enfoncé dans la solitude. J'habitais l'arbre derrière moi', *La Tentation de Saint Antoine*) 1896, lithograph, 30 x 22.5cm. 11⅞ x 8⅞ in. British Museum, London

85 'The Old Woman: What do you fear? A broad black hole! It is perhaps empty?', *The Temptation of Saint Anthony* ('La Vieille: Que crains-tu? Un large trou noir! Il est vide peut-être?', *La Tentation de Saint Antoine*) 1896, lithograph, 16.2 x 10.8cm. 6⅜ x 4¼ in. British Museum, London

86 'She takes from her bosom a sponge that is quite black, and covers it with kisses', *The Temptation of Saint Anthony* ('Elle tire de sa poitrine une éponge toute noire, la couvre de baisers', *La Tentation de Saint Antoine*) 1896, lithograph, 19.3 x 15.3cm. 7⅝ x 6 in. British Museum, London

87 'And there fell a great star from heaven, burning as it were a lamp', *The Apocalypse of Saint John* ('Et il tomba du ciel une grande étoile ardente', *L'Apocalypse de Saint Jean*) 1899, lithograph, 30.3 x 23.3cm. 11⅞ x 9¼ in. British Museum, London

88 *The Lion Hunt (La Chasse aux lions,)* after Delacroix, c. 1870, oil, 46 x 55cm. 18⅛ x 21⅝ in. Musée des Beaux-Arts, Bordeaux

89 *The Winged Man (L'Homme ailé)* c. 1890-5, oil, 33.5 x 24cm. 13¼ x 9½ in. Musée des Beaux-Arts, Bordeaux

90 *Cyclops (Le Cyclope)* 1898-1900, oil on panel, 64 x 51cm. 25¼ x 20⅛ in. Rijksmuseum Kröller-Müller, Otterlo

91 *Saint Sebastian (Saint Sébastien)* 1910, oil on canvas, 92 x 59.5cm. 36¼ x 23⅜ in. Oeffentliche Kunstsammlung, Basel

92 *The Chariot of Apollo (Le Char d'Apollon)* 1909, oil, 100 x 80cm. 39¾ x 31½ in. Musée des Beaux-Arts, Bordeaux

93 *The Sacred Heart (Le Sacré Cœur)* c. 1895, pastel, 60 x 45cm. 23⅝ x 17¾ in. Musée National du Louvre, Paris

94 *Homage to Gauguin (Hommage à Gauguin)* 1904, oil, 66 x 55cm. 26 x 21⅝ in. Galerie du Jeu de Paume, Paris

95 *Head with Flowers (Tête et fleurs)* c. 1895, oil, 52.1 x 47cm. 20½ x 18½ in. Private collection, U.S.A.

96 *Etruscan Vase (Vase étrusque)* 1900-05, tempera on canvas, 81 x 59cm. 32 x 23¼ in. Metropolitan Museum of Art, New York

97 *Portrait of Mme Arthur Fontaine (Portrait de Mme Arthur Fontaine)* 1901, pastel, 72.4 x 54.6cm 28½ x 22½ in. Metropolitan Museum of Art, New York

98 *Portrait of André Bonger (Portrait d'André Bonger)* 1904, red chalk, 22 x 17cm. 8⅝ x 6⅝ in. Bonger Collection, Almen

99 *The Eternal Silence of these Infinite Spaces (Le Silence éternel de ces espaces infinis)* 1878, charcoal, 22.5 x 27.5cm. 8⅞ x 10⅞ in. Palais des Beaux-Arts, Paris

100 *The White Butterfly (Le Papillon blanc)* c. 1910, oil, 63.5 x 48.9cm. 25 x 19¼ in. Ian Woodner Family Collection, New York

COLOUR

1 *Closed Eyes (Les Yeux clos)* 1890, oil on canvas, 38 x 30cm. 15 x 11⅞ in. Galerie du Jeu de Paume, Paris

2 *Golden Cell* or *Blue Profile (La Cellule d'or* or *Profil bleu)* c. 1893, pastel, watercolour and gold, 30 x 24.5cm. 11¾ x 9⅝ in. British Museum, London

3 *Ophelia among the Flowers (Ophélie dans les Fleurs)* 1905, pastel, 64 x 91cm. 25¼ x 35⅞ in. Marlborough Fine Art, London

4 *Red Sphinx (Le Sphinx rouge)* 1910-12, oil, 61 x 50cm. 24 x 19⅝ in. Collection Prof. Hans Hahnloser, Berne

5 *Buddha (Le Buddha)* c. 1905, pastel, 90 x 73cm. 35⅜ x 28¾ in. Musée National du Louvre, Paris

6 *Pandora* c. 1910, oil, 143 x 62.2cm. 56½ x 24½ in. Metropolitan Museum of Art, New York

7 *Portrait of Violette Heymann (Portrait de Violette Heymann)* 1909, pastel, 72 x 92.5cm. 28⅜ x 36⅜ in. Cleveland Museum of Art

8 *Evocation of Roussel (Evocation de Roussel)* 1912, oil, 73 x 54cm. 28¾ x 21¼ in. National Gallery of Art, Washington D.C.

9 *The Birth of Venus (Naissance de Vénus)* c. 1910, pastel, 83 x 64cm. 32⅝ x 25¼ in. Musée du Petit Palais, Paris

10 *Flowers in a Green Vase (Fleurs dans un vase vert)* c. 1905, oil, 27.3 x 21.6cm. 10¾ x 8½ in. Museum of Art, Carnegie Institute, Pittsburgh

11 *Bouquet of Flowers in a Green Vase (Bouquet de fleurs dans un vase vert)* c. 1907, oil, 73 x 54cm. 28¾ x 21¼ in. Wadsworth Atheneum, Hartford, Connecticut

12 *Woman with Outstretched Arms (Buste de femme, les bras étendus)* c. 1910-14, watercolour, 17 x 20cm. $6\frac{3}{4}$ x $7\frac{7}{8}$ in. Musée du Petit Palais, Paris

13 *Orpheus (Orphée)* c. 1903, pastel, 70 x 56.5cm. $27\frac{1}{2}$ x $22\frac{1}{4}$ in. Cleveland Museum of Art

14 *Roger and Angelica (Roger et Angélique)* c. 1910, pastel, 91.5 x 71cm. 36 x 28 in. Museum of Modern Art, New York

15 *Night (La Nuit)* 1910-11, tempera, 200 x 650cm. 78 x 256 in. Abbaye de Fontfroide

16 *Day (Le Jour)* 1910-11, tempera, 200 x 650cm. 78 x 256 in. Abbaye de Fontfroide

17 *Vase of Flowers (Vase de fleurs)* c. 1914, pastel, 75 x 59cm. $29\frac{1}{2}$ x $23\frac{1}{4}$ in. Musée du Petit Palais, Paris

18 *Pegasus Triumphant (Pégase triomphant)* c. 1907, oil on cardboard, 47 x 63cm. $18\frac{1}{2}$ x $24\frac{3}{4}$ in. Rijksmuseum Kröller-Müller, Otterlo

19 *The Red Screen (Le Paravent rouge)* 1906-8, tempera, three panels, each measuring 168 x 74cm. $66\frac{1}{8}$ x $29\frac{1}{8}$ in. Bonger Collection, Almen

Footnotes

Preface

1 Quoted by A. Mellerio, *L'OEuvre graphique complet d'Odilon Redon* (Paris 1913), p.83

2 Catalogue to Redon retrospective, Musée des Arts Décoratifs, March 1926, p.7

The Shadow of Romanticism

1 'Salon de 1868', *La Gironde*. The articles are dated 17 May, 31 May and 27 June, but were in fact published 19 May, 9 June and 1 July

2 Henri de Régnier, 'Mallarmé et les peintres', *L'Art Vivant*, 15 April 1930, p.307

3 Emile Zola, 'Mon Salon', first published in *L'Evénement Illustré,* May and June 1868

4 'Salon de 1868', *La Gironde,* 19 May 1868

5 *A soi-même,* 2nd edn (Paris 1961), p.36

6 'Salon de 1868', *La Gironde,* 19 May 1868

7 *La Revue des Deux Mondes,* 1 June 1868, pp. 729-30

8 Lafenestre, 'L'Art au Salon de 1868', *La Revue Contemporaine,* 1868, p.526

9 *A soi-même,* p.132

10 Ibid, p.17

11 Ibid, p.14

12 Ibid, p.18

13 Ibid, p.21

14 Quoted by D. Van Gelder, 'Rodolphe Bresdin et Odilon Redon' in *Het Nederlands Kunsthistorisch Jahrboek,* 1966, pp.285-6

15 Ibid, pp.265-304

16 Published 10 January 1869, and reproduced, with the omission of the opening paragraph, in *A soi-même,* pp.164-170

17 Quoted by A. Mellerio, *L'OEuvre graphique complet d'Odilon Redon* (Paris 1913), p.81

18 Ibid, p.81

19 *A soi-même,* pp.26-7

20 Ibid, p.28

21 Ibid, p.125

22 Ibid, p.79

23 Eugène Fromentin, *Les Maîtres d'autrefois* (Paris 1965), p.388

24 H. Babou, preface to S.-C. de Rayssac, *Poésies* (Paris 1877), p.vi

25 *A soi-même,* pp.62, 153 and 182-3. See also A. Salmon, 'Redon citant Chenavard' in *Propos d'atelier,* 2nd edn (Paris 1938), p.81

26 See 'Le Salon de Mme de Rayssac', Ch. 4 in Arï Redon, *Lettres de Gauguin, Gide, Huysmans, Jammes, Mallarmé, Verhaeren . . . à Odilon Redon* (Paris 1960)

27 Letter to Mellerio of 2 July 1898, *Lettres d'Odilon Redon, 1878-1916* (Paris 1923), p.30
28 See Arï Redon, *Lettres . . . à Odilon Redon,* p.84
29 Published in J.-K. Huysmans, *L'Art moderne* (Paris 1883), p.194
30 Ibid, pp.274-6
31 Published in *La Revue littéraire et artistique,* 4 March 1882

The Subtle Lithographer of Suffering

1 Quoted by Auriant, 'Des lettres inédites d'Odilon Redon (à Emile Hennequin)', *Beaux-Arts,* 7 June 1935, p.2
2 J.-K. Huysmans, *L'Art moderne* (Paris 1883), p.276
3 See 'Emile Hennequin et la critique scientifique' in E. Rod, *Nouvelles études sur le xixᵉ siècle,* 2nd edn (Paris 1899), pp.129-53
4 Quoted by E. Rod, ibid, p.134
5 Quoted by Auriant, *Beaux-Arts,* 7 June 1935, p.2
6 Huysmans, *L'Art moderne,* p.276
7 J.-K. Huysmans, *A rebours,* (Paris 1961), p.95
8 In a contribution to 'Hommage à Odilon Redon', *La Vie,* 30 November 1912, p.133
9 Henri Beauclair and Gabriel Vicaire, *Les Déliquescences, poèmes décadents d'Adoré Floupette,* 4th edn (Paris 1923), pp.37-8
10 Pierre Angrand, *Naissance des Artistes Indépendants, 1884* (Paris 1965), pp.76-7
11 At the end of *Cauchemar,* Huysmans' prose poem transcription of *Homage to Goya,* first published in *La Revue Indépendante,* February 1885, and then in the 2nd edn of his *Croquis parisiens,* (Paris 1886), pp.147-53
12 Letter to Mellerio of 21 July 1898, *Lettres d'Odilon Redon, 1878-1916* (Paris 1923), p.30. See also *A soi-même,* 2nd edn (Paris 1961), pp.172-3
13 Annotation made to E. Bernard's *Odilon Redon,* cited by Roseline Bacou, *Odilon Redon,* vol. 1 (Geneva 1956), p.278
14 Letter to Mellerio of 21 July 1898, *Lettres d'Odilon Redon,* p.31
15 Ibid, p.31
16 In a review of the album quoted by A. Mellerio, *L'Œuvre graphique complet d'Odilon Redon* (Paris 1913), p.96
17 Huysmans, *A rebours,* p.95
18 See J.-K. Huysmans, *Certains* (Paris 1889), pp.137ff.
19 In 'Quelques caricaturistes étrangers', first published 1857; Baudelaire, *Œuvres complètes* (Paris 1961), pp. 1019-20
20 See Mellerio, *L'Œuvre graphique,* p.96
21 Huysmans, *A rebours,* p.245
22 *A soi-même,* p.81

The Pandemonium of Symbolism

1 Article in *La Vie Moderne,* quoted by Mellerio, *L'Œuvre graphique,* p.139
2 H. Beraldi, *Les Graveurs du xixᵉ siècle, guide de l'amateur d'estampes modernes,* vol. 10 (Paris 1891), p.177
3 *Le Petit Bottin des lettres et des arts* (Paris 1886), p.114
4 M. Maus, *Trente années de lutte pour l'art* (Brussels 1926), p.44. This book contains much essential information concerning Les XX and their exhibitions
5 'Odilon Redon', *L'Art Moderne,* 21 March 1886, pp.92-3
6 'Odilon Redon', *La Jeune Belgique,* 1 February 1886, pp.131-45
7 J. Destrée, *L'Œuvre lithographique de Odilon Redon* (Brussels 1891), p.56
8 See the two essays that precede the text of *Le Juré* in the 1887 edition: 'Lettre sur le monodrame' and 'Le Fantastique Réel'
9 *A soi-même,* 2nd edn (Paris 1961), p.123
10 See letter of 3 February 1887, Arï Redon, *Lettres de Gauguin, Gide, Huysmans, Jammes, Mallarmé, Verhaeren . . . à Odilon Redon* (Paris 1960), p.150
11 See ibid, p.170
12 S. Sandström, *Le Monde imaginaire d'Odilon Redon* (Paris 1955), Figure 12

13 M. Maus, *Trente années de lutte,* p.101

14 J. Sutter, *The Neo-Impressionists* (London 1970), p.12

15 See R. Bacou on Redon and Belgium, *Odilon Redon,* vol. 1 (Geneva 1956), pp.100ff.

16 I. Gilkin, *La Nuit* (Paris 1897), pp.238-39

17 I. Gilkin, *La Damnation de l'artiste* (Brussels 1890), p.10

18 A. Mellerio, *L'Œuvre graphique complet d'Odilon Redon* (Paris 1913), Item 104

19 I. Gilkin, *Ténèbres* (Brussels 1892), p.37

20 Letter of 21 July 1898, *Lettres d'Odilon Redon, 1878-1916* (Paris 1923), p.32

21 See letter of October 1915, 'Quelques lettres d'Odilon Redon', *La Vie,* Nov. 1916 p.349

22 J. Destrée, *L'Œuvre lithographique de Odilon Redon,* p.46

23 'Hommage à Odilon Redon', *La Vie,* 30 November 1912, p.131

24 See Arï Redon, *Lettres . . . à Odilon Redon,* pp.131-46

25 Article of 2 April 1885, quoted by Mellerio, *L'Œuvre graphique,* pp.133-4

26 C. Morice, *La Littérature de tout à l'heure* (Paris 1889), pp.358-79

27 Ibid, p.198

28 G.-A. Aurier, *Œuvres posthumes* (Paris 1893), p.103

29 *La Revue Encyclopédique,* 1 April 1892, p.483

30 Ibid, p.483

31 R. de Gourmont, *Le Problème du style* (Paris 1938), p.89

32 *A soi-même,* p.27

33 First published in *Le Chat noir,* 23 May 1891

34 *A soi-même,* p.92

New Horizons in the Early 1890s

1 C. Mauclair, 'Exposition Odilon Redon chez Durand-Ruel', *Le Mercure de France,* 1 May 1894, p.94

2 Ibid, p.94

3 Article of 15 April 1894, quoted by A. Mellerio, *L'Œuvre graphique complet d'Odilon Redon* (Paris 1913), p.146

4 First published in *Le Courrier français,* 30 December 1894; reproduced in Frantz Jourdain, *Les Décorés. Ceux qui ne le sont pas* (Paris 1895), pp.243-4

5 Article of 10 April 1894, reproduced in Jean Lorrain, *Sensations et souvenirs* (Paris 1895), pp.213-20

6 Quoted by Mellerio, *L'Œuvre graphique,* p.144

7 'Exposition Odilon Redon', *La Revue Blanche,* May 1894, pp.470-2

8 'Un Album d'Odilon Redon', *La Revue Blanche,* February 1897, p.140

9 T. Natanson, *Peints à leur tour* (Paris 1948), p.58

10 'Hommage à Odilon Redon', *La Vie,* 30 November 1912, p.129

11 Ibid, p.129

12 M. Denis, *Du Symbolisme au Classicisme, théories* (Paris 1964), p.63

13 C. Chassé, *Les Nabis et leur temps* (Lausanne and Paris 1960), p.28

14 'Hommage à Odilon Redon', *La Vie,* 30 November 1912, p.133

15 M. Denis, *Du Symbolisme au Classicisme,* p.63

16 'Hommage à Odilon Redon', *La Vie,* 30 November 1912

17 E. Bernard, *Lettres . . . à Emile Bernard,* 2nd edn (Brussels 1942), p.135

18 *Le Cœur,* September-October 1893, p.2

19 Ibid, p.2

20 E. Bernard, *Lettres . . . à Emile Bernard,* p.149

21 See J. Lethève, 'Les Salons de la Rose-Croix', *Gazette des Beaux-Arts,* December 1960, pp.363-74

22 The Société des Peintres-Graveurs had been founded in 1889 and held annual and retrospective exhibitions in Paris. See Claude Roger-Marx, *Graphic Art of the 19th Century* (London 1962), pp.169-71

23 Article by Tiphereth, *Le Cœur,* May 1893, p.8

24 See Arï Redon, *Lettres de Gauguin, Gide, Huysmans, Jammes, Mallarmé, Verhaeren . . . à Odilon Redon* (Paris 1960), p.244

25 See E. Schuré, 'L'Œuvre de Gustave Moreau', *La Revue de Paris,* 1 December 1900, pp.587-622

26 Letter to Bonger, February 1896, quoted by R. Bacou, *Odilon Redon,* vol. 1 (Geneva 1956), p.115
27 *The Idler,* April 1900, p.139
28 Letter to Bonger, 9 June 1894, quoted by R. Bacou, *Odilon Redon,* vol. 1, p.112
29 *A soi-même,* p.67
30 See Arï Redon, *Lettres . . . à Odilon Redon,* p.228
31 See letter to Fabre, October 1895, quoted in *Lettres d'Odilon Redon 1878-1916* (Paris 1923), p.25
32 See letter to Bonger quoted by R. Bacou, *Odilon Redon,* vol. 1, p.114
33 Havelock Ellis, *My Life* (London 1967), p.209
34 This article was reprinted with minor alterations in Arthur Symons, *Colour Studies in Paris* (London 1918), pp.215-23
35 F. Fénéon, *Œuvres plus que complètes* (Geneva 1970), p.187
36 Ibid, p.8
37 Rémy de Gourmont, *Le Livre des masques,* vol. 1 (Paris 1896), p.143
38 G. Kahn, 'L'Exposition des 33', *La Revue Indépendante,* January 1888, p.151
39 Léon Daudet, *Les Kamtchatka* (Paris 1894), p.20
40 Quoted by Jean Loize, 'Un Inédit de Gauguin', *Les Nouvelles Littéraires,* 7 May 1953

The Last 'Noirs'

1 At present privately owned in New York; reproduced in colour in Jean Selz, *Odilon Redon* (Paris 1971), p.46
2 Letter of 31 March 1882, quoted by Auriant, *Beaux-Arts,* 7 June 1935
3 J. Seznec, *Nouvelles études sur La Tentation de Saint Antoine* (London 1949), pp.86-8
4 See letter to Mellerio, 21 July 1898, *Lettres d'Odilon Redon, 1878-1916* (Paris 1923), p.32
5 The change is from Flaubert's Ch. 2 to Ch. 6
6 A. Mellerio, *L'Œuvre graphique complet d'Odilon Redon* (Paris 1913), Item 111
7 R. Bacou, *Odilon Redon,* vol. 1 (Geneva 1956), pp.126-7
8 See *A soi-même,* 2nd edn (Paris 1961), p.18
9 Letter to Bonger, 7 August 1895, *Lettres d'Odilon Redon,* pp.24-5
10 E. Schuré, *Avant-propos* (to *Les Grands Initiés* 1926) (Paris 1968), p.18
11 In an illustrated edition of *Parallèlement.* See Una Iohnson, *Ambroise Vollard, éditeur* (New York 1944), p.19
12 See Arï Redon, *Lettres de Gauguin, Gide, Huysmans, Jammes, Mallarmé, Verhaeren . . . à Odilon Redon* (Paris 1960), pp.143-5
13 *Lettres d'Odilon Redon,* p.32
14 C. Roger-Marx, 'Odilon Redon, peintre et mystique', *L'Œil,* May 1956, p.21
15 A. Mellerio, *L'Œuvre graphique,* p.9
16 See Arï Redon, *Lettres . . . à Odilon Redon,* pp.145-6
17 Letter to Mellerio, 2 October 1898, *Lettres d'Odilon Redon,* p.36
18 G. Coquiot, *Le Vrai J.-K. Huysmans* (Paris 1912), p.78
19 *Lettres . . . à Emile Bernard,* 2nd edn (Brussels 1942), p.154
20 Letter of May 1894, Arï Redon, *Lettres . . . à Odilon Redon,* p.250
21 André Gide, *Journal 1889-1939* (Paris 1948), pp.140-1
22 See Arï Redon, *Lettres . . . à Odilon Redon,* pp.290-1
23 Quoted by R. Bacou, *Odilon Redon,* vol. 1, p.275
24 Ibid, vol. 1, p.283
25 Ibid, vol. 1, p.280
26 *Lettres d'Odilon Redon,* p.30
27 Ibid, p.33
28 Ibid, p.44

Colour

1 *A soi-même,* 2nd edn (Paris 1961), p.138
2 'Hommage à Odilon Redon', *La Vie,* 30 November 1912, p.133
3 See Arï Redon, *Lettres de Gauguin, Gide, Huysmans, Jammes, Mallarmé, Verhaeren . . . à Odilon Redon* (Paris 1960), pp.234-5

4 'Quelques lettres d'Odilon Redon', *La Vie,* December 1916, p.381
5 Ibid, p.381
6 Jean Pascal, *Le Salon d'Automne en 1904* (Paris 1904), p.10
7 R. Marx, 'Le Salon d'Automne', *Gazette des Beaux-Arts,* December 1904, p.465
8 Letter of 4 December 1904, quoted by R. Bacou, *Odilon Redon,* vol. 1 (Geneva 1956), p.74
9 In 1913; *A soi-même,* p.137
10 'Quelques opinions sur Paul Gauguin', *Le Mercure de France,* November 1903, p.428
11 A photograph of a drawing called *Spring.* Redon was interested in the way photography might allow him to multiply his drawings, as lithography had done
12 See F. Jammes, *L'Amour, les Muses et la chasse* (Paris 1922), pp.25-6
13 See Arï Redon, *Lettres . . . à Odilon Redon,* Ch. 11
14 F. Jammes and A. Fontaine, *Correspondance* (Paris 1959), p.194
15 Ibid, p.56
16 Quoted by R. Bacou in Arï Redon, *Lettres . . . à Odilon Redon,* pp.274-5
17 Quoted in P. Claudel, F. Jammes, G. Frizeau, *Correspondance* (Paris 1952), p.395
18 *Lettres d'Odilon Redon 1878-1916* (Paris 1923), pp.76-7
19 F. Jammes and A. Fontaine, *Correspondance,* p.98
20 'Redon: mystique with a method', *Art News,* New York, January 1957
21 *Lettres d'Odilon Redon,* p.56
22 *La Revue Bleue,* 24 October 1903, p.528
23 Ibid, p.528
24 Ibid, p.529
25 'Odilon Redon', *La Revue Illustrée,* 20 February 1907, p.159
26 Ibid, p.158
27 Letter of 31 March 1907, published in *La Vie,* November 1916, p.349
28 Ibid, p.349
29 *Arts et Spectacles,* October-November 1956
30 Jacques Rivière and Alain-Fournier, *Correspondance, 1905-1914* (Paris 1926-28), vol. 3, p.105
31 Ibid, vol. 2, p.376
32 A. Vollard, *Recollections of a Picture Dealer* (London 1936), p.191
33 At the time of writing, this correspondence is soon to be published in France
34 T. Reff, 'Redon's *Le Silence:* an iconographic interpretation', *Gazette des Beaux-Arts,* 1967, pp.359-68
35 A. Salmon, *Souvenirs sans fin,* vol. 2 (Paris 1956), p.231, and vol. 3 (Paris 1961), p.244
36 See E. Lockspeiser, *Debussy, his life and mind,* vol. 2 (London 1962-5), Appendix C
37 Letter of 22 December 1914, quoted by G. Jean-Aubry, 'Odilon Redon', *La Renaissance de l'art français* (August 1920), p.334
38 See Arï Redon, *Lettres . . . à Odilon Redon,* pp.254-5
39 G. Jean-Aubry, *La Renaissance de l'art français,* p.328
40 Ibid, p.328
41 J.Cocteau, *Le Rappel à l'ordre* (Paris 1926), p.48
42 Arï Redon, *Lettres . . . à Odilon Redon,* p.256
43 A. Salmon, *Souvenirs sans fin,* vol.3, p.244

Epilogue

1 *A soi-même,* 2nd edn (Paris 1961), p.116
2 Ibid, pp.64-5
3 Ibid, p.157
4 Ibid, pp.148-53
5 Ibid, p.152
6 Ibid, p.159